DATE			

The World of Carl Larsson

With commentary by Görel Cavalli-Björkman and
Bo Lindwall, published by Hans-Curt Köster

English Translation by Allan Lake Rice, Ph.D.

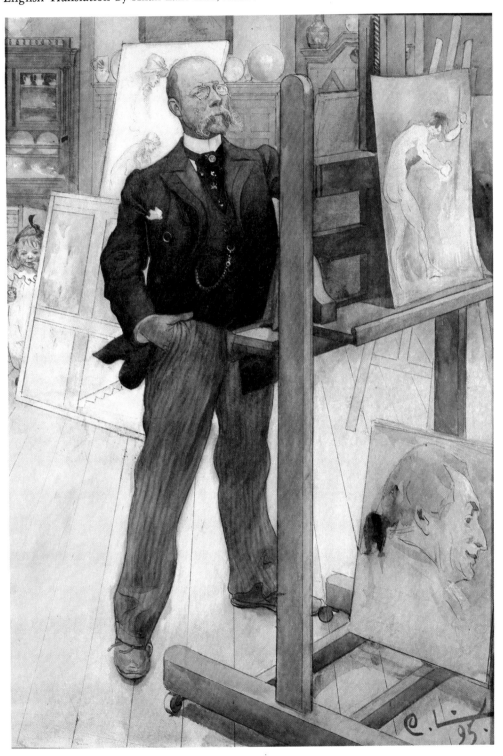

CONTENTS

Photo credits: Albert Bonniers Förlag, Stockholm: pp. 22 right, 39 top right, 56 top right, 93 top. Carl Larsson-gården, Sundborn: pp. 35, 124 top left. Dalarnas Museum, Falun: p. 79 to left. Ulla-Brita Frieberg, Sundborn: p. 29 top left. Göteborgs Konstmuseum: pp. 14 top right, 19 right, 20 top left, 30 top left, top center, 31 bottom left (both), top center, top right, bottom center, bottom right, 36/37 top, 45 top center, top right, 46 all, 48 top right, 50 al, 51 all, 56 left, 61 top right, 76, 96 right, 103 bottom, 104 right, 124 top center top right, middle center, middle right, 132, 138 all, 141, 152 bottom left, bottom right. Kungl. Akademie för de fria Konsterna, Stockholm: pp. 9 top right, 19 top left. Lars Larsson-Hytte, Smedjebacken: p. 123 right. Nationalmuseum, Stockholm: pp. 12 left, 16, 20 right, 21, 22 left, 24 left, 28, 29 right, 32 left, 33 all, 34 left, 37 bottom right, 39 left, 40, 47 all, 53 left, 56 bottom right, 94 bottom, 108 top right, 122 top right, 126 bottom right, 130 bottom left. Thomas Normark, Västerås: p. 136. Pressensbild, Stockholm: p. 42. Prins Eugens Waldemarsudde, Stockholm: pp. 1, 27 right, 179. Stig Ranstrom, Göteborg: pp. 32 right, 43, 94 top, 142 top right. Tag Ranström, Eskilstuna: pp. 82, 117 left. All others: The publisher's archives.

Copyright © 1982 by Verlag Karl Robert Langewiesche Nachfolger Hans Köster, Postfach, D-6240 Königstein im Taunus
Printed in the Federal Republic of Germany

Published in the U.S.A. by Green Tiger Press, San Diego CA, ISBN 0-914676-93-8.
Published worldwide outside the U.S.A. by Nordic Heritage Service, London: ISBN 1-870180-00-3

GLOSSARY

Larsson's books are listed by their original Swedish titles for ready reference. Dates and English meanings are given

1895 *De Mina* My (Loved) Ones

1899 *Ett Hem* (Also known as *Ett Hem i Dalarna*) A Home in Dalecarlia

1902 *Larssons* The Larsson Family

1906 *Spadarvet* (older spelling *Spadarfvet)* (The curious name of an old property bought by Larsson; approx. English meaning: "hereditary digs")

1910 *Åt Solsidan* House in the Sun

1913 *Andras Barn* Other People's Children

1919 *De Mina* My (Loved) Ones (second, revised edition)

Other terms: *Palettskrap* Scrapings from a Palette
Hyttnäs Cottage Point
Waldemarsudde Waldemar's Point (mansion, now museum)
Prästgatan Priest St.
Gråbergsgatan Greymountain St.
Åsögatan Ridge-Island St.
Korum (regimental) prayers
Konst art

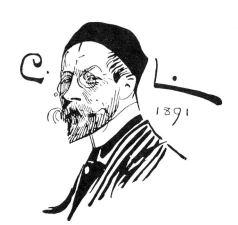

Page 1: *Self-portrait* Watercolor, 1895, Prince Eugen's Waldemarsudde, Stockholm

Self-Portrait Drawing, 1891, Owner unknown

PREFACE

The Carl Larsson Exhibitions at the Amos Anderson Museum in Helsinki in 1981/82 and at the Brooklyn Museum in New York late in 1982 make it clear that perennial interest in this artist continues even in our day. In recent years Larsson (1853-1919) has even conquered countries in which he had until then been almost unknown. For example, books by or about him have appeared in France and Italy. Countries such as Finland, Germany, the Netherlands and later England and the United States have been integral parts of his circle of readers. If we may take as a measuring stick the sales figures of his best known book, *Åt Solsidan (The House in the Sun),* which appeared in 1910, interest in Larsson has had it ups and downs. The astonishing thing is, however, that sales figures have really always been higher than average since that time.

What is the basis for this so constant interest in an artist who is hardly ''modern''? At all events, what we may call the ''generation gap'' does not seem to have been a factor regarding this interest in the case of Larsson. The present work seeks an answer to this question in, I feel, a new form, in that it confronts the reader with his work, his life and also his thought and his feeling in a sequence which has hitherto not been attempted. The picture-sequence is thematic rather than chronological or biographical. One exception has automatically arisen from the fact that his ''open-air painting'' is confined to a relatively short period of time. The accents that this book seeks to bring out are clearly related to the question enunciated above. For this reason the ''typical'' Larsson pictures, no matter how we define this problematic word, are in the majority, while his development in that direction and his constant experimentation in other directions are represented in only a sketchy way.

At the same time, the range of questioning that still requires thorough and unprejudiced treatment becomes

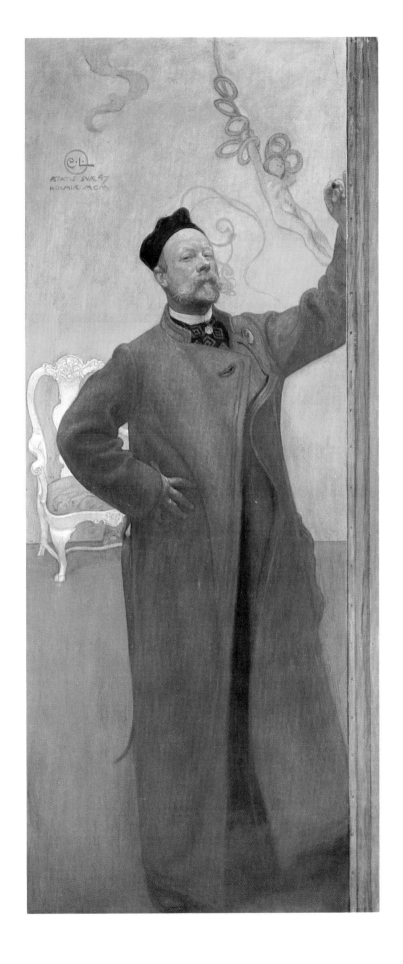

In Front of the Mirror (Self-Portrait) Oil, 1900, *Larssons,* 1902, Art Museum, Göteborg

clear in this book. Chiefly, however, this book may be said to be the fullest collection of Larsson pictures that has ever been undertaken in a single volume.

In particular there will be found here also the majority of those pictures which have been shown in the two exhibitions this year. This book should therefore contribute to render visible a bit more of "the whole Larsson."

The book falls naturally into sections. The introductory portion, attempts a total representation of his life and work. It also features a special chapter concerning Larsson's "open-air" painting in France. Between this section and the main picture section, constructed in the form of an album, is inserted a consideration of the interaction between Larsson's life and his work. This incorporates the most important text passages from Larsson's own books. At the end of the book the reader will find a comprehensive chronology of Larsson's life.

In the Springtime of Youth Text and drawings from *Jultomten (Santa Claus)*, 1910

My Ma and Pa had not a cent.
I don't know how they paid the rent.

So off they went to earn some cash
and left young Carl 'mid all the trash.

A crust of bread was all I had
to eat, and that's what made me sad.

Amanda Hammarlund demands
I doodle for her with my hands.

She just won't cease to rant and rail
until I've told my childhood's tale.

The well-known stork delivered me
A crosser child you'll never see.

For I was cold and grey as lead,
but one good slap and I turned red,

and on the spot began to laugh,
though no one stirred on my behalf.

I fished out books and magazines
and cut them up to smithereens.

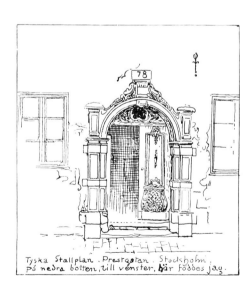

Carl Larsson's Birthplace (Prästgatan 78, Stockholm) Drawing, from *Larssons*, 1902

INTRODUCTION

For our parents and grandparents he was the man with the permanent twinkle in his eye who radiated happiness; a sterling personality representative of the patriarchal bourgeoisie in the reign of good King Oscar II and "uncle to the whole Swedish nation," as one critic put it. Carl Larsson had done all he could to create this myth about himself. Twelve years after his death he punctured it posthumously. In his remarkable autobiography with the characteristic and all encompassing title, *Jag (Me)*, the reader got to know a new Carl Larsson, unstable, sensitive, a splintered personality, self-centered, who loved mankind as a matter of principle but now and again impulsively hated one or another of its individuals. The idol peeled off his geniality and turned out the twinkle. In his pathetic nakedness there stood a man, an individual of much goodwill and an artist with a splash of genius.

The book did not come at the right time. Carl Larsson was not the rage in 1931. His art was passing through the purgatory where the work of most artists ends up after its master's death. His paintings were looked upon now as old-fashioned and uninteresting. The radicals had long since taken up other artistic ideals. It was nothing to them whether Carl Larsson had been sad or happy. The general public refused, insofar as it showed any interest at all in him, to accept a dismal Carl Larsson who had spent his childhood in gutters in the midst of prostitutes, pimps and all kinds of riff-raff and who according to his own revelations had lived in disreputable sin. The life he had sometimes led in his youth had not been picturesque or so-called Bohemian, the romantic safety valve of the middle classes. It had been a dismal and depressing life devoid of charm. Carl Larsson, who had been the figurehead of the Swedish bourgeoisie, and whose art was considered in other countries the escutcheon of an Oscarian welfare state! This escutcheon brooked no criticism. "He has been etched so deeply into the concept we call Swedish temperament that if we besmirch him we besmirch ourselves," had written a Stockholm critic, after his death.

But in the 1920s Carl Larsson had begun to lose his hold on the general public too. His home life and family pictures lay a bit too far away in time for the public to want to identify itself with that cast of characters, yet too near in time for their dress to have had time to acquire the charm that goes with the history of culture. They were in a painful incubation period in which what was not up-to-date seemed laughable. There were rather few outside the ranks of faithful critics who this time felt they had any cause to ponder any more deeply on the new, more complicated self-portrait of Carl Larsson.

Since the appearance of *Jag* more than half a century has passed. The perspective on Carl Larsson has been corrected. What the 1920s and 1930s regarded as absur-

So I got spanked and shouted at,
and life was pretty full of that.

When I went out I kissed the girls.
That's the best thing in the world! (Oops!)

I fought with all the other boys;
Their mamas swooning at the noise.

Nobody liked me, you can bet.
No bed of roses did I get.

But once (I can recall it still)
one Charly Larsson showed his skill.

I drew my Ma some columbines,
a poem, too, of many lines.

Much fire-wood did I saw and split
but didn't earn much bread for it.

As water-boy for older folks
I never earned enough for smokes.

I swept the walks and cleaned the yard
No time to loaf! I worked real hard.

The Poor-School there at Lagardland—
of that I wasn't very fond.

Our teacher didn't spare the rod;
most oft 'twas I who got the nod.

But all at once I caught the knack.
My drawings mounted stack on stack.

They let me in th' Academy.
That made the others sore at me.

There teachers doubted at the start:
"That Larsson's no damn good at art."

I drudged and vowed: "Someday I'll do it!
Nobody's going to beat me to it!"

What I've become let others tell,
but there's one thing you know damn well:

On no one else have I relied;
with nose on high I stroll with pride.

Gråbergsgaten (Street Where Grandma Lived) Drawing from *De Mina*, 1895/1919

dity has long since taken on the patina of cultural history. The typical props of the 1880s, which the functionalism-infected 1930s regarded as monstrosities, call forth pleasurable emotions among collectors of antiques. *Jugendstil* has regained respectability and independent esthetic value after decades of deep scorn. The films and television are more and more choosing the milieu of the turn-of-the-century and the years before the outbreak of the first World War for their romantic subjects.

Carl Larsson's art has been topical again for a couple of decades. But we discover that his world no longer is of this world, but a world east of the sun and west of the moon (mailing address: Sundborn, Sweden). Sundborn was a rural summer cottage in the Arcadian paradise of the new idealism of the 90s. We flee from the grey humdrum to an epoch prior to all world wars, when life was a sunny series of summer vacations, interrupted only by white Christmas Eves. And in the 1970s the young also discovered Carl Larsson's paradise. Their view of Carl Larsson bore the stamp of "the green wave" and ecological activism, linked with the anti-nuclear movement. Even in the early 70s such things aroused nostalgic interest in artists who depicted a Sweden where no automobiles were poisoning the air and no lakes had died; where the vegetation of the earth was free of poisons, and radioactivity, to the extent that it had been discovered, was proclaimed as beneficial to health.

That's the way Carl Larsson wanted it. He wanted to sow happiness. It would be a mistake to let surprise at the picture of the artist revealed in the autobiography completely obliterate the old picture. For several happy decades of his life Carl Larsson himself believed in happiness. He believed that every human being had a chance to be happy. At a time when twilight was descending ever more heavily over Swedish painting and when its artists were sinking into melancholoy moods, now and again taking echo soundings of the frightening depths of the mind, Carl Larsson remained—despite nerve-wracking tribulations in the 90s—an 80s style developmental optimist. His own life spoke for that faith: he was born a child in hell and became a happy tourist in a bourgeois idyll. The tourist sees only what he wishes to see—Carl Larsson saw a paradise and there he wanted to stay. He stayed on as a marveling discoverer where others walked about blinded by a surfeit of seeing. Some of his contemporary artists of middle-class origin made their journeys of discovery in the opposite direction. What they had to report could hardly meet with comprehension in one who did not want to remember. Carl Larsson had no need of reminding people of their misery and baseness. He was quite naive about wanting to make them happy. As early as 1882 he had written in a letter: *"I am Swedish and—shudder!— a socialist. I want to do good, and cheer, not one person, but everybody!"*

Grandma's Dreams for the Future Drawing from *De Mina, 1895/1919*

Grandma as a Young Woman Drawing from a pastel by a Miss Brandström (1848), from *Larssons,* 1902

Carl Larsson would never have settled down into middle-class security if he had not found safe anchorage through his marriage. It was his wife who provided him with the social prestige that was needed; it was she who created about him the harmonious environment that he was then to perpetuate in his entire life. What she meant to him when it came to smoothing the way in self-sacrifice and self-effacement, banishing difficulties and inspiring and encouraging, we can only infer. Without her Carl Larsson would hardly have found the peace for working that made it possible for him to create a parade of remarkable works. It was she who enabled Carl Larsson to maintain so long his belief in happiness, the happiness he wanted to share with others when he painted the watercolors for *Ett Hem.* With that series of pictures he wanted to chart the environment of happiness and he did so painstakingly with a ruler and without demonstratively bright colors. The motif was the essential thing; artistry had to be relegated to second

place. One must not try to seek out any swirling emotional outburst in these pictures. That is to be found rather in his murals at the Nationalmuseum, where despite all setbacks joy has found a genuine personal expression that makes them uniquely fresh and original among European murals of the entire nineteenth century.

It was about the turn of the century that the fateful myth about happy Carl Larsson became fixed in the consciousness of the Swedish people. The myth embodied the conception about him that he had forced on the age in which he lived. It was a picture in which all irrational features were eradicated. What was left was a sun god in pince-nez glasses and a blond imperial. In the long run that picture became of no interest. It reveals not merely nice features; the all over stature is human, sometimes touching.

Thanks to *Jag* we know what a strong effect his childhood experiences had on the development of his

personality. He had been an ugly, weak little guttersnipe, bullied by everybody and loved by nobody, not even at home, if we may believe his bitter autobiographical words. The things he had had to be a witness to in Gamla Stan (the old part of the town) and the proletarian Ladugård quarter in the 1850s had not been edifying. Nothing was hidden from his sight. He had full realization that life was hell. But he had a forward-looking spirit, a yearning for self-assertion, a purifying purposefulness, which at an early age neutralized all the bitter and degrading memories for many years to come. Only at rare intervals of paralyzing dejection, when the regularly recurring depression exceeded the limits of endurability, did his will-power weaken and memories from childhood days slip past the guard of his consciousness to haunt his tortured dreams.

Thus it was in Paris since the 1870s. The Stockholm Academy of Fine Arts had not shown him the understanding he felt he deserved. His economic situation was

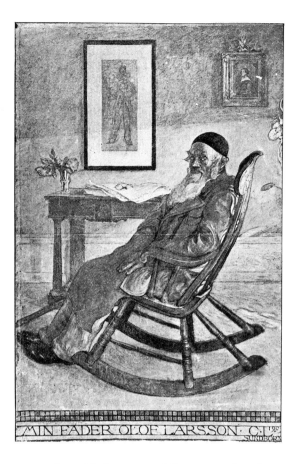

My Father, Olof Larsson Oil, 1903, Privately owned

felt his career as a painter was over. But then his childhood memories surfaced again with searing sharpness of contour. This time he did not transform them into romantically symbolic compositions. Instead of that he wrote them down, calling a spade a spade with no mitigating euphemisms, with relentless frankness, probably bolstered by this realization that he no longer needed to keep alive the Carl Larsson myth, even for himself.

For more than thirty years, at any rate, he had successfully told the story of the unalloyed Carl Larsson style of happiness. For the first twenty years this had not been difficult for him. Sometimes he even believed in it himself. But about the turn of the century came a change in climate. The murals at the Nationalmuseum had been completed in 1896 but the committee had refused to approve them. He had, however, with undaunted strength avenged himself by decorating the ceiling of the foyer at the Opera house only a few years afterward and had made a brilliant success with his watercolors for *Ett Hem* at the great Exhibition of Art and Industry in Stockholm in 1897; they were published in full color in the album of the same name in 1899. His fiftieth birthday came in 1903 and he was feted as a national symbol. His popularity was unprecedented; his international renown was to increase still more, but his triumph was not long to continue uncorroded. At home in Sweden people were starting to nibble at the edges of his fame. New artistic directions alienated the younger generation of painters and critics from his ideal. People began to question his greatness. Carl Larsson, who had become accustomed to having the critics on his side, became irritated and launched an attack on youth; Prince Eugen took up the cudgel in its defense in a letter to Carl Larsson, very much to the point but moderate in tone. His life was clouded still during the first decade of the twentieth century by severe personal sorrow. August Strindberg, who in his youth had been his foremost supporter, turned to a low attack against him and his wife in a book in 1908. His temperament became once more unstable but he was able to control himself for a good while. He pretended to laugh at adversity.

The Swedish people, who had become accustomed to come face to face with happy Carl Larsson's happy family in its happy home and who did not stop to think that that much happiness would hardly be possible in our imperfect world, did not sense anything in the wind. They were so anxious to believe in the Sundborn saga. But the artist himself cracked under the strain of maintaining the illusion. The bitterness showed through a few times. The self-portrait with the clown doll (in the Uffizi gallery), painted in 1906, the year after his son Ulf's death, symbolized with full intent his Pagliacci moods. The painter's sacrifices for human happiness were something nobody wanted to comprehend. People refused to see anything in the self-portrait but a droll

rascal's prank. The few who sensed the bitterness did not think it rang true and kept urging him to keep casting his lot with his summer cottage. But the notion of sacrifice had taken full possession of him; he was obsessed with it, and it took monumental shape in *Midvinterblot,* which was received by both the critics and the public with complete lack of understanding, since nobody either could or would figure out what lay behind this bizarre fantasy. All of Carl Larsson's moods other than the idyllic and humoristic ones had always been treated with disbelief, irritation, and exasperation. It is possible that *Midvinterblot* would not have produced such a public sensation if Carl Larsson had not been painting his way into the hearts of the Swedish people so assiduously and so successfully.

It was during the troubled years at the start of the new century that Carl Larsson began to falter in his belief in the permanency of happiness. He began to be doubtful of man's chances of achieving ultimate happiness. He had lost faith in himself as a do-gooder. His depictions of the home began to change in step with his philosophy. When he was painting the watercolors for *Ett Hem* it was a matter of taking a factual cross section of the milieu of happiness which would serve as a pattern for others. When he did the watercolors for *Åt Solsidan* in 1908 and 1909 the title itself, *The House in the Sun,* provided him with his theme. There were shady sides to life, even at Sundborn. *Åt Solsidan* was never intended to be a textbook on interior decorating for future happy people, as *Ett Hem* had been, but rather an expression of an aging artist's happy gratitude for the joy that surrounded him in spite of all. Happiness had lost its obviousness; therefore he saw it in a new luster that transformed reality. In his pictures on the sunny side, the sun shines more brightly and the colors are cheerier than ever before. It is the shady side that brings out their intensity. In the midst of the moment of happiness he was already mourning its memory.

hopeless. Back home in Sweden, just before he left, Vilhelmina Holmgren, the woman who meant the most to him in his spiritual development in his youth, died while trying to give birth to their second child; the first had died at birth. Now he wandered along the Seine embankments, firmly resolved to put an end to his miserable existence. But his paradoxical will to live won the day. He painted away his death wish with a series of callow romantic fantasies about death and misery and desperate zest for living. Poor, sick, emaciated children, memories of his little dead brother, peopled his paintings, which are of more psychological than artistic interest.

It was forty years later, after the fate of the projected mural, *Midvinterblot (Sacrifice at the Winter Solstice),* had effectively broken his powers of resistance, and he

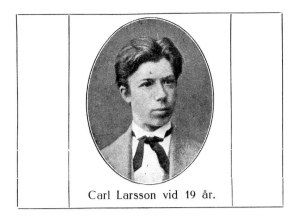

Carl Larsson vid 19 år.

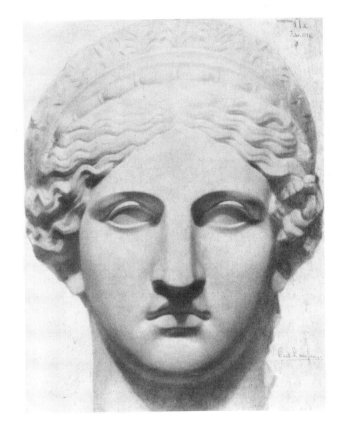

THE LIFE AND ART OF CARL LARSSON

Carl Larsson at 19 Photograph

Head of Hera Charcoal, 1871. Royal Academy of Fine Arts, Stockholm

YOUTH

Carl Larsson was born May 28, 1853, in Gamla Stan, the old town, in Stockholm. As he himself tells us, he was descended *"on his father's side from peasant stock, on his mother's from city craftsmen."* His maternal grandfather had been a painter by trade but in his early youth had studied in the preparatory section of the Academy of Fine Arts, known as the Principskola. Later on he had amused himself in his spare time copying pictures by the Great Masters.

Carl Larsson's father was a ne'er-do-well who had deserted the family when the boy was still very little and had not been heard of for many years. His mother had supported herself and her two small sons by washing and ironing. When her husband abandoned her she was put out of her lodgings in Gamla Stan and forced to move to the East End of Stockholm, Ladugårdslandet. It had not yet become the fashionable quarter it developed into a few decades later. Carl Larsson has described the squalid slum where he was to grow up: *"If I say that the people who lived in these houses were swine I am doing those animals an injustice. Misery, filth and vice—every kind of vice flourished there—seethed and smouldered cosily; they were corroded and rotten, body and soul."* To a question as to his happiest childhood memory he replied; *"I recall nothing happy, so there was no 'happiest' one, either, in my childhood."*

THE ACADEMY YEARS

At the age of thirteen Carl Larsson, at the urging of his teacher at the "poor school" in Ladugårdslandet, had sought entry into the Principskola where his maternal grandfather had studied two generations earlier. He had been accepted as a student but the first years he felt socially inferior, confused and shy. In 1869 however he had been promoted to the Antique School and became a real Academician; at that juncture his shyness wore off and he had become one of the central figures in the student life. He became editor of the student paper, *Pajas (Clown)* and his drawings there were discovered by the manager of the leading Swedish humor publication, *Kasper (Punch),* who hired him at an annual salary that gradually grew to a respectable figure. He had previously supported himself also as retoucher at a photography studio. He was able now to support both his mother and his younger brother with his work as an illustrator. He developed quickly in sketching and in 1875 was hired as sketching reporter in the newest and most popular weekly in Sweden, *Ny Illustrerad Tidning.* He got to travel all over Sweden, sometimes even abroad. he went to scenes of accidents, dedications, unveilings, sports competitions and cattle shows. At celebrations for the opening of new rail lines *"there was the same ceremony with different city officials, different governors and different triumphal arches, but two of the participants never varied: the King and I."*

When he had established himself as a well-paid sketching reporter he had already studied for three years at the Academy's Model School, its actual school of

painting where, to be sure, he didn't get to paint as great compositions as he wanted to, but where he was met with understanding and interest on the part of the leading professors of the Academy, Director Johan Boklund and Secretary F. W. Scholander. He painted both genre pictures and historical compositions. In 1873 he had worked on the painting *Thor Unwittingly Slaying His Son Svade,* a motif from Norse mythology, and *Hector's Farewell to Andromache;* he did not succeed in finishing either. On the other hand he did complete an Old Testament motif, *Moses Placed in the Bullrushes by His Mother,* which netted him 150 kronor from the Academy. In 1874, 1875 and 1876 he competed for the Royal Medal, the Academy's highest award; he did not win it until 1876, when, to his great disappointment, he did not win the travel stipend the medalists thereupon competed for and which he had confidently counted on. That same spring, a female fellow student at the Academy, Vilhelmina Holmgren, who had for several years meant more to him than anyone else for spiritual and intellectual advancement, died. Disappointed and saddened, he left Sweden and a good annual income and arrived in Paris in April, 1877.

PARIS AND STOCKHOLM—1877-82

When Carl Larsson arrived in Paris for the first time, French art was not characterized to any extent by sunny Impressionism. The disastrous Franco-Prussian War of 1870-71 had created a gloomy atmosphere of pessimism. Naturalistic painting was wallowing in macabre motifs. The Danish art historian, Julius Lange, who sent in reports to the Danish press on the Paris World's Fair of 1878 was horrified: "There was the odor of corpses all over the World's Fair". Carl Larsson was easily affected by such moods at this time; his nerves were already shattered by his sorrows back home. The new atmosphere and new friendships in the Swedish artists colony had rather a stimulating effect to begin with. His depression changed to an exalted feeling of exhilaration, colored by macabre fantasies. He started work on a gigantic painting, *The Bard of the Merry Sins Singing his Swan Song to the Setting Sun.* But economic worries, now that he no longer enjoyed a regular income, caused him to relapse into pessimism and depression. The huge painting remained incomplete. Instead he painted greyish landscapes full of thorns and thistles or figures redolent of melancholy and death fantasies. Among his friends he seemed sprightly and gay but when he was alone he sank into hollow despair. He was close to suicide but his will to live was stubborn.

He went home to Sweden and employment as illustrator for *Ny Illustrerad Tidning* to raise the needed funds for a new stay in Paris. He stayed home for a year and a half, a cheery, popular sociable fellow who in his solitary moments toyed with fantasies of a macabre nature. His most ambitious venture this time was *A Suicide's Journey to Hell* (again uncompleted)—"*A dreadful escapade which was symptomatic of my state of mind at that time.*"

His reportage drawings from these eighteen months in Stockholm are freer, lighter, less detailed and more artistically summary. He tucked little vignette-like figures into his text, too. In November of 1880 he drew his last sketch as a news illustrator: a reproduction of the mural decorations he had himself painted in the Bolinder mansion in Stockholm.

The story of these murals was this: In the autumn of 1879 Professor Scholander, secretary of the Academy, had written to Carl Larsson, "If you would like to spend a few days at 'monumental' painting, i.e., murals, there might be an opening at the same time an opportunity to perform a little service for humanity. It's about the finishing touches to Bolinders' residence, you see, which was entrusted to Werner and Staaf. It would give you a chance to study their fresco techniques, from which there is a lot to be learned, and the main job is to complete the latter's small motifs which illness prevents him from finishing." Carl Larsson completed the job. The results were not outstanding but it was the first time he had tried mural art, which in future days was to mean both triumph and tragedy for him, both on a grand scale.

The 1870s had also been a time of book illustration for Carl Larsson. When Richard Gustafsson, editor of *Kasper,* was planning to publish his own stories it was natural that he asked the young Academician to do the illustrations, which however had little of the personal about them. The stories came out in 1874. During the following years commissions for illustrating came thick and fast, among others Hans Christian Andersen's *Fairy Tales,* but it was some time before he ventured to impart a personal touch to his pictures. During the 1870s they were influenced by the romantic French art of illustration, which is most evident in his illustrations for the collections of Norwegian stories by Asbjörnsen and Moe, *Norska Folksagor och Äventyr.* Ordinarily we come across Carl Larsson's pictures in the form of soulless woodcuts. Whatever of artistry might have been present in his original drawings was carefully engraved out of them. As for Asbjörnsen and Moe's tales, they never appeared in the Swedish edition because of the publisher's business failure. For that reason the woodcutter had no time to ruin the wash-drawings Carl Larsson had handed in, which had been done directly on the wood blocks; they are therefore still in existence. In them can be seen that the artist was well on his way to finding himself.

They are skillful in technique, quite expressive, fresh and sometimes vivacious, sweet and sentimental at other times, sometimes spookishly romantic with a touch of the macabre.

In 1878 he started work on the illustrations that were to herald his big breakthrough to the public at large, pictures for the long series of novels *Tales of an Army Doctor* by the Finnish author, Zacharias Topelius, with motifs from Swedish history during the 1600s and 1700s. Carl Larsson wrote, "*It won't do to draw for a work of this serious historic theme such cute little drawings as the ones for Andersen's fairy tales.*"

His financial situation improved and in November 1880 he was back in Paris. No later than February of the following year he received a flattering offer. August Strindberg "*asked me to come home at once to illustrate a work he was planning, a cultural history of Sweden.*" This was *Svenska Öden och Äventyr.* Carl Larsson had no real desire but finally promised to come home "*in a month.*" Before going home he entered at the Paris Salon a painting entitled *Häxans Dotter (The Witch's Daughter),* which in murky chiaroscuro depicted a large-eyed, famished little girl with an owl on her shoulder, a skull, and rats gnawing at her feet—the painting was refused; this reverse cured him of the bizarre ideas that Professor Scholander, secretary of the Academy, had warned him against.

By the end of May he was in Sweden: "*I made my way through Stockholm right out into the archipelago among the rocky reefs where Strindberg and his wife and children and maid were already living...It was a splendid summer.*" Four months later the first volume of *Svenska Öden och Äventyr* came out and Carl Larsson was able to go back to France.

In 1882 he entered at the Paris Salon a vapid picture, *Chez le Peintre du Roi,* a studio interior in Louis XV style, in which, according to the artist, was to be seen a half-finished painting of Leda and the Swan, a naked boy and a woman taking off her shift. The picture was refused because of its wanton motif, in Carl Larsson's opinion; he felt himself humiliated and tore the picture to shreds. He grew ill with undernourishment, overexertion and disappointment. His nerves went to pieces and everything looked hopeless.

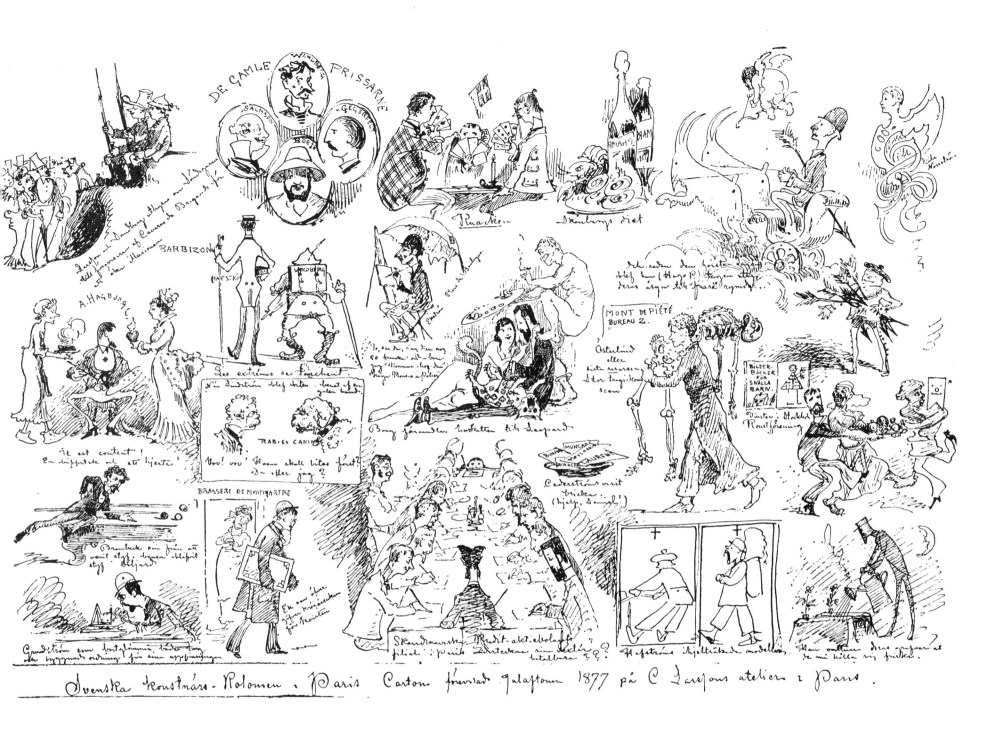

The Swedish Artist Colony in Paris Cartoon sketch,
Exhibited in Larsson's studio on Christmas Eve, 1877

11

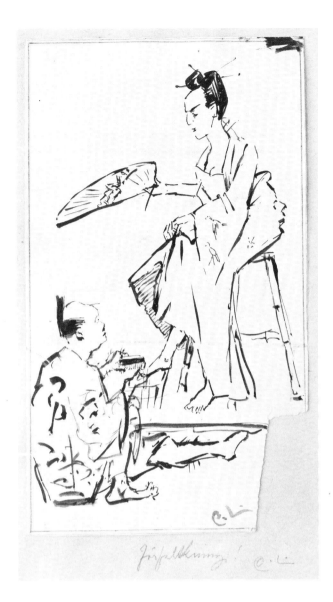

Pen and Ink Drawing from a Japanese Original Nationalmuseum, Stockholm

Carl Larsson stayed there close to three years and there he got more closely acquainted with his wife-to-be, Karin Bergöö, whom he had met at a dance at the home of a Stockholm family while he was studying at the Academy. They became engaged in Grèz, to which they returned after their wedding in Sweden, and where Suzanne, their first child, was born in 1884.

There, too, his art underwent a change. What followed was Carl Larsson's first period of greatness. He was a success at the Paris Salon, made sales to the French government, to choosy art collectors in France and in Sweden, among them Pontus Fürstenberg, a wholesale dealer in Göteborg, who was one of the most generous patrons of art in the country, and to the Nationalmuseum in Stockholm. His art coincided with the new artistic ideal among the exacting salon public in Paris.

He turned from oil painting to the less pretentious watercolors, which had come into style and were better suited for adaptation to the popular Japanese series. Not only he but also a great many artists in Grèz at that time painted this way—Englishmen, Americans and Frenchmen—but few of them measured up to Carl Larsson's elegance, to his effortless naturalness in the fine variation between modest suggestion and carefully brushed-in details in free, airy compositions.

He now illustrated the works of the Swedish poetess of the 1700s, Anna Maria Lenngren, in pleasant wash drawings. His popularity in his homeland was great. In the *Svea* calendar August Strindberg wrote a laudatory write-up in 1883; at the same time he was written up in another calendar, *Nornan,* by his future biographer, George Nordensvan.

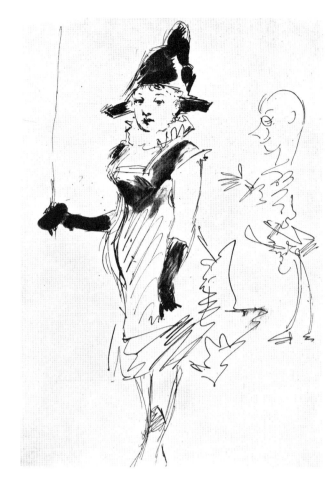

Parisian Girl and Carl Larsson Pen and ink, about 1877, Nationalmuseum, Stockholm

GRÈZ—1882-85

But *"now came the turning point! When the pinch is worst, help is nigh. Into my studio walked Karl Nordström."* Nordström was a landscapist; he had studied at the Academy in Stockholm at the same time as Carl Larsson. He said, "You belong out in the country, out among the birds! Come with me to Grèz-sur-Loing." Grèz is a tiny village about 70 km southeast of Paris.

THE OPEN-AIR PAINTER
An excursion by Görel Cavalli-Björkman

An exhibition of Carl Larsson's, Bruno Lilefors' and Anders Zorn's painting was arranged in 1916 at Liljevalch's art gallery in Stockholm. In this exhibition, which filled thirteen halls, Carl Larsson was represented by 143 items. The catalog of the exhibition began with *Autumn* (refered to in the Paris Salon as *The Pumpkins* and later by Carl Larsson himself as *Mère Morot* and at the Art Museum in Göteborg as *October),* dating from the year 1882. (The artist wished to identify 1882 as the year of his artistic breakthrough.) After several failures during the Paris years he had now finally achieved a personal style which felt right. His teacher at the Academy, Fredrik Wilhelm Scholander, had advised him to stop trying for "the remarkable, the striking, the 'never-before-done' but rather leave such things to those who had lost their heads. You have to paint a study, a quite

simple one, in such a way that you have to blush at its lack of originality, while at the same time you think it looks like a little fragment of Reality."

The decisive change in Carl Larsson's life, both socially and artistically, occurred in the little village of Grèz-sur-Loing. There he painted watercolors with the simplest motifs—a bed of pumpkins and cabbage-patches and little old men and women in work clothes. These were the motifs that sold and gained him medals

in the Paris salons. In a letter home Carl Larsson wrote: *"I looked at Nature for the first time. I chucked the bizarre into the trash-heap and dumped my remarkable combinations of ideas into the lake. They can stay there. No, I have now given Nature a wide embrace, no matter how simple it may be. The pregnant, lusty earth is now going to be the theme of my painting."* (Carl Larsson, Stockholm 1952, p.71)

Grèz was a place of refuge for the Scandinavian art colony. At the same time as Carl Larsson there were living here the Swedish painters Karl Nordström, Richard Bergh, Nils Kreuger, Georg Pauli, Theodor Lundberg, Emma Löwstedt, Julia Beck and Karin Bergöö, the Finnish sculptor Ville Vallgren and the Norwegians Christian Krogh and Christian Skredsvig. Here too lived American, English and Irish painters. Many have described this rural idyll, where Camille Corot had in his day derived inspiration. August Strindberg, who visited Grèz, gives a detailed description of the place in an article about Carl Larsson, and George Pauli describes the artists' life in *Parispojkarna (The Paris Boys),* (Stockholm, 1938).

The village was quaint and full of charm. Among the more picturesque features was an ancient arched bridge, a medieval church with moss-clad walls and the ruins of a castle. The grey stone houses with their gardens were screened from the street by stone walls. The gardens with little flights of stone steps, trellises with grapevines, bowers, fruit trees and vegetable patches sloped down in terraces to the river Loing. The damp mists from the river had contributed to the growth of lush vegetation along its banks and in summer imparted a soft silvery tone to the landscape. Open-air painters and tourists flocked to the town's two *pensions*—Madame Chevillon's *Hotel Seine et Marne* and Madame Laurent's *Hotel Beauséjour,* a former cloister. Carl Larsson lived the first two years at Laurent's, but after his marriage he and Karin rented the summer pavilion in Chevillon's garden.

Strindberg noted that the *pension* life was particularly simple and unconventional. Everybody dressed to suit himself. One painter went around in knee-breeches and a beret, another in wooden shoes, dressing gown and a Japanese hat. Some ambled "shamelessly down to the river to bathe wearing nothing but bathing suits." In the evenings they amused themselves singing and dancing. In this uncomplicated atmosphere many bonds of friendship were forged and several artist marriages took place. Carl Larsson was an obvious central figure in the comradely circles.

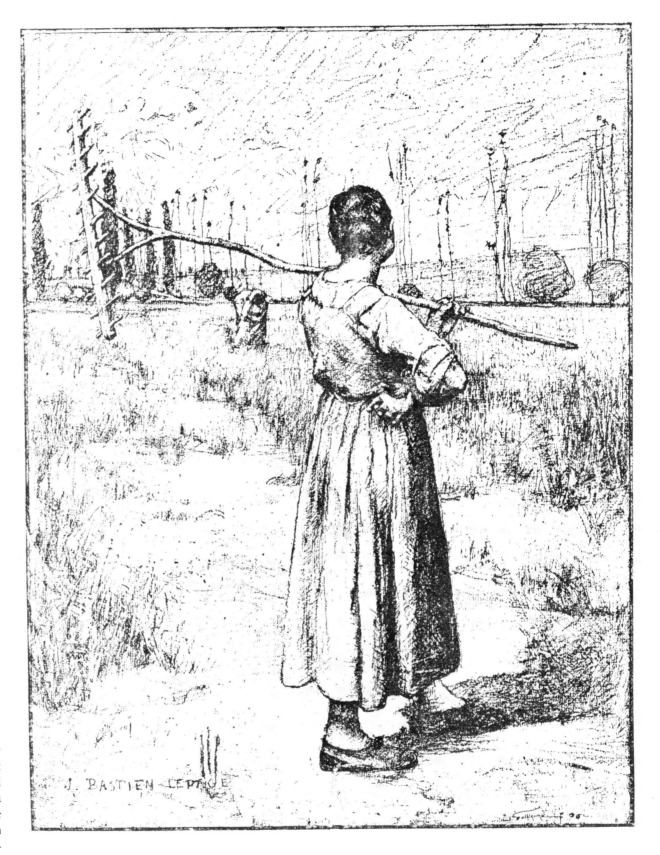

The Hayfield by Bastien-Lepage Drawing, about 1875

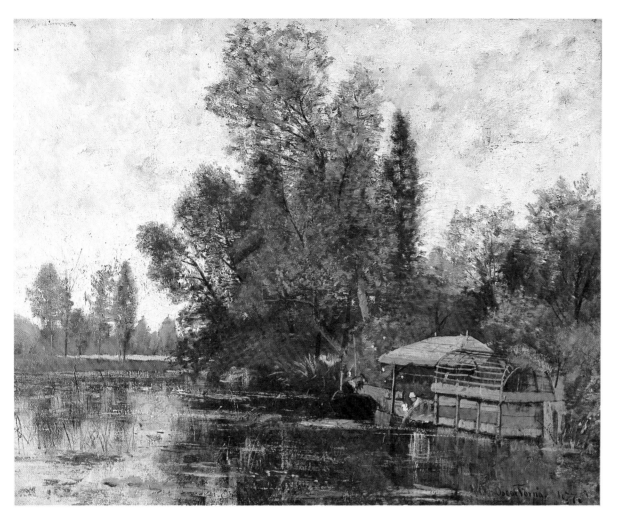

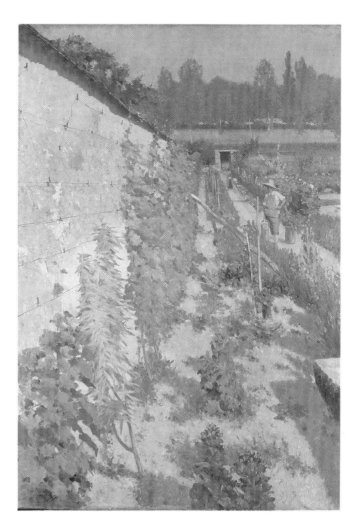

Landscape by Oscar Törnå, Grèz, 1877, Royal Academy of Fine Arts, Stockholm

Karl Nordström: *Garden in Grèz* Oil, 1885, Art Museum, Göteborg

Georg Pauli has described Grèz as a charming but perhaps a bit puerile idyll. "Everything flows blithely along like the River Loing," he said. "No nudity, no obscenity and no crass realities, either; everything is respectable without excessive prudishness, everything is sensible, refined, often enough with a certain elegiac accent like the willows that line the riverbanks." *(Parispojkarna,* Stockholm 1938, pp. 114-115).

In this milieu "open-air painting" flourished. Its roots were fixed in the little village of Barbizon on the outskirts of the Fontainebleau forest. There in the mid-1880s had developed a freer view of nature on the part of a group of painters who broke with the academic tradition. The founder of the Barbizon school was Theodore Rousseau and among its most prominent members were also Dupré, Diaz, Daubigny and Millet. Their landscape painting was based on direct study of nature, a more intimate observation of the motif with a sensitivity to light and atmosphere. It was their sketches that pointed the way to the actual open-air painting, for until then paintings had been completed indoors in studios. Another great predecessor of the open-air painters was Camille Corot, who painted landscapes directly from nature. Around 1850 he developed a landscape type that was much imitated: poetic dawn and twilight motifs in a grey-green silvery tone.

The first flock of Swedish painters who journeyed to Paris in the 1870s were very close to the Barbizon masters. Among them was Oscar Törnå, who painted in the woods at Fountainebleau and as early as 1876 discovered Grèz. His landscapes remind one most of Corot's, with their grey-green palette of colors and nuances of lighting. His motifs from Grèz-sur-Loing

presage the special style that was developed by Carl Larsson and his contemporaries. It was intimate and realistic painting, much lighter and airier than that of the Barbizon painters. At Grèz they liked to paint in watercolor and ceased to present long-range landscape scenes but were satisfied with depicting some chance snippet of reality—often with a lone human figure for accent. The painter could stand at a single spot and report details in his immediate vicinity. Karin Larsson has told of Carl's sitting for days on end in Madame Chevillon's garden. When he wanted to switch to some new motif he needed merely to turn around.

The intimate "Grèz style" of painting was practiced also by the Englishmen and the Irish who were there before the Swedes arrived. Among them were Weldon Hawkins, John Lavery and Frank O'Meara as well as the American, Alexander Harrison. They all belonged to the open-air Movement. They placed their models out of doors and they tried to achieve a subtle relation between figure and landscape. Their great prototype was Bastien-Lepage, the young French painter who had achieved success at the Salon with his peasant paintings. He wanted to tell the story of country life in a series of pictures. His haymakers, harvesters, potato gatherers and rustic lovers filled the Grèz painters with delight. They admired his detailed work in every corner of a painting. It was almost possible to count every blade of grass. They adopted his soft, greyed colors and slightly sentimental touches.

These Anglo-Saxons can be sought for in vain in the literature of the history of art. None of them seems to have made a name for himself except perhaps John Lavery, who, after his stay in France, made his fortune as a society painter in London and America. Weldon Hawkins got his big break at the Salon in 1881 with his *Orphans,* which was a composition in the spirit of Bastien-Lepage. After that nothing further was heard of him. Georg Pauli writes that the Swedes were influenced by this already established British school of painters. Karl Nordström on the other hand was never willing to admit that there was any special "Grèz style" inspired by Anglo-Saxons. He says, "I know that I myself never got any inspiration from that sector, not least for the reason that those Anglo-Saxons never interested me— quite the opposite! As for Larsson, his Grèz paintings, his grey-on-greys, need not have been inspired by foreigners to France; the prototypes in French painting itself are all too obvious." *(Strömbom,* 1945, p. 170 ftn. 180).

Georg Pauli also mentions an American, Edwin Austin Abbey, as a source of inspiration for Carl Larsson's art. The parallels between them were many, he thinks. Both began as illustrators and went over later to painting in watercolor. During the Grèz period Pauli

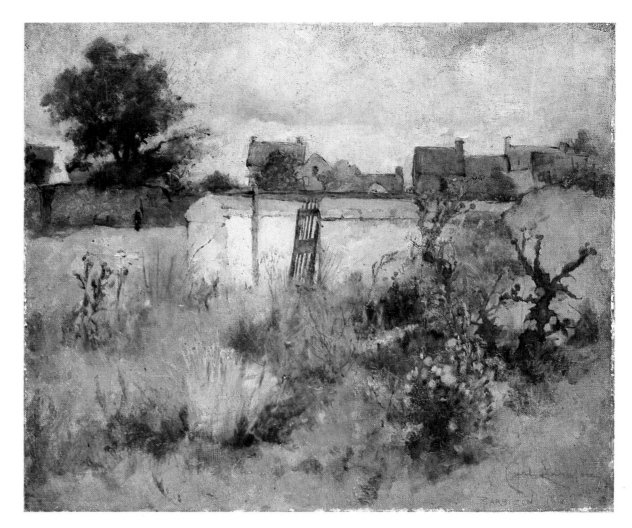

Landscape Barbizon Oil, 1878, Nationalmuseum, Stockholm

and Larsson thumbed through several issues of *Harper's* to which Abbey was a regular contributor.

Carl Larsson's painting was somewhat fresher and airier than what many others achieved in Grèz, mainly perhaps because he did not try to compete in oil but remained the whole time true to the particular modes of expression inherent in the watercolor technique. The free landscape picture had been around for a long time in watercolor painting. Even during the Renaissance, painters betook themselves out into nature to paint what they saw there. During the decades around 1800 the possibilities inherent in watercolor were discovered by the English landscape painters Thomas Girtin and William Turner. The technique was simpler and fresher and at the same time gouache had come to be the style in Paris through a series of special exhibitions that were set up during the seventies. Carl Larsson had probably seen several of these and learned from the French masters who had sought to combine the modern open-air painting with the English watercolor tradition.

The few landscapes Carl Larsson painted before his time in Grèz were done in oils. He spent the summer of

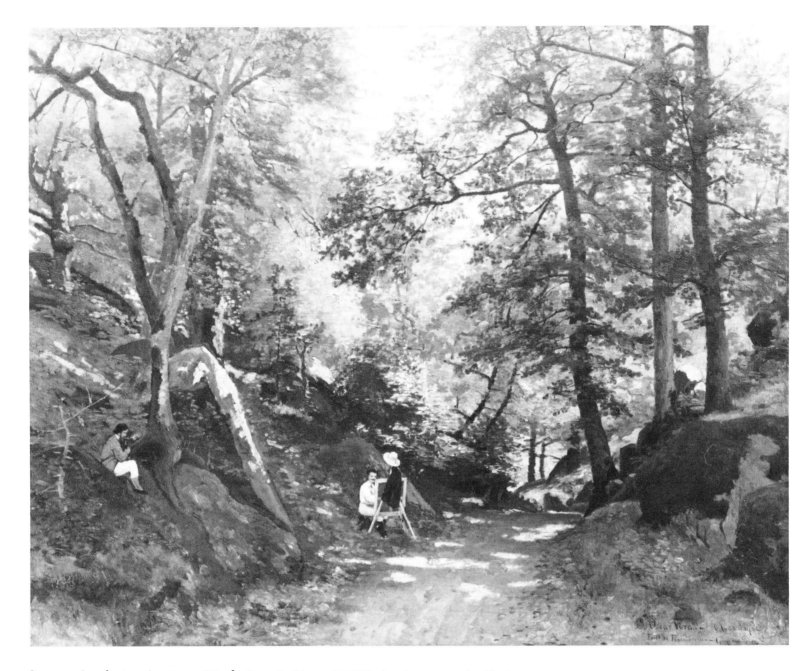

Summer Landscape by Oscar Törnå, Fontainebleau, 1876 Nationalmuseum, Stockholm

1877 in Barbizon and painted there some studies, among them a garden motif with thistles and weeds in front of some gabled houses. *Garden with Sculptures* came into being in Paris in 1881. This latter composition is rather muddled and lacks the earmarks of open-air painting—fresh, clear color plus light airiness—despite having been painted right on the spot directly before the subjects.

Characteristic of open-air painting was also interaction between man and nature. The folk-life motifs out of doors—the "rustic school"—had their origin with Millet but were further developed by Jules Breton, Jean Cazin and Bastien-Lepage. Bastien-Lepage especially had a far-reaching influence on the Swedish painters. Carl Larsson's Grèz watercolors most often show a lone figure in a natural setting. One of the first, *The Pump-*

kins, which was also painted at the same time by Karin Bergöö, shows that he had digested very well his impressions from contemporary French painting. The motif is an old woman with a basket on her arm and seen from one side, standing in a garden with a single bare tree, next to a patch of ripe, ruddy pumpkins. The composition is very positive. The picture is taken from an elevation, the angle of view is from above, and the figure,

Forbidden Fruit Watercolor, 1882, Privately owned

The Bee Hives Watercolor, 1884, Owner not known

which has been moved a bit into the scene, stands out against a masonry wall in the background. The perspective is very strongly emphasized by a bush having been intruded into the foreground. It is reminiscent of the principles of composition present in Japanese art, where some large object is generally placed in the foreground in order to bring out a sense of depth. The composition in Karin Bergöö's painting differs somewhat but it is evident that both come close to one of Bastien-Lepage's best known and often reproduced drawings, *The Hayfield*. It shows a peasant girl walking home through the meadow with her rake on her shoulder. The whole figure seen from behind is strikingly expressive. It has the Japanese simplicity that is so characteristic of contemporary French painting.

The out-of-doors folk-life motif after Bastien-Lepage is a combination of the ideal of open-air painting and Naturalism's demand for truth. The attempt was made to present the peasant in his natural environment. The great prototype was Jean-Francois Millet, who had depicted the arduous life of the peasantry with an almost religious pathos. However the genre has its limitations. Millet had depicted his peasants in motion but the open-air painters who did their painting on the

Hotel Chevillon Illustration from *Svea* calendar for 1884

Dinner party in Grèz Illustration from *Svea* calendar for 1884

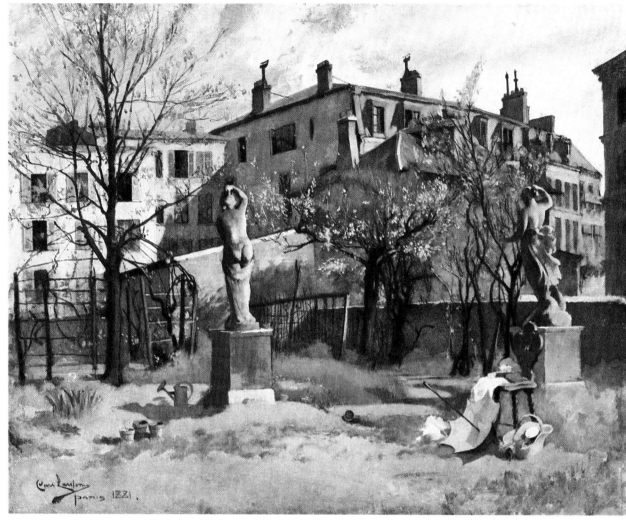

Garden with Sculptures Oil, 1881, Privately owned

spot found that it was easier to depict their models at rest. They pose for the painter during a break in their work. The "candid glimpse" of reality thus has become a delusion, because the composition is posed. The viewer gets no impression that the potato harvester is ever going to stoop over and hack at the earth or that the old woman is going to fill her basket with fruit. Carl Larsson's watercolor compositions are posed in the same way. The old woman in *The Pumpkins* and the old man in *November* (also known as *Hoar-Frost)* and the young girl in *Autumn* have all been posed off to the right in the pictures, where they will look best in the composition.

Light was the artistic tool of expression for the painters of the 1870s. The ultimate harbinger of open-air painting was Impressionism, in which forms disintegrate and contourless objects become vehicles for the play and refraction of light. Impressionism is generally regarded as having taken a step beyond the "open-air" style. Despite the fact that it was not generally accepted, especially by the critics at the salons, did not keep Impressionism from having its effect on the Grèz painters. The color divisionism of the Imperessionists was not accepted, but their study of light and its

Mère Morot Drawing after the watercolor by Karin Bergöö, Grèz, 1882, *Larsson, 1902*

Carl and Karin on the Stairs Drawing from a letter to Karin, 1883

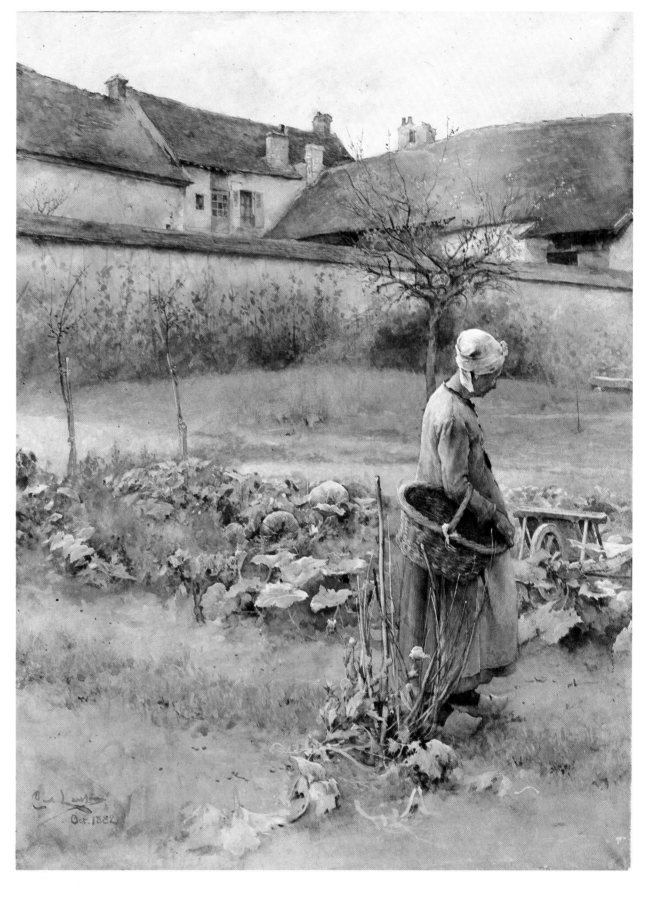

October (The Pumpkins/Autumn/Mère Morot) Watercolor, 1882/1883, Art Museum, Göteborg

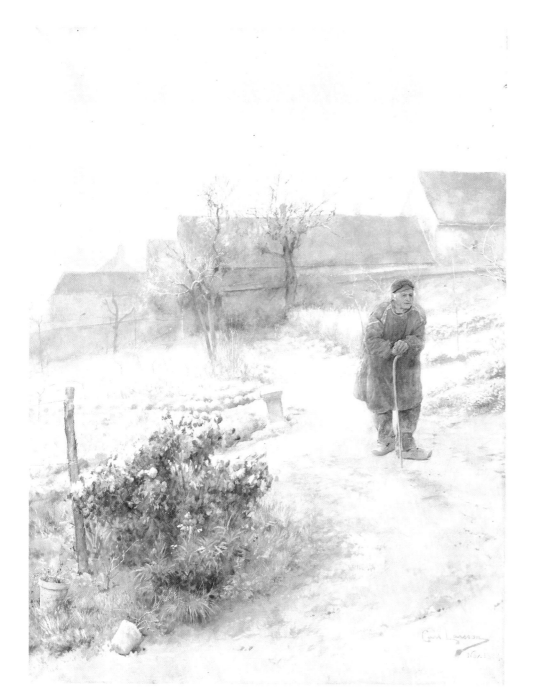

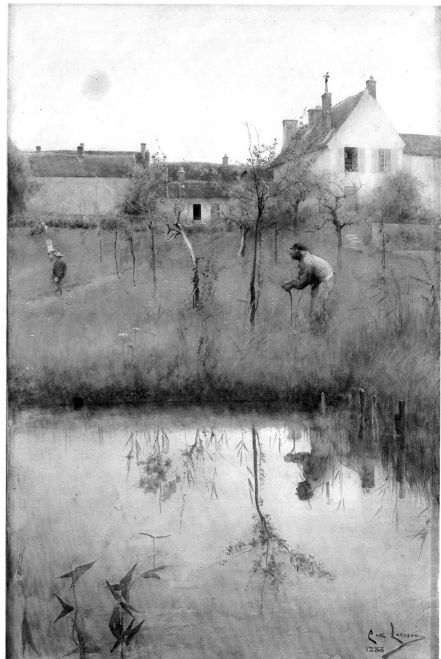

effect on the subject did leave its mark. Karl Nordströms *Garden in Grèz* of 1884 is a typical example of a deepened study of light in the impressionistic sense. He has depicted the dazzling sunlight and white masonry walls contrasting against blue-green vegetation.

Carl Larsson studied the light at different times of day and during different seasons just as the impressionists had. He also emphasized the artistic reflections of the light and also the tones of the air. *The Kitchen Garden*, painted in 1883 and purchased the same year by The Nationalmuseum in Stockholm, is a picture of a little girl fetching carrots. She is standing, shading her eyes against the flooding noonday sunlight which seems to be obliterating all sharp contours. The foreground is dominated in the Japanese manner by a huge red flower.

The Old Man and His New Saplings, painted the same year, is pervaded with an even, gentle grey light. A bent old man is seeing to newly planted fruit trees while some children are playing off by the road. The whole picture is effectively reflected in the pond.

From a technical standpoint *The Bee Hives* is one of Carl Larsson's boldest paintings. For the whites he has made use of the paper. The sunlight is expressed with

November Watercolor, 1882, Art Museum, Göteborg

The Old Man and the New Trees Watercolor, 1883, Nationalmuseum, Stockholm

In the Kitchen Garden Watercolor, 1883, Nationalmuseum, Stockholm

cold colors. The white in the masonry wall and house facades contrasts strongly with the white ground. The colors flow out as though they had been applied at random. The sense of an approaching storm in the midst of blazing sunshine is palpable.

Carl Larsson's most impressionistic picture was painted as late as 1887 when he returned to Grèz for a temporary stay. He met his fellow artist Bruno Liljefors who was honeymooning there at the time. The latter's wife Anna was recruited to be the human focal point in a painting entitled *Grèz-sur-Loing*. In a "snapshot" Carl Larsson has frozen the river with its running water and reflections of the lush vegetation on the banks. The air is suffused with sunlight. Anna Liljefors is peering out of a boat house. Her red dress is a color accent that hits the nail right on the head.

A comfortable blend of Japanese decorative composition and pastel tones borrowed from rococo art is characteristic of Carl Larsson's Grèz watercolors. *The Vine* of 1884 is just such a picture. The girl picking grapes in the left hand part of the picture is wearing a

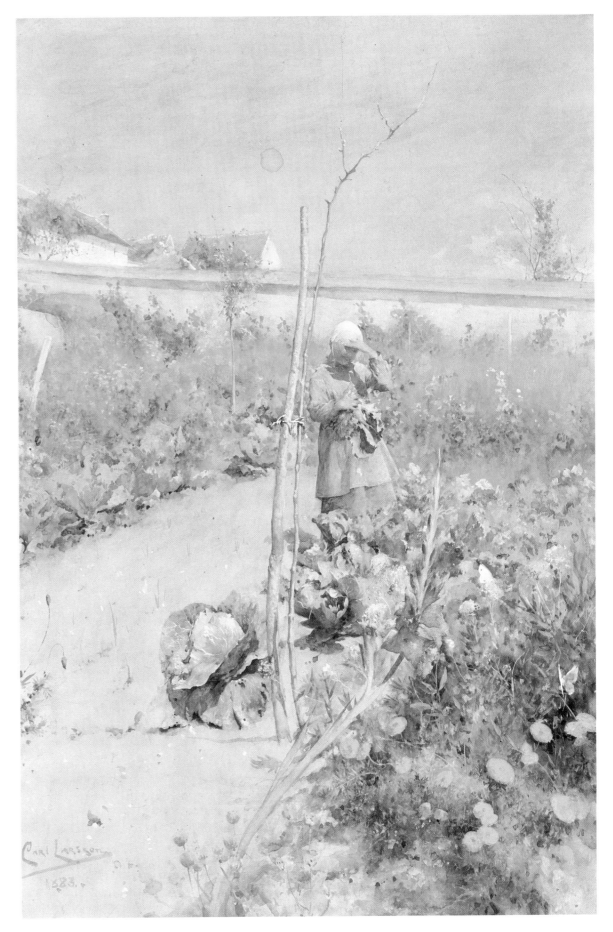

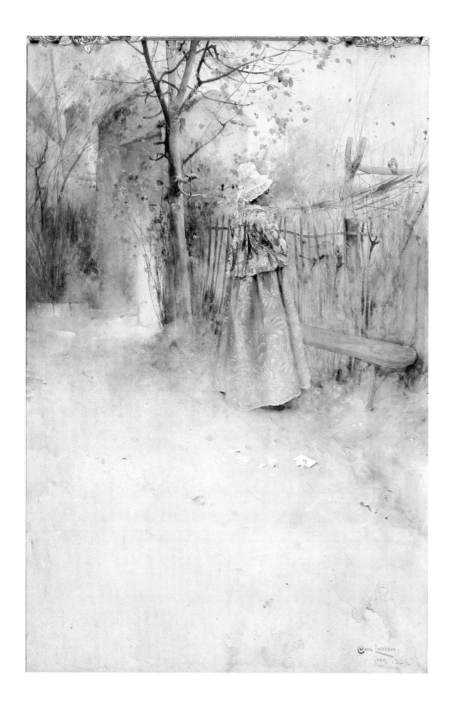

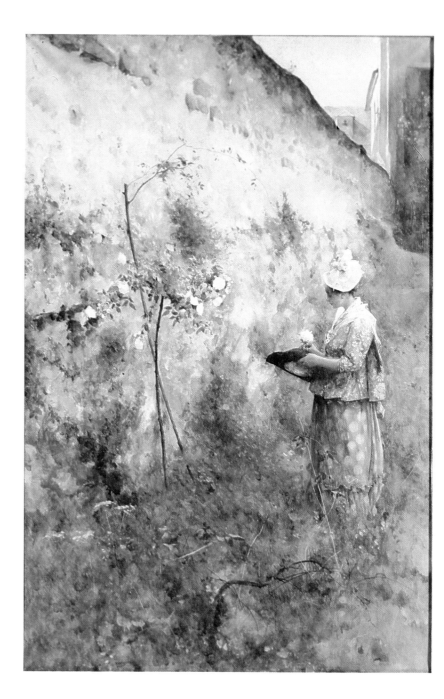

Autumn Watercolor, 1884, Nationalmuseum, Stockholm

The Old Wall Watercolor, 1885, Albert Bonniers Förlag, Stockholm

costume with a rococo air about it, and the colors are very soft shadings of green, pale yellow and pink.

The Bride, a portrait of Karin after the wedding, follows the traditional composition pattern but is sweeter and more fanciful in character than the other watercolors. Here it is not mere representation but also feeling which finds expression. Carl Larsson himself said of this picture *"I posed her in her bridal finery, my young wife, right there in the center of the spot on Earth where for the first time I had felt happy and where my artistic talent had shown its first bud on a hitherto dormant plant."* This picture was the initiation of the series of family pictures.

Studio Idyll with Karin and newborn Suzanne was also painted in Grèz. The young mother is sitting with her face in shadow, looking straight forward with her "cow-eyes", as her husband used to call them. The medium is pastel and the composition is a detail, a casually selected corner of Reality. It is reminiscent of Impressionistic painting's dependence on photography and its candid angles. *The Old Stone Wall,* which was painted in 1885, belongs in a certain sense also to the family series. The wall was situated immediately outside Madame Chevillon's garden and the girl putting a rose

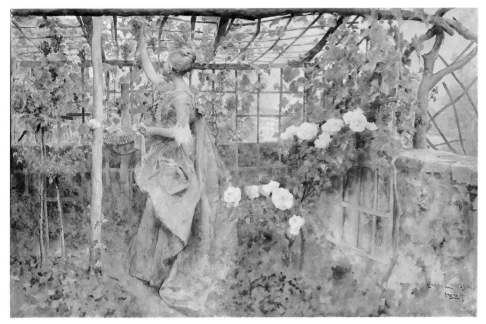

The Vine Diptych, watercolor, 1884, National-museum, Stockholm

into a uniform hat is little Suzanne's French nurse Zerline.

One of the last subjects Carl Larsson painted in Grèz was *The Old Bridge*. The bridge was a favorite subject among the Grèz artists. They all introduced it in some form or other. For Carl Larsson it had a special meaning. It was there he had proposed to his beloved Karin.

Carl Larsson's watercolors were received with delight by the Swedish and French public alike. Back home he got a showing at the *From the Banks of the Seine* exhibition which opened on April 1, 1885 in Stockholm. All the Paris Swedes were showing their collected works. Carl Larsson participated with *The Bride, The Vine, Autumn, Winter Scene from Grèz, An Old French Peasant* and *The Bee Hives*. The critics made much of his free and easy manipulation of the subjects. His success at the Paris Salon and the sales to the French and Swedish governments brought about a great change in Carl Larsson's circumstances. In 1885 he decided to return home for good in order to explore and depict Nature in Sweden.

The landscapes which he had learned to portray in France had had their colors softened by the moist atmosphere. In Sweden the dry, clear air made the encounter with Nature more intimate. It forced him to use brighter pigments. While living in a humble district in Stockholm he painted a winter scene, *The Open-Air*

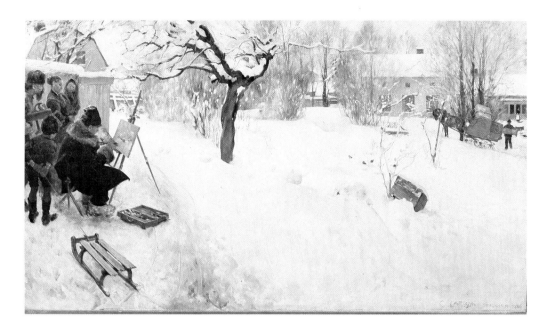

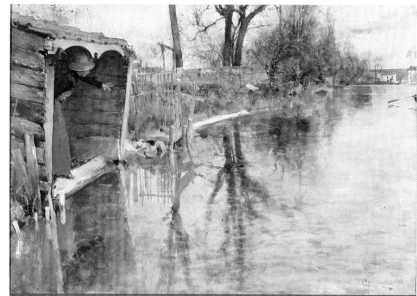

The Open-Air Painter ("In Sweden") Oil, 1886, Nationalmuseum, Stockholm

By the River Loing Watercolor, 1887, Privately owned

Painter, which serves as a contrast to his pictures of balmy French summers. The Swedish climate was indeed more rigorous for the outdoor painter. The artist is sitting with his easel out in the snow, wearing fur coat and headgear and straw boots. About him is gathered a group of the curious: a carpenter, a boy with a sled and a woman. The painting is of a different character also from a technical angle. It is done in oil and in larger format.

With this painting Carl Larsson laid to rest his open-air paintings in the French style. Several of his colleagues, among them Karl Nordström, blended the impressions earned from French paintings with their feeling for nature in Sweden and came up with something entirely new—the Nordic Landscape Mood of the 1890s.

The objective perception of reality was accompanied by an emotional expression and the luminous daylight of the dawn and dusk. Value painting was replaced by a synthetic form. Richard Bergh wrote that the nordic landscape painters had to be poets. This was a thought that was foreign to Carl Larsson who had made a comfortable niche for himself in the open-air painting of the 1880s. After some groping attempts to maintain the genre in the country around Sundborn, which reminded him of Grèz, he chose another field of subject matter, interiors and family pictures.

Caricatures of 18 Paris Colleagues Colored drawings,
1884, Privately owned

SWEDEN AND PARIS—1885-89

In the 1880s a nationalistic spirit arose among the
foreign artists in Paris. The French artists, who had lost
their American market because of higher tariffs on
French artworks, looked with jaundiced eyes on the
foreigners, who no longer felt welcome in Paris. The lat-
ter began to dream about nature in their homelands and
Carl Larsson expressed the feelings of the Swedes in Paris
when he wrote in a letter, *"Why in the name of all
that's blue-green not paint Swedish nature in Sweden
itself?!"*

In 1885 he took Karin and Suzanne with him away
from France to settle in the home country. The change
in environment did not, of course, imply an immediate
change in his painting. The technique was at first still
the light Parisian one; he gradually went back to oil
painting, however. His color treatment became more
contrasted than it had been in France, and the light did
not have the same silvery, veiled character.

At first the young family lived in Stockholm, where
Carl Larsson was very much involved with the revolt of
the youth against the instruction at the Academy of Art
and against the government's policy on the purchase of
art works. The opposition movement had been begun
by the young Swedish artists in Paris in 1883-1884; they
had since then enlisted practically all the Swedish artists
in Germany, Rome and England. At the same time as
the signal was given for the definite revolt they opened
in Stockholm in the spring of 1885 an exhibition called
Från Seinens Strand (from the banks of the Seine). This
showed the startled Swedish public what modern art
wanted to say. In the fall the opposition had brought
the revolt to a full boil in Stockholm with a large, long-
term exhibition managed by Carl Larsson. The following
fall there was a meeting for Scandinavian artists in
Göteborg. Then word was received that neither the
Academy of Art nor the Swedish government would
meet the demands made by the opposition. In protest
the opposition then formed a union, the *Konstnärsför-
bundet,* on the pattern of the socialistic trade unions.
Carl Larsson joined as an enthusiastic member, but soon
reacted against the political trends, and left the union as
early as 1891.

Stork with Baby Drawing, tinted. From *De Mina*, 1895/1919

French Landscape Drawing with watercolors, 1883, Nationalmuseum, Stockholm

In the spring before the Scandinavian artists' meeting, Carl Larsson had borrowed a sum of money so he could travel to Paris in order to submit his large painting *The Open-Air Painter* at the Salon, where it was entitled *"En Suède" (In Sweden)*. He continued his trip then on to Venice, Florence, Rome and Messina. He wrote a description of his trip, illustrated with impressionistic drawings, and published (Christmas 1886) in the same *Svea* calendar which three years earlier had published the Strindberg write-up. In the course of the trip he studied murals especially. He was fascinated by Michelangelo and Tiepolo. Traces of influence by the latter can be found in Larsson's work. Carl Larsson was even now beginning to dream of decorating large walls.

During the Scandinavian artists' meeting in Göteborg, where some artists were gathered one day in Mr. Fürstenberg's gallery, one of Carl Larsson's artist friends suggested that he should decorate the gallery with a motif from the life of artists and from the history of the gallery itself. At that time nothing came of the suggestion but two years later the architect of the gallery requested decorative wall treatment of the vestibule. Carl Larsson immediately drew up a proposal: The three periods of modern times; Renaissance, Rococo and Modern Art were to serve as the subjects of three murals. At Fürstenberg's expense, the artist and his wife took up residence in Paris to study modern decorative art for a year and to complete the triptych. In Paris he studied *"Baudry in the Opera, Besnard in the School of Pharmacy (oh, oh, oh!), Laurent's powerful ones, Puvis de Chavanne's odd, blond ones, and Chabanel's skillful but almost tiresome murals in the Pantheon, and Laurent's ceiling in the Odeon Theater."* Baudry's art, which was meaningful to Carl Larsson's own graceful interpretation of reality, Larsson had admired on a brief visit to Paris in 1887 when Baudry's work was put on exhibit after his death. Larsson had also seen Besnard's and Puvis de Chavannes' work represented in the Paris Salon the same year.

The triptych was finished, and shown to the public at the Paris World's Fair in 1889, where it scored a success. Carl Larsson felt that he had created something new and personal. *"I think that I have now for the first really become an artist. This is really something worthwhile, to erect on a basis of reality lines of fantasy and color con-*

Little Suzanne Pen and ink drawing for a woodcut, from *De Mina,* 1895/1919, Nationalmuseum, Stockholm

Parisian Model Watercolor, 1885, Prince Eugen's Waldemarsudde, Stockholm

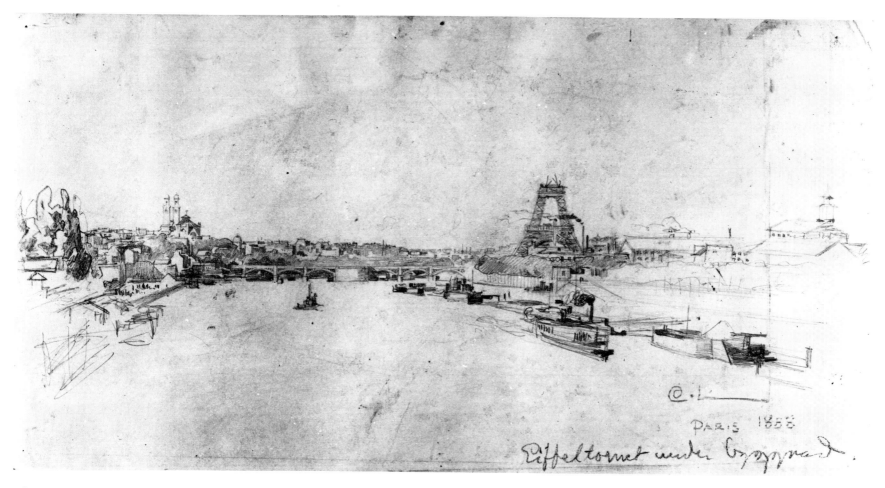

The Eiffel Tower Under Construction Pencil, 1888,
Nationalmuseum, Stockholm

trast.'' He broke with Naturalism and presaged the symbolic painting of the 1890s. But he had not broken with the illustrative; on the contrary, in his future decorative painting the narrational was to dominate. *"What else is 'monumental' painting,''* he asked, *"other than, really, the pinnacle of illustration. The same conditions apply, the same sort of talent, though ...excelsior!''*

One suspects that Carl Larsson was thinking of something other than just the decoration of Fürstenberg's gallery. Since 1866 the Swedish people

had been reading about the great expanse of walls in the stairwell of the Nationalmuseum in Stockholm: "Space for the painting of frescos." In 1878 Strindberg had written in a newspaper that as long as Carl Larsson stayed in Paris "we have to wait for powerful contributions to Swedish art, and the walls of the vestibule of the Nationalmuseum will probably have a long wait for someone to come." Many Swedish artists dreamed of someday being chosen to decorate the empty wall space at the museum.

In 1883 a competition was announced for suitable subjects for murals: Carl Larsson, who was living down in Grèz, composed, together with two friends, a proposal, and sent it in to the competition, though without result. But in 1888 he wrote to Fürstenberg from Paris, *"I would like to confide one thing to you, Mr. Fürstenberg, and that is that I have made a sketch for the walls of the Nationalmuseum. I am not giving my name but I have written a motto: Everything for the Fatherland. Now it is certain that the committee will im-*

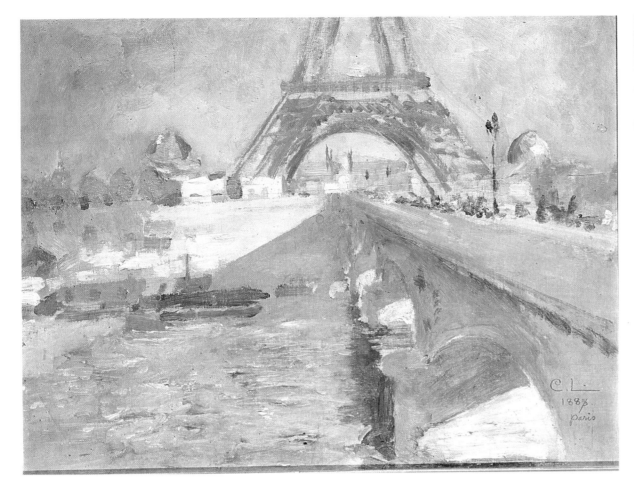

The Eiffel Tower Under Construction Oil, 1888, Mrs. Ulla-Britta Frieberg, Sundborn

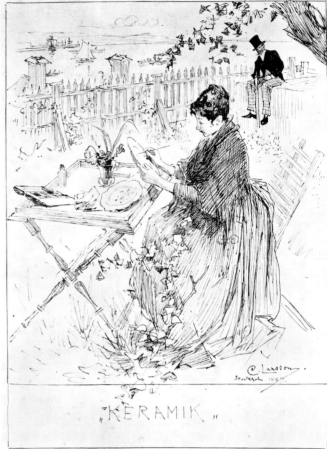

Ceramics Pen and ink drawing, 1887, National-museum, Stockholm

mediately see who the author is—and for that very reason I have little or no hope. However I know that I have not done badly.''

He won the second prize after Gustaf Cederström, professor at the Academy and painter of historic motifs. The competition committee liked Carl Larsson's suggestion, even though it was criticized as being too illustrative. A run-off competition between the two prize winners was held, but the results of this were not to the liking of the committee, and an entirely new general competition was announced in 1890. Carl Larsson surprised the committee with a proposal not only for the lower stairwell, but also for the upper one. In addition he now had entirely new historical motifs to suggest. He received first prize, but the committee could not agree and likewise decide on how the work was to be apportioned among the various prize winners. All in all it was a matter of eight wall areas. The government did not express itself, but 35 artists and three professors of art history entered a protest against the committee's dawdl-ing, and recommended Carl Larsson. But still no decision was reached.

Thoughts about the frescos for the Nationalmuseum occupied Carl Larsson's mind during this entire period, but his imagination toyed also with other projects. In 1890 he had by means of a sort of coup succeeded in getting Fürstenberg to defray the costs of decorating the walls of the vestibule of the newly constructed girls' high school in Göteborg. *''I regard this as an epoch-making project. To be sure, Fürstenburg had already at an*

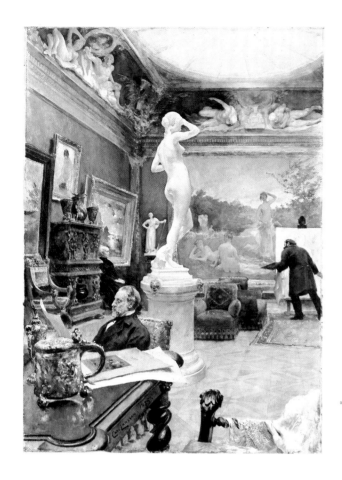

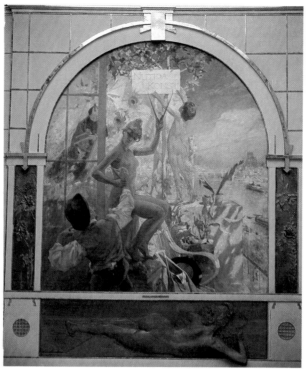

On Åsogatan (Street in Stockholm) Drawing from *Larssons,* 1902

Modern Art The right hand panel of the triptych for the Fürstenbergs' gallery, oil and relief, Paris, 1888-1889, Art Museum, Göteborg

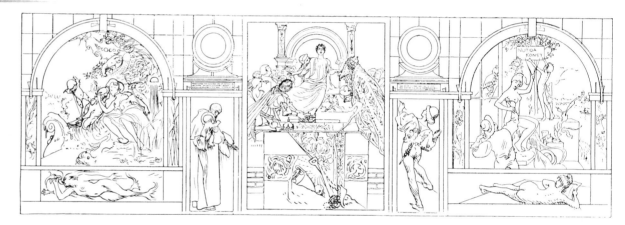

The Fürstenbergs' Gallery Watercolor, 1885, Art Museum, Göteborg

Renaissance, Rococo, Modern Art Drawing from a photograph of a triptych for the Fürstenbergs' gallery (three decorative oil paintings with sculptured reliefs by

Carl Larsson, winter 1888-1889, Paris) Drawing from *Larssons,* 1902

earlier time defrayed (I believe all by himself) the cost of decorating the walls of one of the same city's other high schools, but I will nevertheless insist on my paintings in the girls' school as marking the moment when art, the bestower of happiness, gained entry to the halls of our schools." He had chosen as his motif "Swedish womanhood through the centuries."

A HOME

By this time Carl Larsson had put down roots in Dalecarlia. He and his family had been spending their summers in a little cottage in Sundborn village. The cottage had been given to the young family by Larsson's father-in-law in 1888. During the first years Carl Larsson had been fully occupied with the competitions about frescos for the museum. But he resumed easel painting,

more to fill in the long waiting periods than anything else. He now attempted to shake off the Paris influence of lightness and elegance. Like the other homecoming Swedes from Paris he strove for a more austere and sometimes even more heavy-handed painting style in order to create a genuinely Swedish art form. He preferred oil colors, and permitted himself larger formats for his pictures. The idyllic did not attract him so much. Suddenly, too, nature in the vicinity of Sundborn began to seem to him too soft; not even that was Swedish

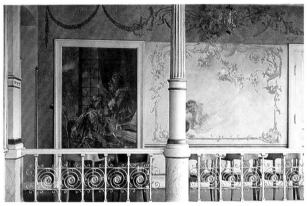

Details from Murals at the Girls' High School (Now called the Engelbrekt School, Göteborg, 1890; restored 1976. From the series *Swedish Womanhood through the Centuries,* thirteen large compositions, framed in rich ornamentation

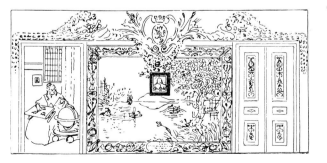

Swedish Womanhood through the Centuries Two drawings from paintings in the Engelbrekt School, Göteborg, 1890, From *Larssons,* 1902

enough for him. He moved deeper into the forests of Dalecarlia, where Finns had been living since the 1600s, and searched for more primitive motifs. There he painted pictures of the life of the forest dwellers in the intensive glow of sunsets and even in the meager light of tallow candles. But as in his French-oriented 1880s watercolors, the human figure was still subordinated to the environment and the overall mood.

This tendency soon faded, however. He came to be affected more than before by both his illustrative work and his thoughts of mural painting. He forced himself in his narrative pictures to a decorative stylization that was tinged with superficiality. The times were tending toward ornamentation but not coloristic refinement. Carl Larsson himself had enjoyed the naively romanticizing play of lines in the folk art of Dalecarlian woven wall-hangings in the farmhouses and also the primitive story-telling in decorative murals by Italians of the 1300s and 1400s, especially in Siena.

But in addition Carl Larsson was compelled by current

31

Queen Lovisa Ulrika Charcoal and pastel, undated, about 1890, Nationalmuseum, Stockholm (A study for a mural in the stairwell of the Nationalmuseum)

Rococo Model Charcoal, 1897, Stig Ranström, Göteborg

imperfect color printing techniques to simplify his own style in line and color. We are able to perceive this in his watercolors for the Swedish balladist Elias Sehlstedt's *Sånger och Visor I Urval (Selected Songs and Ballads)* which was published in 1893. *"Do you know, I am really a little worried over how Sehlstedt* [i.e., Sehlstedt's book] *with my little old men is going to look and how it is going to 'go over'* [with the public]. *I have certainly meant well and done my best, but...I am afraid it isn't enough like a photograph to please the public's rotten taste,"* he wrote, when the book came out in 1893. But the previous year, when he had seen for the first time a

proof of a Sehlstedt illustration in color, he had written, delightedly, *"If a person can get his artwork out before the world in that form, I say to hell with bothering to do paintings!"* As early as 1882, indeed, he had written that what he wanted for his art was *"to be useful and make people happy, not just one person, but everybody."* That was the way Strindberg had seen his mission. Now Carl Larsson saw in color printing a possibility for reaching an ever wider public with his art.

In the summer of 1894 Carl Larsson painted the first of the watercolors which would be reproduced in 1899 and collected in the form of a picture album with text by

the artist himself, called *Ett Hem (At Home).* It had become the thing to do in middle-class Swedish families to have their homes photographed, sometimes with members of the family as subordinate parts of the scene, and file them in elegantly bound albums. Carl Larsson did something of the kind in watercolor: *"I decided to get busy at what I had been dreaming of for a long time—to draw souvenir pictures from my little home. I thought it would be a kind of family document. (Well, it was really Karin's idea: with a view to giving me something to do one summer when it rained for six weeks without let-up and I was restless and unbearable.)"*

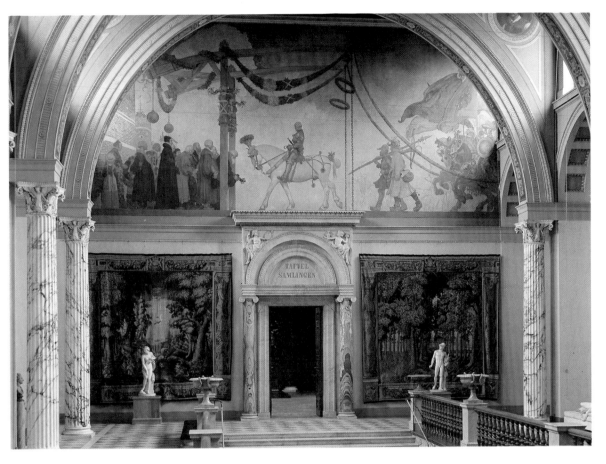

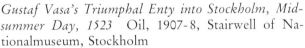

Gustaf Vasa's Triumphal Enty into Stockholm, Midsummer Day, 1523 Oil, 1907-8, Stairwell of Nationalmuseum, Stockholm

Ehrenstrahl Painting Karl XII's Portrait Sketch in oil, 1890, a proposal for mural in the stairwell of the Nationalmuseum, Stockholm

It is of course not improbable that Carl Larsson had it in the back of his mind from the first that it might be possible to get these memory gems reproduced in color (and a hint of such intentions is the fact that the drawing and selection of colors was calculated with an eye to available color reproduction techniques of that day) and published as guides to interior decorating. In 1897, at any rate, he had clearly in mind what the pictures were for, when he declared at the big Art and Industry Exhibition in Stockholm that his watercolors should have been hung in the arts-and-crafts section. In the introduction to the *Ett Hem* album, which came out two years later, he wrote, *"It is not with the vain intention of showing merely how I live, but rather because I consider that I have been so sensible about all this that it might be worthwhile—oops, dare I say it out loud?—as a guide (Well, I've gone and said it!)—for many people who feel the need to fix up their homes in a nice way."* This ambition to pump for a new, lighter style in Swedish home furnishings was in the air at the time. A number of younger Swedish culture advocates, authors, painters and architects were fired with enthusiastic ideas about cleaning up the standardized gloomy, tasteless home furnishing style. They were nationalistically minded but at the same time deeply influenced by Anglo-Saxon ideas on the art of interior decorating, from William Morris to The Studio.

THE MUSEUM MURALS

Years went by one after the other and Carl Larsson was unable to get to the bottom of the matter of the murals for the Nationalmuseum; and it was getting on his nerves. In December 1893 young Prince Eugen, who was also one of Sweden's leading landscape painters, had demanded that the Academy of Art should strongly back Carl Larsson's proposal, which had won first prize some years before. And the Academy of Art did suggest that Carl Larsson's plan for the decorative work be accepted and that he himself, to begin with at least, get to paint the panels on the north wall of the lower stairwell while Professor Cederström should get to paint the east wall of the upper stairwell with motifs from the history of king Gustaf Vasa. Cederström declined the commission because he considered that the proposal that Carl

33

Gustav III Receiving Ancient Art Treasures Partly finished frescos on the north wall of the stairwell, Nationalmuseum, Stockholm, summer, 1896, Drawn from a photograph, from *Larssons,* 1902

Gustav III Receiving Ancient Art Treasures Mural, 1899, North wall of the stairwell, Nationalmuseum, Stockholm

Larsson had made in the competition of 1891 could not possibly be improved upon and should not be sacrificed for his sake. In 1895 Carl Larsson had the working drawings for the murals for the north wall ready. They were approved by the committee, who also ordered plans for the opposite wall. These too were approved the next year and Carl Larsson proceeded to the completion of the work. In the fall of 1896 the murals were completed. Press criticism was positive but the committee was this time strongly negative. It demanded that the artist should undertake far-reaching changes according to its own wishes. Carl Larsson refused and the committee

decided to "accept" but not "approve" the paintings. Two of the committee members wanted the paintings removed from the wall. The question of the paintings in the upper stairwell, *Gustaf Vasa's Entry into Stockholm on Midsummer Day 1523,* was tabled. The artist's nerves were severely affected by the tension and reverses through all these years. His eyes had also been severely affected during the completion of the work on the murals.

As far as the content was concerned, the development from the first sketches seven years earlier to the finished compositions involved great alterations away from il-

lustrative milieu painting to, admittedly, a still illustrational approach, in which however the milieu was not allowed to overshadow the human figures, which had been reduced to just a few in each picture. Stylistically the changes meant that Carl Larsson was to give up his 1880s style open-air technique with emphasis on lighting and atmosphere and depth of perspective and instead emphasize the surface through rococo-inspired contours and by suppressing the impression of depth by means of surface composition. Color played a lesser role for Carl Larsson in the finished murals than in the sketches. The uncolored plans were considered the important thing by him. If the plan is carried through *"almost any dauber can plaster it up on the wall and smear a little color inside the contour lines,"* as he put it. Actually, he went at the final work on the walls with great ambition and he did succeed in imparting a light and festive air to them, the color scheme, despite his scorn for the importance of the colors, was harmoniously radiant.

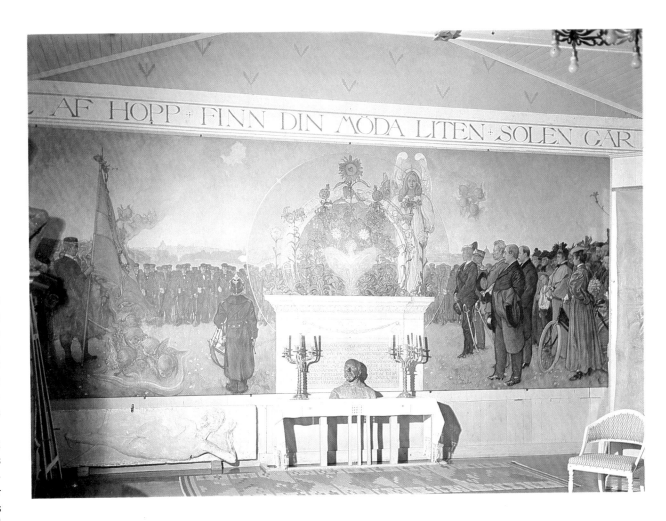

Time has, to be sure, dulled and in some respects distorted the color scheme, especially the red parts of the picture, but the result must even so be regarded as one of the high points of Swedish monumental art. The theoretical underrating of the artistic craft and of the significance of colors was shared with Carl Larsson by his contemporary Swedes. The painters of the 1890s regarded an artistically thorough and polished piece of art as superficial artistry.

While Carl Larsson was still at work on his museum murals he had already received a new commission. This was for the new Stockholm Opera, then nearing completion. A ceiling mural was wanted for one of the foyers or in the auditorium. Carl Larsson proposed that Anders Zorn be approached, but the latter declined. Carl Larsson then chose to paint the ceiling and a number of lunettes in the public foyer. In December 1897 they were finished and were greeted with praise without any jarring notes. The ceiling had forced him to take into consideration the depth of perspective and he had skillfully met the challenge with a strong feeling for the rhythm of line and composition. Albert Besnard's theater ceilings in Paris had been inspiring prototypes.

A preamble in decorative work in the 1890s had been a commission for a school in Göteborg. The final year of the decade saw him involved with another school. In 1899 Carl Larsson completed plans for a mural in the Norra Latinläroverket (northside classical high school) in Stockholm, commissioned by a newly formed group called *Konsten i Skolan (Art in the Schools)* which at the same time was commissioning paintings from a number of other prominent Swedish artists. Carl Larsson's mural was finished in 1900; it was characterized by his typical blending of realism and fantasy. Realism in this instance is photographically palpable, which renders the gracefully imaginative factor in the picture all the more surprising. The motif shows school students at an outdoor religious ceremony, called a *Korum.*

In 1902 there followed a new commission for a school painting. The Latin high school in Göteborg received a large grant and Carl Larsson took on the assignment *"after a little shilly-shallying."* He suggested as the motif St. George and the Dragon but this aroused little enthusiasm and he withdrew it himself only to select instead a realistic summer scene, *"Outdoors Blow the Summer Winds,"* a panorama in festive mood without overtones. It was dedicated in 1903.

The following year Carl Larsson played with the old dream of Gustaf Vasa's entry into Stockholm and he sent a new sketch to the Nationalmuseum. There were no objections this time. The committee expressed its desire that his compositions, the old proposal and the new one, should be made the basis for decoration of the east wall of the upper stairwell. Carl Larsson however was not satisfied with either of the sketches and undertook to draw up a new proposal, which the committee also approved in 1906. During the summer of 1907 the painting was executed in oil on canvas and not as a fresco like the compositions in the lower stairwell. *Gustaf Vasa,"* he said, *"he represents life! Now the king himself and his horse are ready and I tremble as I look at them and think this is a splendid masterpiece with big, splendid lines and noble, clear, pure (unsullied) colors."*

Already in 1905 he had gotten a commission for another decorative job, a ceiling painting in "Dramaten," the Royal dramatic theater in Stockholm (so named in distinction from the Opera, or "operatic theater") which was to be dedicated in 1907. It did not turn out to be a happy, festive composition like the ceiling in the Opera or *Gustaf Vasa's Entry* but rather a serious, almost compulsively dramatic ideological composition: *The Birth of Drama.*

IN DALECARLIA AROUND THE TURN OF THE CENTURY

While "the Swedish landscape" in Swedish painting during the 1890s had gone into a deep eclipse and the artists were showing less and less interest in human figures, Carl Larsson had moved in the opposite direction. He had always liked people and regarded the human fugure as the prime motif for the artist. Now he was painting candid shots from his own home as before but with all the more emphasis on the human side.

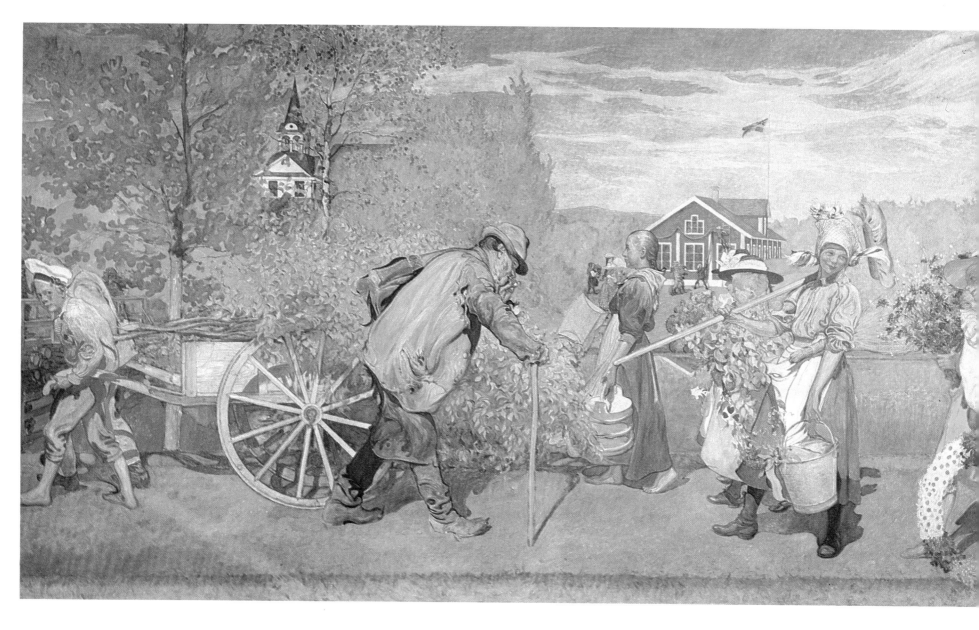

"Outdoors Blow the Summer Winds.." Oil, 1903, Latinläroverket (Classical High School, now Hvitfeldska Gymnasiet), Göteborg

"Outdoors Blow the Summer Winds..." Study after a mural in Göteborg. The Atheneum, Helsinki

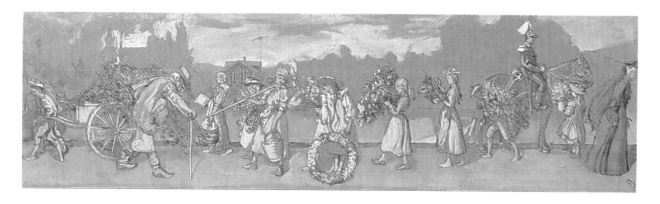

Watercolors were in the majority still but in larger format. More often than in many years, however, he chose oil colors as his medium, perhaps in order to break away from a habit that was clearly becoming fixed. When he painted in oil he no longer felt the compulsion to stick to the more neutral scale of colors. His oil paintings were not intended for reproduction so he could deal freely with the range of colors. When he painted watercolors the mild tones still were allowed to dominate for a time. The pen-and-ink contour lines had to give way to the soft-lead pencil. But the times were tending toward a fascination with strength and activity and sunlight and clear colors, and Carl Larsson went along with the trend. He could so much more easily intensify the color scheme now that techniques of color reproduction were developing so rapidly at this period.

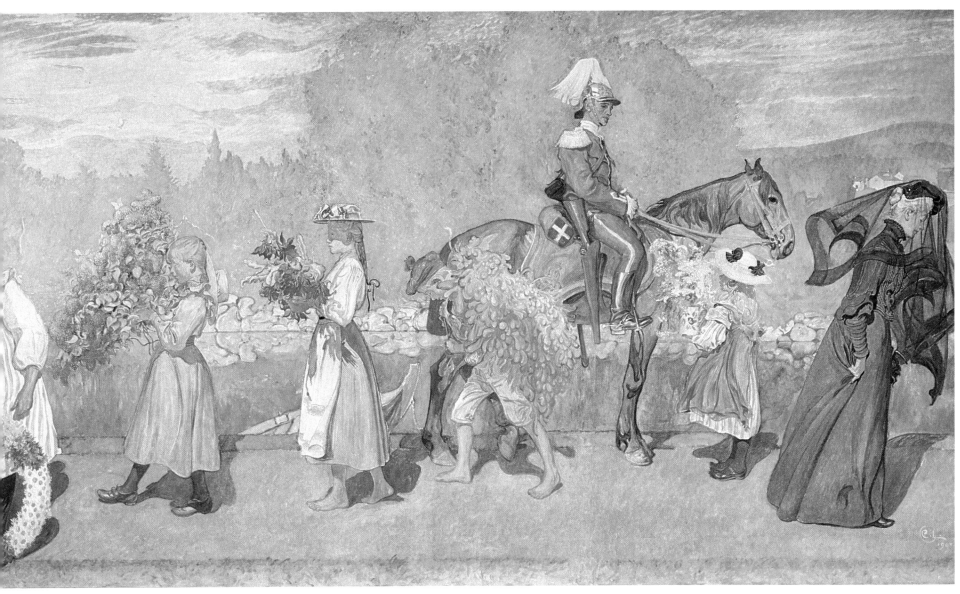

Study of a Girl with Pail and Broom Study for *"Out-doors Blow the Summer Winds..."* Charcoal and chalk, 1902, Nationalmuseum, Stockholm

Now thoughts of Paris went against the grain with him. *"Paris, hell! I've no longing for Paris any more,"* he wrote in 1900. And he had in his album *Ett Hem i Dalarna (A Home in Dalecarlia)* spoken about what was going to replace the dangerous French influence: *"Therefore, O Swede, save yourself in time; become simple and dignified; be clumsy rather than elegant; wear leather, fur and wool; make yourself furnishings to suit your stout body and slap on all the strong colors, yes, all right, the gaudy ones we need to counter the deep green of our pine forests and our cold white snow; and let your hand carve away unleashed on your furniture, cut out or paint the curlicues it likes and wants."*

Carl Larsson had come to feel all the more strongly his deep bond with the Swedish peasant tradition and his own peasant origin. From 1897 on he had been listed in his *prästbetyg* (the parish register, on which government vital statistics are based) as "artist and farmer." He had become the owner of a farm.

"To Carl Larsson, artist, the undersigned hereby relinquishes and sells the real estate known as 'Spadarf-vet' in Sundborn parish, consisting of the farm located there with outbuildings attached thereto and the surrounding terrain, seventeen *spannland...etc.

Sundborn, March 10, 1897, E.G. Björk"

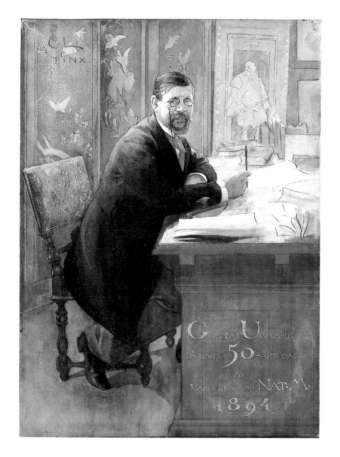

Gustav Upmark Oil, 1894, Gripsholm Castle, Mariefred

Eva Upmark Oil, 1894, Gripsholm Castle, Mariefred

Jac Ahrenberg Watercolor, 1898, The Atheneum, Helsinki, Finland

A romantic boyhood dream had come true. Even during his international years in Paris he had, despite his socialism, stressed his Swedishness. During the 1890s his nationalism found nourishment in the spirit of the times. Poets and artists had moved back to Sweden but they had not remained in Stockholm but had made their way out into nature, taken up residence out in the country, perhaps as a reaction to the growing flight from rural areas to the big cities and to America. The rapidly progressive disintegration of the old peasant community had called forth among poets and artists a new idealization of life and work. For Stockholmers this romanticism

*Roughly eight and a half acres.

**The spelling-reform of 1906-13 simplified many fanciful old spellings, and among others -fv- became just a -v-, which was how it had always been pronounced, anyhow.

***"personal" because, though two countries, Norway and Sweden lived under one monarch, the king of Sweden.

was expressed in that city's famed outdoor museum, Skansen, dedicated in 1891. For Carl Larsson, **Spadarvet became a similar expression; the purchase was the emblem of reunion with the soil, the return of the prodigal son. Around the turn of the century nationalistic feelings were further intensified. Nationalism, which until then had fallen away to passive sentimentality about nature, now became active, even activistic. In place of a feeling for dreamy quaintness that had symbolized the Swedish spirit at the close of the century, the popular fancy now turned toward a cult of youth and sunshine and manly strength, and this activism was intensified at the time of the dissolution of the Union. Sweden had been united in a "personal union"*** with Norway since 1814, and after decades of a mood of crisis Norway declared its independence in 1905.

Peasant-romanticism was an expression of active Swedishness; national strength was to be drawn from the soil. It was in those years that Carl Larsson painted his watercolors of Spadarvet as a salute to the Swedish peasants' labor. The peasant became a national symbol: *"Think what that is worth in this neurotic age. Nay, he*

is the most suitable one to advise king, ministers and the people! When the country is in danger he will always defend it—with his foodstuffs and his blood!" This was written the year after the dissolution of the Union, when Swedishness was licking its wounds. The Swedish colors are resplendent in the pennant, sky-blue and golden yellow, on the cover of the *Spadarvet* album. *"These are beautiful chauvinistic times now,"* he wrote to his publisher about the cover. Even in the watercolor medium we note a new energetic spirit in the attitudes of the human figures, in the motion of the lines and the composition of the pictures, an energy that was absent in the placid, factual pictures in *Ett Hem*. The fullness of expression is reminiscent of two passionate painters, precise contemporaries of Carl Larsson, namely Van Gogh and the Swiss, Hodler. Any influence from them must therefore have been indirect, for Carl Larsson disliked Van Gogh as a matter of principle. Whether he was better acquainted with Hodler, who at this time enjoyed much international renown, is unknown. In certain details, however, the similarity is so great that one may suspect that Carl Larsson had seen works by Hodler in the course of his trips to Germany or in periodicals.

Selma Lagerlöf Drawn in oil, 1902, Nationalmuseum, Stockholm

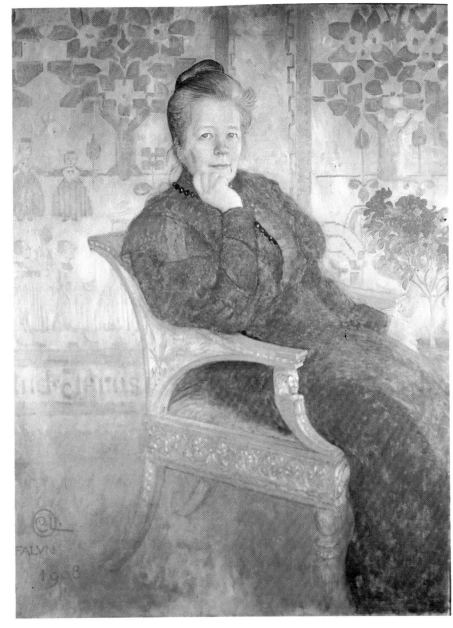

Selma Lagerlof Oil, 1908, Albert Bonniers Förlag, Stockholm

In 1903, when Carl Larsson was fifty, he was saluted in all cheerful shades of color. His fame had reached its pinnacle; no dissonances had yet become audible. In 1906, when he organized his first independent exhibition in Stockholm since 1894, the triumph was equally intact. As for the man himself, he had fallen into periods of severe depression; his mind had been shadowed by personal sorrows. The year before his eldest son, Ulf, had died on the operating table with appendicitis.

Two years later came Strindberg's surprising and infamous attack on Carl Larsson and especially on his wife, Karin. It was no wonder, therefore, that in his new album, *Åt Solsidan (The House in the Sun)* we can read:

"Now I suppose I will have to speak of that day of dread called 'life.' For life is, indeed, dreadful. Each one makes the best he can of it, but if one of us sometimes has something so bearable, yes, happy, as I enjoy at the present moment, he can not help seeing side-by-side with himself pitiful, angry, mean individuals or poor creatures whimpering in sickness, vice and want. He can not put it from him. One beast torments and devours the other, one flower stifles and kills the other.

"There sits a youth on the seashore and rejoices in the breakers. Then comes a great wave that washes him away and draws him into the depths; and father and mother wring their hands and are never really happy again...

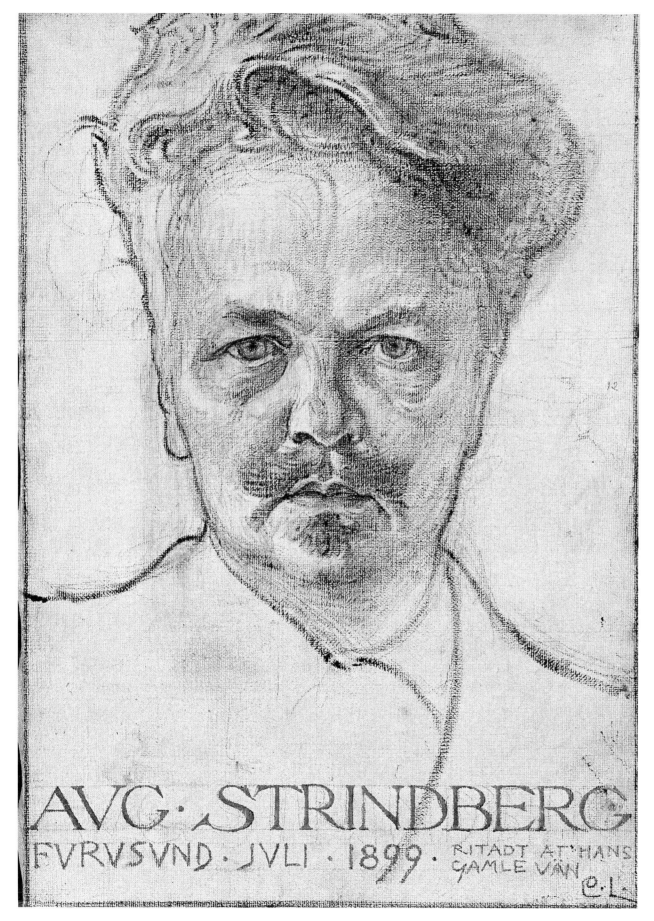

August Strindberg Charcoal, augmented with (oil) color, 1899, Nationalmuseum, Stockholm

"That is life. Good and bad. We have to live it and live it as well as is possible. You all know that as well as I do, but in order not to despair we must always call encouragement to one another and say, 'What nice weather we are having today!' Now we see that the good and the beautiful really do exist!"

Thus wrote Carl Larsson in the introduction to his album, *Åt Solsidan*, which came out in 1910 with pictures from Sundborn and from the *skolhushållet*, lodgings in Falun needed in those days before autos when the children had to live near their school once the primary grades were behind them. (Falun was the county seat of Dalecarlia and the higher schools were there.) These scenes were filled with sun and air and happy colors. *Åt Solsidan*, too, is reminiscent of the photograph albums of that day, not of the pompous ones but rather those of the amateur with happy or slightly sentimental snapshots, where capricious captions sometimes help to make a point. But the mood of the artist springs forth most distinctly in the contrast between these clear-eyed pictures and the despair evident in the introduction.

MIDVINTERBLOT

In 1910, the same year when *Åt Solsidan* came out, Carl Larsson's fantasy began to play with a new project for the west wall of the upper stairwell of the Nationalmuseum, thus opposite *Gustaf Vasa's Entry into Stockholm on Midsummer Day, 1523.* As a striking contrast to the cheerful summery day in the picture of the king's triumphal entry he wanted to take a winter motif from heathen times, namely *Midvinterblot (blot* being an ancient term for a sacrificial ceremony.) He executed a sketch which he sent in to the Nationalmuseum with an explanatory text: *"Here a king is being sacrificed for the weal of the people (to ensure a good harvest year.) He was drowned in the sacred well at the root of the tree (according to Adam of Bremen there stood before the well a tree whose leaves were green all year.)"*

The proposal met with strongly negative criticism, both as to the motif and for the execution of the idea as well. The artist was surprised at its reception: *"I wonder the screaming isn't a little too loud, even so... I had done my work in a happy frame of mind and feel as un-*

Drama is Born Ceiling painting in oil on canvas, 1907,
Foyer of the Royal Dramatic Theater, Stockholm

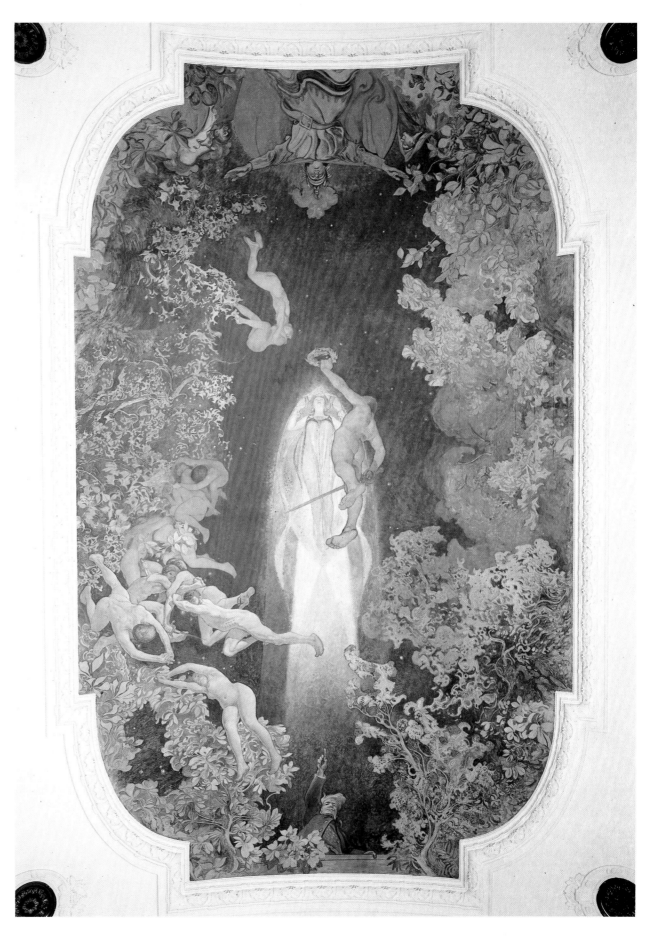

*concerned as ever... I had wanted to impart lustre and
grandeur. Good Lord, we know so little about those
days, so I hadn't wanted to deny myself anything along
those lines. And by the way, when they were grandiose
in those days, I believe they were pretty damn great!
And so it was the idea of the sacrifice that appealed to
me: the king who tosses his furs aside and in nakedness
stands ready to die. There was talk of something
theatrical about the composition, but there is a connec-
tion between the theater and religious ceremonies, you
know.''*

The setback incapacitated him. He was bothered by
exhibitions and orders for pictures of children and he
was fed up with his pictures of home; he was neurotic for
a while. Not until July 1913 did he face up to a new
sketch: *En Drömsyn (Vision in a Dream.)* The motif was
so much altered that he now wanted to make the king's
death into a voluntary sacrifice for the good of the peo-
ple. The committee declared that Carl Larsson should
have the opportunity of completing the decorative
embellishment of the Nationalmuseum but it could not
approve of the king's voluntary sacrifice as a motif, since
no such event was to be found in historical sources. They
therefore suggested that he depict a midwinter festival
without this savage touch. Press criticism was still more
negative, though couched in respectful terms. Carl
Larsson himself refused to go along with the
committee's suggestion and on March 1, 1914, wrote a
letter to the minister of religious affairs in which he
declared that he was abandoning the walls to their fate.
But he was obsessed with the idea and in the summer he
was in full swing with a definitive embodiment of it. At
his own expense and without the support of any patron
of the arts he now painted *Midvinterblot* in oils on can-
vas in wall-sized heroic dimensions. Anders Zorn, who
saw this new painting, offered in 1915 to defray the ex-
penses of executing both *Midvinterblot* and *Gustaf
Vasa's Entry* in fresco. In the summer of 1915 the big
painting was hung experimentally on the intended wall
in the museum. But the museum committee disapprov-
ed proposals to purchase the painting for the 35,000
kronor demanded, and Zorn's offer as well. But the
committee still wanted Carl Larsson to complete the
embellishment project, but if so it was to be done using
a motif of less sensational nature. Carl Larsson took the
proposal as an insult and made no reply. The govern-
ment, which would have the last word in the matter, did
not accept the committee's disapproval. The minister of
ecclesiastic affairs, who was regarded as being in favor of
Carl Larsson's proposal, requested expressions of opinion

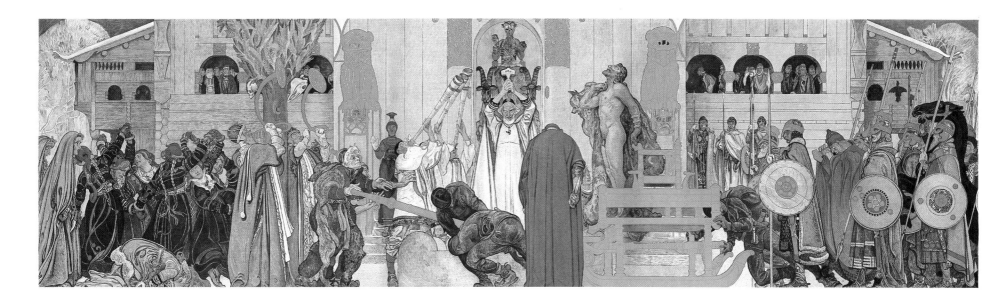

Midvinterblot (Sacrifice at the Winter Solstice) Oil, 1915, Arkiv för Dekorativ Konst, Lund

from several sources, which were on the whole on the positive side. The press sensed in the air signs of a coup on the part of the government and a violent storm broke in the newspapers. However the whole matter ended with Carl Larsson flatly refusing the commission in a letter to the government.

THE FINAL DECADE

The last decade of Carl Larsson's life thus became a stormy one, and the tempests broke down his strong self-esteem and finally also his will to live. The hot breath of new ideals in art felt to him like a threat to his own artistic authority and caused him to himself attack with the fury of a conservative the young artists who, since 1908 had in Paris whole-heartedly espoused the ideals of Matisse, with clear colors, expressive lines and relentless respect for the integrity of the surface.

The long years of struggle for *Midvinterblot* had ended in defeat with its sense of humiliation that remained an open wound in his mind. Uneasiness over its fate embittered his last years. But he went on indomitably painting his pictures of the home that the public adored, and in ever sunnier moods. The feeling of hap-

piness which in spite of all pervaded *Åt Solsidan* nevertheless was replaced with a forced cheer that was based on his hard-won self-discipline. It became a matter of moral prestige for Carl Larsson not to let bitterness creep into the pictures he painted for his public. The sunny spirit became a caricature of security, but the reverses had not broken down his creative zeal. With tight-lipped strength of will he gave form to his pictures in icy-clear plasticity.

As early as 1908, in connection with Strindberg's attack, Carl Larsson wrote in a letter: *"Being in Stockholm is like walking in a jungle full of malicious apes and horrid serpents."* He felt the need of security in his uncer-

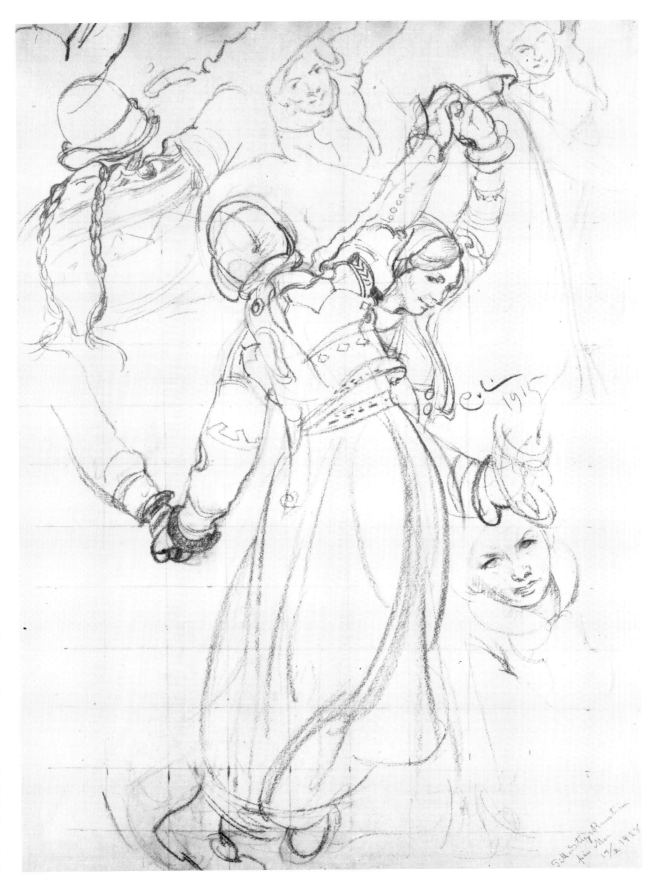

tainty within the intellectual atmosphere of Stockholm. The great strike of 1909 in Sweden had finally put an end to his ever more sketchy socialism; his old leftist zeal had sufferd a setback and he became more and more reactionary: *"I think now that the big and the strong should run things... But I have all my life been a faithful member of the lower classes; nevertheless I now say right out that since the summer of 1909 I have been of the middle class."*

To be sure he had become a farmer in 1897; now he found security in the conservative camp and identified himself ever more strongly with the country folk. He felt a need to participate in political life in the years preceeding 1914 with their debate over defense; he wanted to add the authority of his personality to the political scales. He wrote an open letter to the minister of war in which he attacked the government for its stand on the matter of defense. When in February 1914 Swedish farmers gathered from all over the country to confront king Gustaf V in the palace courtyard in Stockholm and demand intensification of defense measures, Carl Larsson demonsrated his sympathy with the ideology of the Farmers' March by contributing an article to its publication, whose cover he designed. He now painted the farmers and artisans of Sundborn as a monument to national security in a style that took its posture from early German painting of the 1500s.

The final years passed more peacefully. Carl Larsson had in 1910 purchased a cottage on his ancestral farm, Lövhult, in Hammarby parish in Södermanland where the family spent several summers. Things had thus come full circle and Carl Larsson had come back to his point of origin. He painted a picture of the church and graveyard that he called *Our Fathers' Graves*. For the most part he was occupied with portrait commissions in these last years. He also worked at his memoirs, which were completed September 11, 1918. Since the time of the museum frescos he had suffered from eye trouble which now became worse; at the beginning of January, 1919, he suffered a minor stroke which was not considered a matter of alarm. On the evening of January 22 he was sitting with his family in his studio in Falun. One of his daughters was at the piano, singing. He and Karin withdrew to his bedroom. For many years he had suffered from severe pain in his head. This now suddenly became unbearably intense: *"It feels so strange, I think I'm dying."*

His daughter was still singing when her mother came in to say that Carl Larsson was dead.

NUDES

It is well known in art history circles that Carl Larsson was in demand as a painter of nudes. We can offer a small sample of these in this book but not without referring the reader to his text *Aims and Media,* where he in a passage is able to demonstrate the rank value that the painting of nudes has for him. There is really nothing that can be added to that. We may perhaps merely mention that Larsson used living models because of the need for anatomical studies for his desire to achieve realistic perfection. For this reason this series of reproductions follows immediately on our presentation of his great commissioned works, especially the ceiling painting at the Royal Dramatic Theater.

But we may also take advantage of the opportunity to make clear how versatile Carl Larsson was from the point of view of technique. For we have made a point of illustrating alternate versions of numerous motifs, for instance, the pencil drawing and the subsequent etching. Larsson experimented, for example, with the then relatively new technique of soft-base or "vernis mou" etching, in which the pencil drawing that was completed first was to a certain extent automatically traced on to an etching plate. But he also tried the aquatint technique and dry-point etching.

FAMILY LIFE AS A PLAY

by Hans-Curt Köster

These thoughts are directed at the possible interactions between artistic work on the one hand and thought, life and feeling on the other on the part of Carl Larsson, Karin Larsson and their family.

Such reflection is demanded by current requirements, since the appearance last year in Sweden's largest daily newspaper of an article by Prof. Madeleine von Heland of the Institute for Art History at the University of Stockholm in which an attempt was made to answer this question anew. This article has been still further elaborated and is soon to be published in various forms elsewhere. I should therefore like to take up the matter, not only because the conclusion it reaches seeks to destroy the well known picture of Carl Larsson, nor because the words in which it is couched are filled with hate, but because the answers it affords have been developed unscientifically and subjectively, if not utterly prefabricated.

These are no new questions, for no less a figure than August Strindberg (1849-1912) has already essentially raised them way back in 1908 in a chapter of *En Blå Bok (A Blue Book)* and answered them with biting sharpness, admitting however that he could not substantiate his opinion. Furthermore literary critics still today feel that this "blue book," Strindberg's last work, bore distinct signs of a gradually disintegrating great mind, which certainly alters nothing in justification of the questions raised. Briefly, his thesis is that Carl and Karin Larsson, who at the time were the most celebrated family in Sweden, were merely putting on a show the whole time, were not revealing their true characters because the latter were diabolical and despicable, and especially that the Larsson domestic bliss, well-known throughout the kingdom, did not in reality exist—was just a lie.

ALOOFNESS

The writings published by Carl Larsson himself in his own lifetime contain perhaps a few hints of what we are to make of these reproaches. First of all I should like to point out by means of a number of quotations that Larsson has revealed an extraordinary amount of aloofness to himself and his statements (in words and pictures!) At this point I must beg my readers' forgiveness, once and for all, if I become tiresome with the may quotations I have lined up. I am however of the opinion that the irridescence of Larsson's personality as well as the human seriousness and evanescent striving for truth that lurk behind it will become evident in these many passages from Larsson's text.

"Little as I represent the figure of a prophet, I nevertheless draw the priestly toga about my shoulders and speak that with which my heart is filled." (Andras Barn, 1913)

"Let us just chat about it, just chat, because any sort of precise investigation or any sort of definite statement I am incapable of; it will be only a few and somewhat frivolous thoughts and ideas. Generally, if it is said of this or that artist that he is the best, that is of course entirely subjective, and this is very true. But you have to be a little coy about it, as if you mean to add, as it were, 'in my humble opinion.' I have perhaps been a little too brusque in the way I have made pronouncements about Raphael and now I'll have to take the consequences. Actually, that was in my younger days, when I used to speak out pretty precociously about this and that and in later years I have in many instances come to hold directly opposite views... What I am trying to get at is the insistence that everybody must have the right to express himself about artists, be they dead or alive. What I really feel is that a person ought once and for all to quit believing in authority, it is so depressive to one's character and effectiveness." ("Belief in Authority,"

"Fame" Charcoal, 1897, study for a ceiling mural in the foyer of the Royal Dramatic Theater, Stockholm, owner unknown

Graziella Asking Whether She Will Do as a Model Etching, 1888, Art Museum, Göteborg

Teresa Vitti Etching (dry point), 1888-1889, Art Museum, Göteborg

first published in the women's magazine *Idun* in 1912)

"Meanwhile I have become much calmer since those days. In this instance and in cases where it has to do with my religious and political views. In every respect I used to be unbelievably sure of myself and everything pointed in that direction, you see." (Larssons 1902)

"You probably recognize a number of these interiors, dear reader, from my book Ett Hem; for example, my own bedroom where the sun simply radiates health and burns away whole heaps of germs. And after that comes my wife's room. There are still two cribs in there, but they'll soon be just museum pieces, because even little Esbjörn is getting big ideas about life." (Åt Solsidan 1910)

"No, I've got something more to say about the love of work. Would you care to listen? I almost wish you didn't, because I feel it's going to be a mess. I know perfectly well I'm not sure about it and, as Tegner has said, 'what's unclearly thought will be unclearly spoken.' But it can't be helped, I'm started now with pen in hand and the inkwell has just been refilled." (Andras Barn 1913)

While I was proofreading it occurred to me that in mentioning my bigger works I had completely forgotten the mural in the girls' school in Göteborg. And that mustn't be overlooked. I see it as an epoch making inspiration... This painting is no great work of art, it was

45

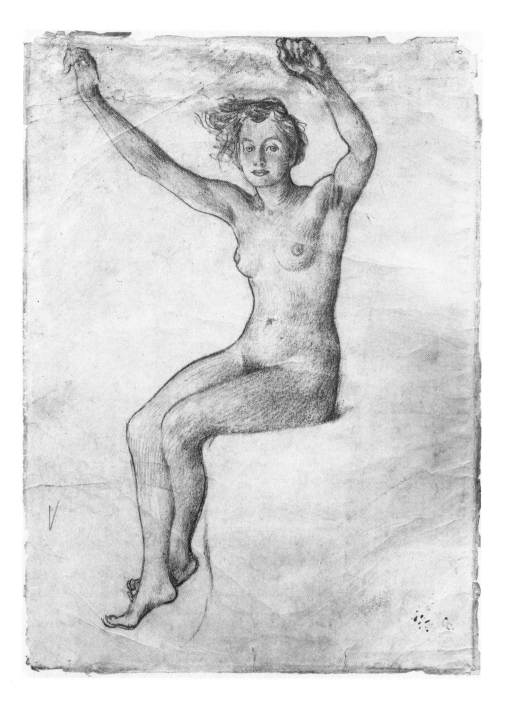

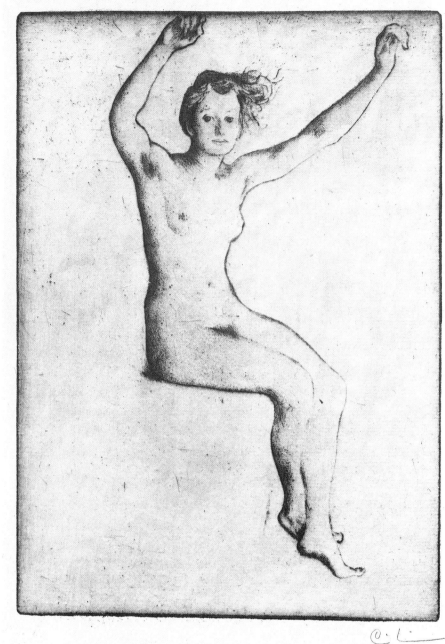

painted too quickly for that, but the idea itself that here takes on flesh and blood is certainly right and good.'' (Larssons 1902)

If I am allowed to be so uncritical here there will probably be plenty of textual matter here (in this book.) However, and I really mean this, I always have something on my chest and am happy and grateful when I can get it off.'' (Andras Barn 1913)

When I had finished my not-only-famous frescoes in the Nationalmuseum it so happened that with especially

solemn intent I went the following Sunday to Storkyrkan (Stockholm's cathedral)—I was living in Södermalm at the time—accompanied by Lisbeth and a servant girl. As I sat there dangling my legs I thanked God from my heart for having helped me with everything 'typically Swedish' at the final critique of the frescos…'' (Min Storkyrka, first published 1907 in Bonniers' Månadhäften)

''But I must, I guess, even if I'm a bit ashamed—and blushing, with shame, too—speak a little about the small pictures. One might think they ought to be good

Model Pencil drawing, 1896, Art Museum, Göteborg

Model Etching (soft base), 1896, Art Museum, Göteborg

Model Aquatints, 1896, Left, plate A4 (line etching), middle, plate B (aquatint), right, A&B (B pale red), Nationalmuseum, Stockholm

enough to speak for themselves. But that does not seem to be the case, because the publisher says I won't get any money unless I slap together some text material. Money—yes, that's a nice word. Your money or your life, robbers used to shout. Why or? Here in Sundborn we can't live without money and not without life either.'' (Åt Solsidan 1910)

"My firmly-rooted Liberalism got a severe shock in this summer of the General Strike. I believe now that the Big and the Strong have to remain on top—in a word, I believe that 'Might makes Right'!! That is a rather harsh way of looking at things, but it is simple and clear, sound, practical and wins out. You see, it will always be a tempest in a teapot as to what 'right' is, whereas there is never any question about what 'might' is. The Great and the Powerful are not as dangerous or as bad as the Lowly, and besides, there are fewer of them... No, Enlightened Despotism, that is my political motto at the moment... Well, yes, that is the kind of political harangue I dished out within the four walls of my little castle. There, you see? I'm right: Politics is demoralizing!'' (Åt Solsidan 1910)

Of course I am unable to draw here a psychogram of the Larssons, even if material for that were available. Whether the letters, photos and writings of the Larssons

and the reports of contemporaries and also the artistic and other documents on the two Larssons are the proper material must therefore be doubted, because of course even this material might be to some extent 'lies.' Therefore we will have to settle for the fact that even Strindberg, generally regarded as being a keen observer, was not able to prove his thesis and that it is going to be still more difficult to do today. M. von Heland embroiders Strindberg's thesis still further, however, although her proofs for it bear still more distinct signs of untruth. In brief, her theses are: Carl and Karin were united only by hate-love and desire for notoriety. Because Carl ''forbade'' his wife to continue her work as an artist, she took revenge on him by forcing Carl to paint only what she had thought up.

RIDICULE AND SCORN

How did the Larsson's take such attacks? Directly, naming Strindberg by name, Carl Larsson did not reply until in his autobiography, which he completed in September, 1918, four months before his death but which was not published until 1931, almost 20 years after Strindberg's death in 1912, by the way. Indirectly, Carl Larsson reacted quickly. Several passages in his books of 1910 and later can be referred to Strindberg's attack but he had clearly even before this particular attack to deal with the problem, as the following remarks show:

"For life is, indeed, dreadful. Each one makes the best he can of it, but if one of us sometimes has

something so bearable, yes, happy, as I enjoy at the present moment, he can not help seeing side-by-side with himself pitiful, angry, mean individuals or poor creatures whimpering in sickness, vice and want. He can not put it from him. One beast torments and devours the other, one flower stifles and kills the other....For many years you have been happy to call your best friend your own and then he turns his face against you—and that is hellish. You ask and ask, 'why? Why all these horrors?' Meanwhile clouds, white or shimmering pink, cross the blue sky. The wind strokes your cheek, the sun kisses the flowers of the field and your children, awakens life and beauty. And great, splendid deeds are performed...That is life. Good and bad. We have to live it and we have to live it as well as we can. You know all this as well as I do. But we must, in order not to despair, keep saying encouraging things to ourselves and saying: 'Nice weather we're having today!' (Åt Solsidan 1910)

"But the tone, the manner in which the newspapers quarrel, no matter which color they profess to represent, is brutalizing, hateful and poisonous... No matter how strong and proud he is, no matter how much he does his duty to the best of his knowledge and conscience, he will nevertheless finally note that constant dripping wears away a stone; he will 'withdraw,' he will become 'one more tired senator' and his place will immediately be taken by a 'politician' who is less worthy but has a thicker hide.'' (Åt Solsidan 1910)

"Virtue can also reap a perverted reward, but I simply don't know whether you should just sit down and 'weep

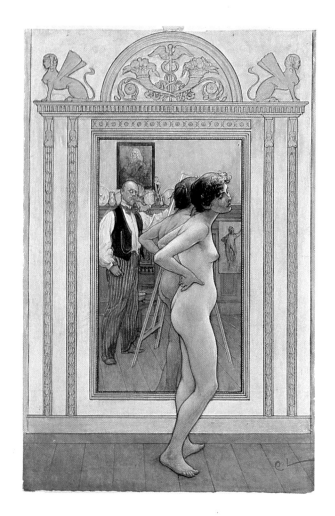

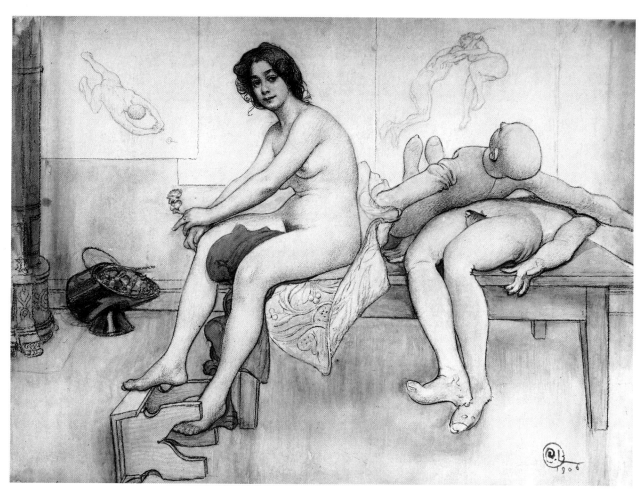

In Front of the Mirror Watercolor, 1898, Zorn Museum, Mora, Sweden

On the Model Table Watercolor, 1906, Art Museum, Göteborg

for Jerusalem;' but what I do know is that you should die like a man for a good cause if it comes to that, and over your paled lips let pass with your last breath the words: 'Forgive the blockheads!'" ("An Open Letter" to his son Pontus in Åt Solsidan 1910)

"I heard a man raging in proud anger against meanness, the rat-race, lies and servility. He was beautiful to watch, with sparkling eyes and a thundering voice trembling with deep emotion and his breath coming in gasps from the great, powerful throbbing of his heart... When he suddenly perceived something wrong that bothered him—he didn't know quite what—and noticed a scornful laugh; he smiled, laid his head to one side, winked and looked so extraordinarily ridiculous, the noble man remembered his own unpaid bills, some ugly white lies and—his future, on which he depended—and relaxed. His listeners who had just been

feeling edified, now spoke among themselves of prominent people who had made it their goal in life to arouse the masses against the outwardly magnificent drones. The next morning it said in the papers that Scornful Laughter had become chancellor. He had the prince's ear now, the poor, good prince was so afraid of appearing stupid and sentimental that he grinned, and with him grinned all the courtiers and his wife and the ladies of the court. And then the whole nation." (From "Scornful Laughter," first published 1891 in the newspaper Nutid)

FITS OF DEPRESSION

"What does it mean to be an artist? It's a very nice, pleasant way of pottering about and calling it a profession, isn't it? This profession! It is a ceaseless repetition of failures, that's what it is! That takes guts, dammit!

This is the art of believing until the bitter end that you are accomplishing something you know you can never succeed at." (Larssons 1902)

Such experiences can probably be understood as the basic experiences of every human being, but they must be recognized as especially applicable to artists. Modern psychology knows that artists, actors, writers, musicians, etc., are so-called "borderline personalities," always on the verge of what in the popular mind is thought of as insanity. This character trait is, it seems to me, inherent in being an artist, because, among other things, it guarantees also the necessary sensitivity which alone makes it possible to record living emotions and articulate them farther, all of which is self-evident. Let us again listen to Larsson on that subject:

"The May sun is shining outside and Karin looks dismal and solemn. Is she perhaps digging in the

Model, Writing Picture-Postals Watercolor, 1906,
Thielska Galleriet, Stockholm

mystery of the future for the happiness and bliss of the
little one at her breast? I don't think so; she is too smart
for that, Karin is, to sit there and dream wishful dreams,
but it may be that she is thinking of one thing or
another about the baby. It is a gross error to wish for
happiness and strive for it. That is not the way life is
planned. If happiness comes, that is good, and if it
doesn't come, then that's good too…And that's the way
Karin is thinking in the picture, too—unless she's think-
ing about what to give me for dinner.'' (Larssons 1902)

"Don't let your Self go down into the deep, dark
shaft of your soul like some poor miner, but lift it into
the light, into the sunshine, the song of the birds, the
fragrance of flowers.'' (Åt Solsidan 1910)

A SHARED CREATIVE BINGE

In the book *Larssons*, put out in 1902 by Carl Larsson,
a book he had written himself and filled with pictures,
he depicts somewhat systematically the growth of his art-
istry. But the undoubtedly central experience unfor-
tunately is mentioned only very succinctly: After he
describes in detail how he came to fall in love with Karin

Bergöö, he says: "When a few days later Karin made me
a marriage proposal (in her own way), I told her 'Yes.'
And then we both painted Mère Morot. And the scales
fell from my eyes! I had up to now not brought my so-
called talent into any kind of form, but now I had im-
mediately succeeded with a little masterpiece, I think,
because I got a medal for that picture, a purchase offer
from the French government and through my friends
Birger and Pauli I sold it by telegram to Pontus Fürsten-
berg.'' And he sketches copies of the two pictures—his
and Karin's—in the same book.

The moment when the "scales fell from his eyes'' had
been for Carl Larsson definitely the most important

49

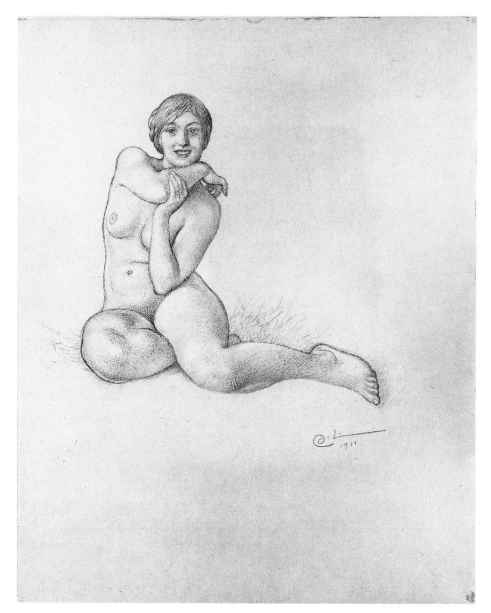

Crouching Girl Pencil, 1911, Art Museum, Göteborg

Crouching Girl Etching, 1911, Art Museum, Göteborg

thing in his life as an artist. This moment could have been of equally great importance for Karin, who together with him had painted *Mère Morot.* She wrote later to her parents that she had never felt so safe, so calm and so strong and at the same time so devoted as now. We do not know which of the two, Carl or Karin, had had the idea of painting this picture. Carl's picture however marks a step away from the pedestrian, symbol-laden motif, a step to which his teacher, Scholander, at the Academy of Art in Stockholm had already urged him. We will spare ourselves further repetition here and refer the reader to the preceding article by G. Cavalli-Björkman. M. von Heland is certainly right when she designates this moment, in which the picture of Mère Morot came about, as "shared creative intoxication."

This shared creative intoxication was probably sought again and again by the two, and in my opinion it is only natural if Carl and Karin shared in creating the subsequent Larsson pictures. I must leave it to others to weigh Carl's talents against Karin's. But this much I may perhaps venture to say: Since 1869, when he was editor of the periodical *Pajas (Clown),* practically his only source of income had been illustration commissions. Since then he had illustrated hundreds of scenes, scenes

Model by a Heater Etching, 1908, Primary stage, Art Museum, Göteborg

Model, Standing "Rouge et Noir" (Red and Black) Etching, 1909, after a 1906 watercolor, Art Museum, Göteborg, (Also Amos Anderson Museum, Helsinki, Finland)

from daily life and from literature. One may imagine that his approach to the world and especially the spirit of his times consisted chiefly in perceiving it as something to be illustrated. At this point, before rambling too far afield in speculation, we ought to listen to him himself speaking on the subject of why, actually, for what purpose, did Carl Larsson work as an artist?

THE AIM OF ART

"...should it not be a sufficiently worthy goal to let people learn to recognize people through my pictures, how pretty a flower looks at the roadside, how charmingly a little girl's braids snuggle against her little round neck, how the rays of sunlight fall on a little nose, what a splendid sight the picture of a naked woman can be, how handsome a man and a horse look!... But it must

be done as well as I possibly can, must be done with enthusiastic joy, with infinite care and deep sighs; and the end-result must be a victory; in it there must be visible no vagueness and yet no effort, it must beam forth to the viewer and fall like scales from the eyes: He should praise God and thank Him for all the beauty there is in this vale of tears and see in it the promise and hint of the splendors that await him beyond the grave." (From

51

Greeting Cards by Carl Larsson, from the Carl Larsson
issue of *Idun*, 1913

Aims and Media, first published in the periodical *Konst* in 1911.)

"*We are very definitely one of the Lord's failures and He had to remodel us and make us over and He will have to devote a good deal more of His valuable time before He has us in perfect form. But he won't be satisfied until He succeeds. And then we will no longer need artists. Why? Because we are one of His tools. That is what it is to be an artist! Beware of the impudent, pompous look (as in the self-portrait Before the Mirror!)*" (From *Belief in Authority*, first published in *Idun* 1912)

"*...for me as an artist, Japan is my mother country. The Japanese are at present the only real artists on Earth. Among us Europeans, art is just something affected, endeavored, snobbish; among the Japanese a sense of art is common and imparts to everything they do, even the merest trifle, a tasteful style. They are for our time what the Greeks were in theirs. But the art of the Japanese, although it seems bizzare to us, has far greater prerequisites for enduring into the future because it does not, as that of the Greeks did, aim only at so-called beauty but also includes the so-called ugly, that is, the exterior character of objects and things. And have you ever seen how prettily and intelligently a Japanese smiles and how wonderfully he knows how to walk?*" (From *Little Suzanne* in *De Mina* 1895)

"*I have gone to church with our maid and Karin is sitting home alone. You can see only her hands. What is she wondering about? It has been ten years already since the portrait was painted on the sliding door and also twenty years since she laughed for the first time in her life. That was when she first got a look at my face... When Strindberg got to see this picture a drama took form immediately in his imagination, the dismal outlines of which he explained to me. Dreadful, but ingenious. But that is his intellectual property and you are not allowed to know about it. But as an example of another concept, I will here venture to copy a few lines out of a letter that I received at a 'Sunday' exhibition from a fine lady: '... I love these folded hands and I'd like to kiss them, those, the ones resting on the table after 'tormenting' themselves all week long lovingly for everybody in the house and working for them, mending many a tear in a heart or a stocking, drying the tears in child eyes and being a blessing and a help for all her dear ones. So much peace and holiday mood wafted out over the whole room from those hands, even to the axe hanging on the nail and the charming fresh-plucked little bouquet on the table that it was like the loveliest divine service to me...' That's the way people ought to look at pictures. Mine, anyway.*" (Larssons 1902)

"*It makes me, at least, happy that these more or less successful pictures will be distributed by this means to a number of my descendants all over the world with motifs from my home. That is my contribution: to go*

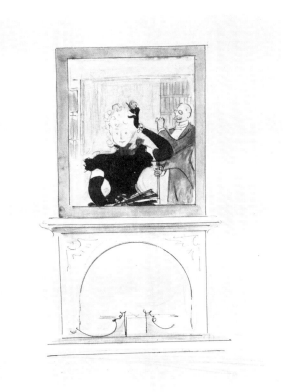

Man and Woman, Seen in a Mirror above a Hearth Pencil and pen and ink drawing with watercolor, Nationalmuseum, Stockholm

Congratulatory Motif with Poem Watercolor, undated. Privately owned

hence and preach to all peoples. What about? About the happiness of a fifty-year old man? Happiness? There is no such thing as perfect happiness! The shoe always pinches someplace, not only the person who owns many shoes but also him who has none. But you children— and it is you that this book is really about—are the children of our hopes and our longing." (Larssons 1902)

"*'L'art pour l'art'*" (art for art's sake): By this is often meant something righteous: looking neither to the right nor to the left, but doing one's level best at one's job. Well, that may be, but in back of it there often lurks a smug scorn for all the rest of mankind and the deepest

reverence for one's own little ego. Isn't that so? Yes, and that's why I want to take this opportunity to underline with the greatest emphasis that those who shout that at the top of their lungs simply lack the capability of communicating with their fellow men through the labour of their hands... That is that insolent crowd that embraces this relatively new direction and claims to take a wicked delight in making nice, kind people, who buy admission tickets for exhibitions and in doing so show at least a budding and surely praiseworthy interest in art, feel stupid and bewildered when they are unable to figure out whether it's supposed to be a picture of the artist's

ILLUSTRATIONS

Carl Larsson really regarded his most monumental works, the murals, as nothing but illustrations, as he himself has written. In his total output, illustrations constitute numerically speaking by far the greatest part. His artistic development started with illustrating and until his last years a reliable source of income was his work as an illustrator. However we will downplay this side of him rather more than Larsson himself did. Obviously there is no room in this book for a presentation that would encompass all or even part of the aspects of his illustration work. The series of pictures included here can show only some of the most important landmarks of his career as illustrator. In the chapter "Family Life as a play" however, the pivotal role that illustrating must have played for Carl Larsson is shown. It may have imposed an artistic attitude that means, among other things, that the illustrator is able to assimilate the world only "illustratively". Because that kind of thinking means that the artist who feels himself to be an illustrator has to be a preacher bearing a message, the questionable nature of that concept becomes clear. For not every artist is able to vouch for these "messages" with his entire life at any given point in time, all the more so if they sometimes are so strange or change character so abruptly. I think however that Larsson understood how to maintain his integrity amid all this fluctuation. For he tried to develop the particular beauty of every single one of his "messages" as he saw it. And at the same time he made use of all his technical know-how, which is why some of his illustration is still valid today.

The Train Wreck at Lagerlunda Woodcut in *Ny Il-lustrerad Tidning,* 1875

grandmother or a sunset—I react to this kind of thing with the greatest revulsion... For why should we not be willing to go forth and preach to all people? Nietzsche's Zarathustra preached to all the people at first, and when they laughed he immediately abandoned them and resolved to limit himself to just a few cronies. He preached that God was dead and that out of that dark cloud, Mankind, a bolt of lightning would flash forth, "Superman." Behold, that is the essence of the poodle. There was no love there. If he had had that, he would not have set out before he had made himself understood; he would have attempted to draw the people to him and bawled them out, but he wouldn't have abandoned them; or he would have gone back up into the mountain and reflected on whether the error might not lie with himself. That is the confounded doctrine, the Antichrist myth, that I hate and at whose prevalence I weep, the doctrine that lies behind all this Superman

business!" (From Aims and Media, first published in the periodical *Konst,* 1911.)

"It was last fall. Both of them, Father and Mother, lived just five minutes away from us. Now Mother is no more. When I saw her white hair flutter in the chill autumnal breeze I sensed, I knew, that she would not grow much older. She died at Easter, aged almost eighty." (Note to the picture *Father and Mother,* in *Larssons* 1902)

"There's nothing new under the sun—but now, only now, have I found her, and her name is Human Kindness, without the slightest limitations..." (Andras Barn, 1913)

"Love life, love thy neighbor, love animals, love the garden and the flowers! Love! Love! That is the solution to the puzzle of life." (From the "Open Letter" to his son Pontus in *Åt Solsidan* 1910)

KARIN'S INFLUENCE ON CARL

It is only fair to measure a person by the demands he makes on himself and his work. In doing so, however, it is undoubtedly important to take also his capabilities into account, but, as I have already said, I feel less called upon to do that. I can merely add a few minor, insignificant observations to that. Carl Larsson's early commissions and casual works (which we should never underestimate!)—for instance his cartoon from Christmas Eve 1877 in Paris—prove what talent he possessed for singling out a point and calling the eye's attention to it. He had at his command in an impressive way the medium of expression in the art of line-drawing, perspective and anatomy. Karin no longer manifested herself artistically with her own artwork after 1884, the year Suzanne was born, so far as we know. Her achievements in the field of textile art, which are to be seen mostly in Carl's pictures

Drawings from Topelius' *Tales of an Army Doctor*, 1878, Albert Bonniers Förlag, Stockholm

Drawings for Strindberg's *Svenska Folket i Helg och Söcken (The Swedish People on Weekdays and Sundays)*, 1882

The Witch's Trial by Water Woodcut for Strindberg's *Svenska Folket i Helg och Söcken (Swedish Folk on Weekdays and Sundays)*, 1882

from their home setting, stem almost all from after 1897. But art historians are agreed that the creation of their Sundborn home was chiefly if not practically exclusively the work of Karin, though Carl did have a hand in it. It is also the prevailing opinion that Carl profited from Karin's feel for color-effect. But do these facts speak against the assumption that the Larsson picture-world was created in concert by Carl and Karin? Where can a shred of proof be found for the thesis that Carl felt his work on these pictures, that we call today "typically Larsson," as a form of oppression exerted by Karin? He speaks rather with complete openness of her participation; also of her general influence on him:

"Here Karin would like to introduce a new baby. Kersti is the most lovable infant there ever was. At least a body couldn't imagine anything nicer. She is always cheery, never bored, whether she's playing with friends or with her brothers and sisters or alone." (Larssons 1902)

"The first picture in the whole series is the one in which Pontus, who has been told to 'go stand in the corner,' is seen sitting between the door and the tiled stove. He had been impertinent at the dinner table and been ordered out of the room; there in the parlor he could sit and reflect on all the disadvantages of misbehaving. Blessed be the moment when I had to go in there after my pipe tobacco! I noticed how the rebellious lad stood out sharply against the plain background and made up my mind to realize the long-cherished ambition to create souvenir candid pictures of our homelife. I thought they would become part of our family history to hand down to future generations. (Well, to be honest, it was Karin's idea for keeping me busy once when it rained for six weeks on end and I was getting in the way and being unbearable.)" (Ett Hem 1899)

"In 'The Retirement' I epitomize all the rooms depicted in the series Ett Hem. This store room was purposely furnished by Karin in such a way that in summer it could serve as a guest-room. (Ett Hem 1899)

"God in His Goodness has blessed me to the fullest with the treasures of earthly goods. My wife is certainly one of His angels, and to me she's as earthly as she is indispensable in running a simple household and seeing to it that the children are clean and keep in line. But when Karin cowers in a corner as the shades of night are falling and all I can see of her is her round, dreamy eyes

Erland Draws his Bow Pen and ink wash-drawing, 1894, from Viktor Rydberg's *Singoalla*, Art Museum, Göteborg

The Tobacco Boy Never-engraved wash-drawing on wood block as illustration for *Norska Folksagor* by Asbjörnsen and Moe, 1877-78, Albert Bonniers Förlag, Stockholm

The Guardian Angel Etching, 4th stage, 1898, *Förening for Grafisk Konst Årsblad (Annual of the Graphic Arts Union)*, 1898

Esbjörn and Grandpa Watercolor, frontispiece to *Larssons*, 1902

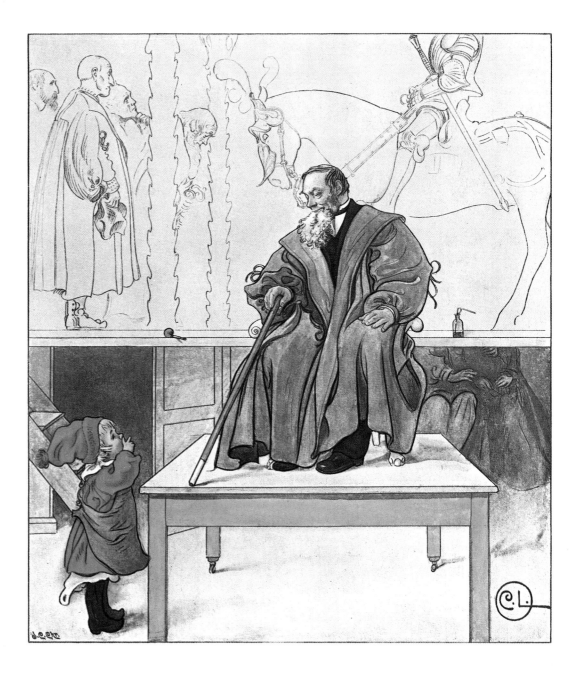

peering out at me from the deep shadows, so full of unswerving affection and abiding love, that's when I fall at her feet, bury my ugly bald head in her lap and feel myself drift away with her, soft and silent, to realms of pure air, to fields where peace alone reigns, where the green shimmers brightly and the air is warmed and lit not by the sun but by the radiant smile of God the Father.'' (Ett Hem 1899)

"It is axiomatic that an artist's studio is supposed to face north, so the sunlight can't get in—and cause trouble. When I one day built a shapeless box like that, I did the same thing, stupid fool that I am. But it wasn't long before I chopped out a big, wide window on the sunny side and the dankness and the melancholy faded and my pictures got more cheerful right away. It is very much the thing nowadays, and very refined, to go around with a morose expression. They call it being 'profound.' I tried that, too, but I only turned out sickly and grumpy and dumb and one fine day Karin took a look and said, 'Heavens, the way you look! Go on out and take a good long walk!' (Åt Solsidan 1910)

"I didn't really know where to put this drawing, dear Reader, but if you don't mind I'll stick it in here. It will serve to introduce my wife and the way she cuts my hair, out by the dump, sort of late in the fall when we are thinking of going back to Stockholm and the way I look, nobody would ride in the same train with me.'' (Ett Hem 1899)

"Karin is 42 now but when she's 60 my love will be a burden to her and then there'll be jealousy, too." (Larssons 1902)

THE RANK VALUE AND FUNCTION OF THE ILLUSTRATIONS

As we have seen, there are on record many whimsical remarks from Carl Larsson about the value of his work. Once he emphasizes the fact that he is sure, "someday when I'm dead and gone they'll consider my little scraps of paper real art treasures," but that even so he is not satisfied with them and wishes he had walls as big as cow pastures for his murals. But at the same time he has

IL TRIONFO DI CESARE
)EL BALLO AMOR (ROMA) AL TEATRO ALLA SCALA.

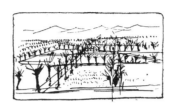

"A snap-shot from Lombardy. It never rains here . . The soil is watered with the aid of countless ditches and canals.

Milan is known for the prettiest women, the largest theater (La Scala) and the handsomest glass-roofed shopping-mall in the world.

I'm not mentioning the Duomo. You have heard a lot about that already. In that cathedral I did sketch a marble statue, though, representing St. Bartholomew (He is of interest to us Swedes.), who was flayed alive and nicely draped in his own skin. On the pediment the sculptor modestly scratched in the words 'non me Praxiteles sed Marcus finxit Agratur' (Not Praxiteles but M. Agratus sculpted me)

Venice. A friend wrote me many years ago, . . . there's nothing in the world you'd like as much as Venice. Tiepolo and Veronese! The blonde (and even black-eyed if you please!) girl in the gondola and the gentle waves of the Grand Canal – or in one of the other small, dark canals where you don't speak – you whisper . . . well, get here as fast as you can! Until now that has been impossible. Now here I am in this marvelous city!

The view from my window (Hotel Bellevue).

A bit of St. Mark's Square and the cathedral, St. George on the column and the Grand Canal.

From Stockholm to Messina Drawing and text, from *Svea,* 1887

stated that he really regarded his frescos, the monumental murals that he had so longed to do, as merely illustration assignments. When again, toward the end of his life, he emphasizes the fact that he had been in financial difficulties all his life, he is indirectly pointing to the monetary value of his countless commissions for illustration work; beside them the "little scraps of paper" assume no insignificant place—especially if we include the books he put out on his own, such as *Ett Hem.* Such remarks coming from Larsson must in all probability be thought of very much relative to the connection in which they were uttered or written down, just like his political views that kept changing all the time. As the two different editions of his book *De Mina (My Loved Ones),* 1895 and 1919, and the text passages in his other books show, he is not at all times one and the same individual. So these remarks can't be regarded as factual evidence on which to judge the question we are considering, namely, whether Carl felt himself put down by Karin. We must not forget that everybody has his ups and downs as he goes through life and that the situation between marriage partners is no exception.

Let us therefore pursue further our hypothesis that Carl and Karin often succeeded in re-living the mutual creative binge from Grèz.

HUNGER FOR PICTURES

No one would deny that the most important factor in any picture is the visual concept. As an illustrator, which Carl Larsson was by virtue of his artistic evolution, he always saw his theme in certain bold outlines. No matter what he made of this material or what "vital impulse" he drew from it, he had to present it in a form comprehensible to a mass-public and such that its connection with the accompanying text remained clear.

Karin certainly shared in Carl's commissions and creations with all of her soul as an artist, a wife and a mother. Carl Larsson was, like many artists, a perfectionist, restlessly productive and therefore constantly on the lookout for new, worthwhile motifs. Karin also gathered motifs for Carl, as is clear from a letter to him when he was away on a trip. In this letter from the year 1889 she describes a scene at home with Suzanne that Carl "simply must" paint as soon as he gets home. (The picture was never painted.) And when once a motif had been fashioned to Carl's and/or Karin's satisfaction it then often happened that Carl repeated it in various techniques or picked it up again after a few years in slightly altered form. In a watercolor from 1912 Carl painted his wife looking reflectively and perhaps critically at a stack of drawings.

Whenever a commission had been offered to Carl Larsson, he and Karin most certainly read the text to be illustrated and discussed it together, and together

DON'T YOU DARE—
or
Respect above all

My picture! NO! The paint's still wet!
Naughty Lisbeth! NO! Not yet!

Lisbeth tries to let it be,
turns and looks away, you see.

LISBETH!! Stop it! Don't you dare!
You do, and Papa'll pull your hair!

Lisbeth tries to go away
but wants to touch it, come what may.

Lisbeth, seething with desire,
her tiny finger all afire...

Lisbeth! No, no! Do you hear?
If you do I'll box your ear.

(I simply can't control myself!)
See there? She's done it! (Little elf!)

Well, you see from all of this
that Lisbeth is a spunky Miss!

Don't You Dare...! Drawings and text, from *De Mina*, 1895-1919

 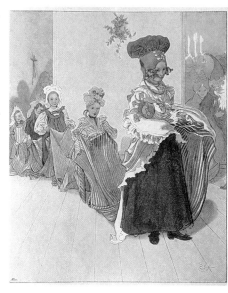

ILLUSTRERAD AF ANDRA BOKEN

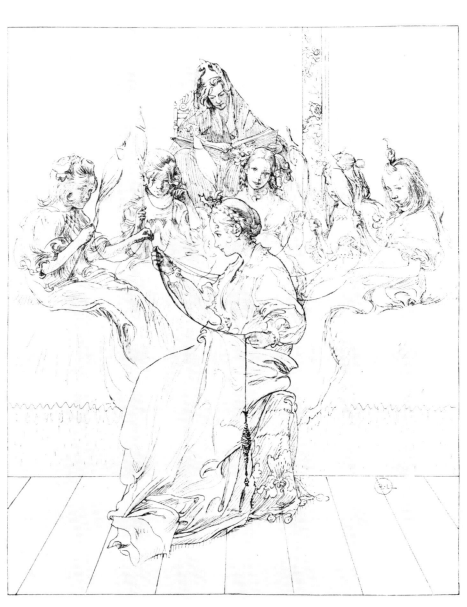

Frontispiece and illustration of other artists to Z. Topelius' *Läsning för Barn*, 1902-3

Sleeping Beauty Illustration for Topelius' *Läsning för Barn*, 1902-3

Processional (Sleeping Beauty) Illustration for Topelius' *Läsning för Barn*, 1902-3

"discovered" the scenes that were to be selected. It came easy, of course, for a reporter-artist to draw scenes from live models. It was the most natural thing in the world, therefore, for him to get his whole family, grandparents, parents, children, even grandchildren in later years, to sit for scenes he had to illustrate. In order to be able to make better selection of suitable scenes he drew capital from the children at play, or even got them and neighbors' children to act out fairy tales or dramatic bits. Karin probably had not only to "dress up" the children for this but no doubt often played the part of

Living Pictures (Sleeping Beauty) Illustration for Topelius' *Läsning för Barn*, 1902-3

The Enchanted Princess Watercolor, 1896, Privately owned

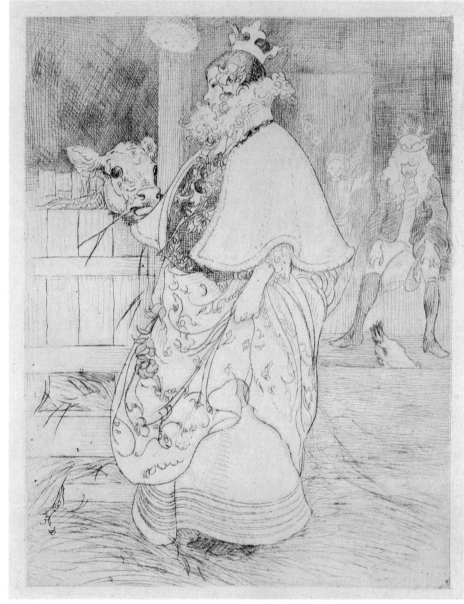

stage director. Sometimes costumes could be borrowed from theaters but many times Karin herself first had to sketch and tailor the costumes from some prototype or other. In tune with the spirit of the times, the illustrations had to be historically authentic by virtue of the props and in addition they had sometimes to be further developed with a good bit of thought to varied, symbolic picture content. For this reason the Larssons used to pick up whatever they could on their travels, when visiting friends, from second-hand dealers and antique shops and when in bigger cities such as Göteborg. The Larssons had also gradually assembled a library that was huge for those days in order to have on hand an additional stock of stage props. Among these props in a wider sense we must not forget furniture of various vintages that the Larssons had also been gradually collecting in their house, likewise the many knicknacks of some-

Lisbeth in the Barn Etching, 1909, second stage. Art Museum, Göteborg

Bluebird Illustration from Topelius' *Läsning för Barn*, 1902-3 *(see page 115)*

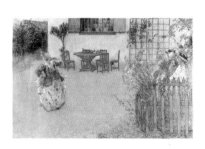

School in Grandma's Day Illustration for Topelius' *Läsning för Barn*, 1902-3

Girl, Boy and Study of a Head Illustration for Topelius' *Läsning för Barn*, 1902-03

Girls' School in Grandma's Day Illustration for Topelius' *Läsning för Barn*, 1902-3

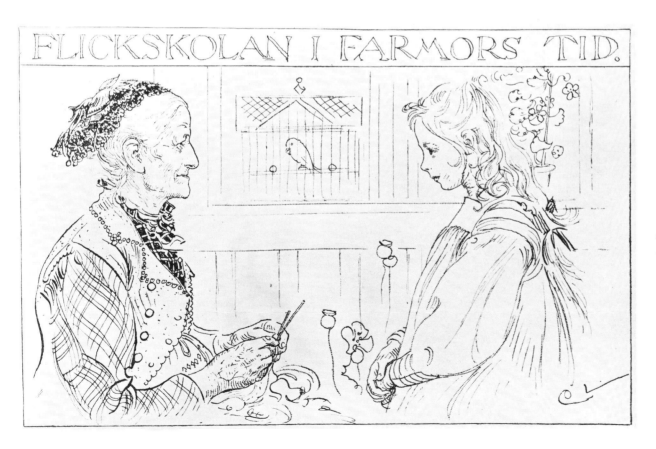

times exotic provenance or the art works and reproductions of the works of other artists. These objects peopled the Larssons' home more and more as time went on but seldom did they stay long in any one place, depending on when they were needed as "atmosphere" for some current commission. It is quite evident from letters that both Carl and Karin were avid and accomplished devotees of the art of collection.

"This bit of text is being written in Copenhagen. On the very day before Easter I got the idea that I had to come down here to sketch an ice-age buckle at the Nordic Museum of Antiquities, and so I abandoned wife and children in the midst of their vacation (a man's profession takes precedence, you see, even over the most precious people on earth) and was here on Easter morning itself, like a letter." (Åt Solsidan 1910)

Grandma and Little Girl (Girls' School in Grandma's Day) Illustration for Topelius' *Läsning för Barn*, 1902-3

MAMA: For shame, Lisbeth!
Smile instead and
I'll give you something nice...

— SER PAPPA LISBETH SKRATTAR BARA

Lisbeth upptacker att hon
"har en knapp på bara
magen"

Lisbeth Discovering that She has a Button on Her Bare
Tummy! Drawing, 1893, from *Lisbeth at 7 p.m.*, in
De Mina, 1895/1919

Two drawings from *Lisbeth och Pullorna (Lisbeth and*
the Chickens) in *De Mina*, 1895

Karin and Lisbeth Drawing from *Lisbeth at 7 p.m.*, in
De Mina, 1895/1919

"O.K.!"

The Poachers Drawing with watercolors, from Topelius' *Läsning för Barn*, 1902-3

To a Little Boy Illustration for Topelius' *Läsning för Barn*, 1902-3

To a Little Girl Illustration for Topelius' *Läsning för Barn*, 1902-3

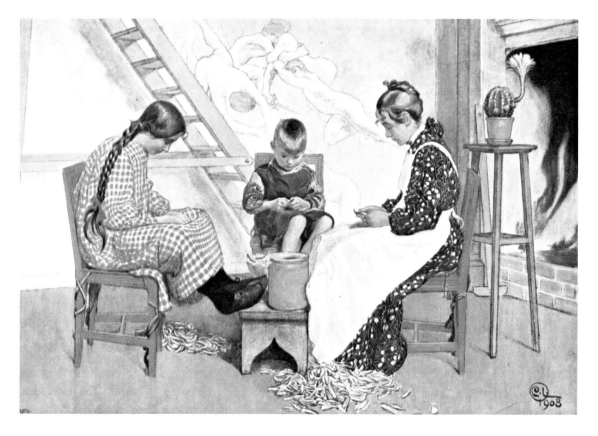

"*The reading room! A sanctuary!... all this and more is to be found on the walls of this little hide-away, this little cabinet; everything—I can almost say—that the human mind has brought forth... I let Fredman babble and Nietzsche rave till my hair stands on end. This room is the only place where I can sometimes shut myself in, stretch out on a sofa and yawn all I want and think of poor Oblomov.*" (*Åt Solsidan* 1910)

"*A stay-at-home, that's what I am. Of course I do love going out into God's great Out-of-doors, it's true, but once I get out on the highways and by-ways it's just as though there was a tether fastened around one foot with somebody pulling and hauling on it; and when, as right now, I'm sitting wedged in between the furniture and walls of my little reading room I yawn a noisy, com-*

Shelling Peas Watercolor, 1908, from *Åt Solsidan*, 1910

Venus and Thumbelina Working drawing in oil for a Gobelin tapestry ordered by "Handarbetets Vänner" (Handcraft Society), 1904, actually woven 1908 or 1909.

fortable yawn and say to myself, "Nice to roam, but nicer home." When I am too stupid to come up with an idea for a big, challenging painting or too lazy and stale to carry out an idea once I've found it, I set myself down in a corner here, a corner there, and sketch wife and youngsters and walls on little scraps of paper. Most often it's a flower that first weaves its spell over me and then there's no peace until I've painted it; sometimes one of the children comes in and in a flash I'm doing a candid shot on the spur of the moment—and there's my picture. After a period of a certain amount of exertion in the course of some of the larger mural jobs I've fallen into unusually long fits of laziness like that—and that's not my normal way, because I feel it in every limb and I'm whiny and have no appetite—and then suddenly I've banged my fist on the table and yelled loud enough to scare the daylights out of the whole family: "Now I'm going to paint, dammit... Now for a new Ett Hem series! And I did it, too! That's the kind of man I am!—and here it is!" (Åt Solsidan 1910)

"Spadarvet, that's my farm,... On that land a whole little Nordic Museum and laboratory have taken shape." (Åt Solsidan 1910)

Barbro Watercolor, 1903, from *Andras Barn*, 1913

FAMILY LIFE AS A PLAY

Depending on how many commissions were coming in, the Larssons were on the lookout for motifs, and what Carl Larsson saw he converted—of course, often to a certain extent teamed up with Karin—to the concept for a picture which he seized upon. After it had turned out that Larsson's at first very private and casual watercolors of his family, individual children, or areas in the home at Sundborn that they had created together had struck a responsive chord—first at the Nationalmuseum and then amongst attenders at the Exhibition of Industry and Handicrafts in 1897 and then at Bonniers' publishing house—the interplay between independent and commissioned paintings became an even closer one. And depending on Larsson's productivity he probably lived more or less steadily in pursuit of his task. That is to say, however, that he first had to try to experience some alleged material that he was to illustrate so that he could create it anew as pictures. We purposely show two illustrations by other artists for the sake of comparison, in order to demonstrate the vitality of Larsson's work. Perhaps therefore one might say that Larsson in a certain sense had to involve himself with the materials assigned to him to such an extent that third parties would regard this a theatrical only. Whenever Karin, who had of course herself been an artist and in her soul at least still was, was able to go along with him in this, this also seemed drama. Even for this—as for almost everything, and maybe also in opposite cases—there is an original Larsson quotation that can be cited. In *Åt Solsidan* he concludes that book with a text and a picture with the theme *"Dressing Up";* his text for this runs, *"At our house we are always dressing up and improvising carnivals… Now I will conclude the reading matter in this book, which in word and picture seeks to depict a little bit of the mummery of life as it looks to…yours truly… C.L."* This book did not appear, by the way, until 1910, two years later than the chapter in *The Blue Book* where Strindberg had accused the Larssons of deceitfulness.

Carl Larsson's Book-Plates

Flower Vignette From *Åt Solsidan*, 1910

Two Initials From *Larssons*, 1902 and *Andras Barn*, 1913

A Little Dachshund Puppy Vignette from *Andras Barn*, 1913

Four Floral Vignettes From *Larssons, Läsning för Barn* Topelius), *Andras Barn* and *Sanger och Visor* (Sehlsted)

Strindberg had dug up his materials himself; Larsson was dependent on his customers, at least for his illustration commissions. This had not always been easy for Larsson, and there is a quotation on that, too, where he complains how enervating it was to paint the pictures for *Andras Barn (Other People's Children)*. Whereas Strindberg was able to take a stand against the current trends, Larsson had perforce to produce what society demanded of him regarding this theme. The manner in which he did that, however, was as a rule imbued with an extraordinary love for every living creature, even plants, it was just this love however that must have been suspect to Strindberg, who was bitterly disappointed in both himself and the world. Even Larsson realized that this love can not, as a matter of course, be poured out ceaselessly and without end. But to attack it is as intellectually dishonest and to not even make allowances for its being depicted as an ideal goal in pictures aimed at a naive public as the Larsson pictures were—they had in fact been created by an illustrator for a fancied mass-public—seems to me to be just as naive in reverse. The very comparison of Larsson's illustrations with those of other artists in the same publications (e.g., *Läsning för Barn (Reading for Children)* or *Idun,* the magazine for women and the home, proves, to my mind, that Carl Larsson also ran the risk of producing trash and that he almost always succeeded in transcending trash through

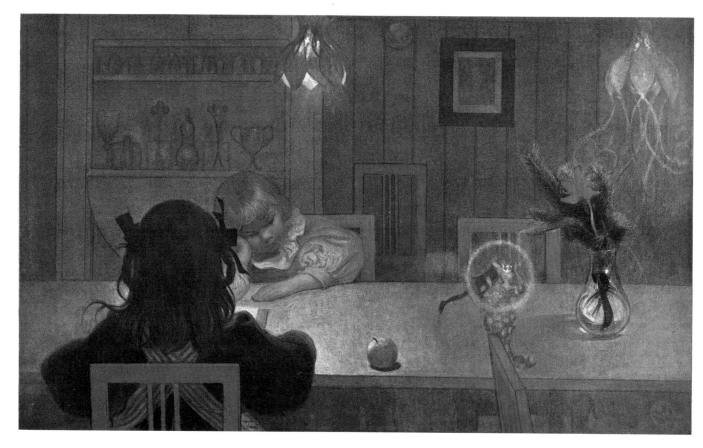

Fairy Tales Watercolor, 1905, Illustration for *De Mina*, 1919

the fresh self-experienced human touch that radiates from his pictures. At this juncture may I add a codicil and say that Larsson, where he wants to depict the fashionable ''exalted'' mode, sometimes disappoints even me. We may, by the way, make the same observation about his writings: where he is telling about everyday life and again where he himself writes fairy tales and depicts simple, though painful experiences, he is a pleasure to read, even today.

If we now summarize this commentary we can not help formulating the basic singleness of our fascination with the picture world of Carl Larsson. In his own books and the pictures that we feel as being ''typically Larsson'' the Larsson family life seems to us as the comprehensive work of art known as the ''Family.'' With a little exaggeration one might say that Larsson represents himself in these pictures as though he had converted the positivistic philosophy of life into actual fact, made it a reality, proved it. If Strindberg had thought that this had been what Larsson had set out to do, then I would have to agree with him: but that is impossible, that would be a lie. Larsson did not intend that.

We come closest to what really happened among the Larssons by granting that we do not know everything about them. M. von Heland is certainly right that the Larssons showed us only what they wanted to show of their life. But no one is a liar just because he tells only what he would like to. It is however undeniable that the Larssons have told more than others have. Hardly anything has been omitted about the lives of the children; the life of the adults, Carl and Karin, was, during the ''report-period'' hardly characterized by misery, and Carl has described at least part of his inner misery and sorrows. From his pictures we learn everything, from his anxiety about pensiveness to reflection, smiling and laughing. To paraphrase a bit a catch phrase used by Larsson himself (see above) we can sum up the advice of the illustrator perplexed about pictures in a new garb: family life as a play; a play of love, as Larsson defined it; this play asks, like other plays, to be sampled. Like other plays, this play comes to an end, but may be repeated. And this play makes no claim to totality, to encompass the quintessence of human life; this play even demands now and then from certain players that they ''only'' act outwardly, even when feeling quite differently at a given moment. ''Family life as

a play'' would be today too, especially, a fascinating challenge. And this formula might perhaps be a missing link between the skeptical questioning of a Strindberg and the pictures by the illustrator, Carl Larsson.

''*But the most charming scenes are enacted in the children's bedroom. Karin's comparison of it to a theater was no idle thought. It is much, much more fun that going to the theater!*'' (Ett Hem 1899)

''*There was something there that she (Kersti) wanted. Whether it was the moon or a lump of sugar I can't recall, only that Karin banished the little darling into the kitchen until she was good again. Brita, who thought this punishment was cruel, howled. And Lisbeth came in letting out wails that seemed as if they would never end. As for Suzanne, who is also only human, great tears dripped down on to her apron. Ulf was now sobbing in earnest without rhyme or reason and Pontus, who is incapable of shedding real tears, was making faces—in a most unpleasant way. In the midst of all this tragedy Lisbeth went out into the kitchen, returned with Kersti by the hand, and led her, with firm tread and staring squarely and resolutely at us, to her seat at the table. It was supper-time, you see. Nobody*

MASK·ROSORNA·

SAGA.

The Dandelions, A Fairy Tale Text and drawings by
Carl Larsson, from *Svea*, 1892

dared to bring the subject up again—because Lisbeth is a character. Barely five minutes later the whole family was beaming with happiness, peace and understanding. Kersti asked whether Papa wanted to hear a pretty song she had composed as usual: 'And the cuckoo calls on the meadow so blue!' Then I kissed Karin in front of all the kids, think what you will.'' (Ett Hem 1899)

''That is supposed to be Esbjörn! He keeps walking around with his slate and begging to have something drawn for him. 'Cow!' he demands; he himself drew a dicky-bird a while ago and Lisbeth said 'very good, with a tail,' and he drew a house with a tail. That boy really has character. Now he's on the title-page and the man who is sitting on the table is my father who is posing as the mayor for my working drawing for Gustaf Vasa's Entry. Grandpa and Esbjörn are two souls that I have discovered. The old one is stone deaf and the young one chatters incredibly much for his age, but both get along very well. Both have what is called 'temperament' and they are both named Larsson and now are showing you what that looks like.'' (Larssons 1902)

''Once upon a time—oh, it was terribly long ago— a very poor little boy was playing 'funeral' with a dead rat. He had made it such a pretty little coffin and painted it green. He patted the little dead rat and said, solemnly: 'From earth hast thou come...' and so on, as he had heard the parson say. He had, you see, witnessed the burials of two soldiers of the Guard, therefore he knew how it had to be done. There he had also seen that crosses and a few flowers were on all the graves. He, too, placed a cross on the rat's grave; and because he was so fond of the little dead rat it had to have flowers, too. The boy was one of those who liked pretty things and the prettiest things round about were some dandelions that were growing in the big yard, up in the passageway by the woodshed. He had reveled at the sight of them, regarded them as his own flowers, because they had taken root by his mother and father's woodshed; and he had been so afraid the other children might make wreaths out of them as he had with anguish seen happen to the pretty dandelions that recently had glowed in lovely, golden, spring-time splendor close by the gutter of the lane. But the rat had to have things really lovely. And so he picked his own dandelions and put them on the little grave mound. They wilted right away. And the boy, who liked beauty, didn't like it any more in the yard; that was now so ugly, so he stayed indoors and painted officers and pears. They came next after dandelions in beauty. When he had filled the empty

margins of the office books he began to long to see his dead rat and dug up the little green coffin. But when he opened it it was full of little creeping worms—and the rat was gone! That was the most curious thing that had ever happened to him. But then he remembered the dandelions. Yes, that was it! But where was the rat, resurrected? Yes, certainly! Then he knew right away that the soldiers of the Guard had also been resurrected and that their coffins were full of roses, because a small bunch of roses had been placed on their graves. He recollected that very distinctly.

The boy became a man, something that does happen sometimes. Now if he, still a worshipper of beauty, saw dandelions glowing in the sunshine with clean, fresh light in big meadows and at the edges of graves, he thought of his dismal childhood and loved the flowers and nodded to them, because they were, of course, the prettiest thing in the passageway in the dirty, smelly yard.

But he never picked them, because he knew that they were full of worms, little crawly worms.

He wondered: What do you suppose was inside all the beauty that I have found and will go on finding? And he didn't dare dig deeper in order to find out. Because if he found worms there he would die and be laid in a drab coffin—and maybe not arise again the way the rat and the soldiers of the Guard had.

SWEDEN

Larsson's enthusiasm for Sweden was boundless. With his understanding of the duty of the artist he wanted to reform the taste of this contemporaries by pointing to the peasant culture. The next pictures show only a portion of this though he pursued this "reform" goal with most of all his pictures, especially those from his home in Sundborn. But we have here collected those pictures in which is expressed his joy in the Swedish landscape, Swedish festivities, Swedish handicraft and Swedish dress. The same joy, whose enthusiasm sometimes was able to take on the tone of a school-master, speaks to us also from numerous passages in his books:

"Our farmers and their wives, who were busy all winter with carpentry and spinning, let nothing leave their hands without giving it an artistic or personal touch. The embroidered cloth lay on the sturdy, scoured, home-made table and smelled of cleanliness; the attractively fashioned beds fastened to the walls with pretty, hand-woven curtains, the massive chairs and benches with cut-out stars in their backs, furniture and implements dating from their forefathers with dates on them as though they wanted to admonish the family members to be just as sturdy as their forebearers. All these cheery peasant patterns that you find everywhere are to me in most cases more significant works of art than are most oil paintings. And the scrupulously fabricated cottage with its facade, its floor, its veranda and its leaded-glass windows! And their garb! Just picture what the Swedish people looked like in days of old, bursting with color and health, as they stood radiantly outside church in the Sunday sunshine." (Ett Hem 1899)

"It is the Sweden peasant-painters from the end of the last century whose footsteps I follow, and I admit it freely. Think for example for the ancient painting you come upon here in Dalecarlia or in Norrland. Such deep, solemn feeling, coupled with such bold, healthy humor. And what a national feeling for style! To me they are a far more precious treasure than the mines in Gällivare could ever be for anybody." (Ett Hem 1899)

"And then here we have real Christmas spirit, with the two old folks and all the children and the neat maids and good old Johan... The cord-wood snaps and crackles in the fireplace and in the middle of the room stands the prettiest of Christmas trees, that we fetched in from woods this morning. What wonderful Christmasses we have up here in the north. (Ett Hem 1899)

"It happened to be the one time they spent the night in the store-house that Emma's name-day was celebrated by the children by dressing up, coffee in bed and a birthday poem recited by Suzanne, disguised in my dress suit. And Ulf, disguised as a Dala girl, bore in the breakfast tray. You will probably recognize all the rest. Johann is standing on the stairs playing the fiddle while tears course down dear Emma's cheeks. All anniversaries are celebrated at our house the same way.

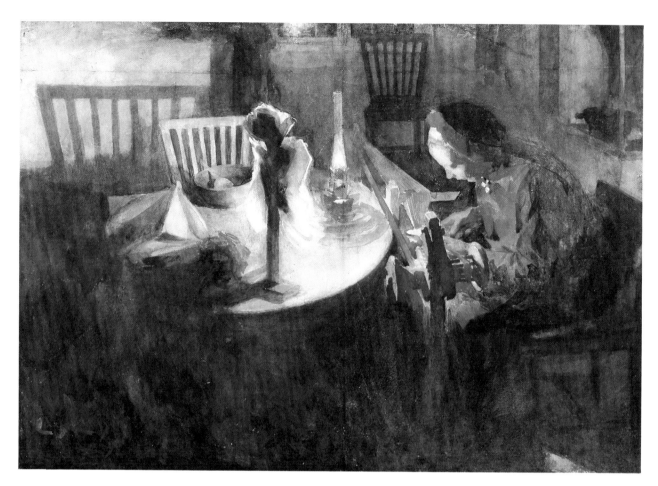

The Ribbon Weaver Watercolor, 1890, H.M. King Carl XVI Gustav, Gripsholm Castle, Mariefred

Early in the morning, five o'clock at the latest, it all starts with gunpowder smoke and little cannons going off. The boys from Bjus and the millers' daughter Svea play guitar and fiddle accompaniment for singing by Ann Sundin who has the prettiest voice in the village." (Ett Hem 1899)

Brita as Idun Lithograph, title sketch for *Idun's Carl Larsson* Christmas issue, 1901

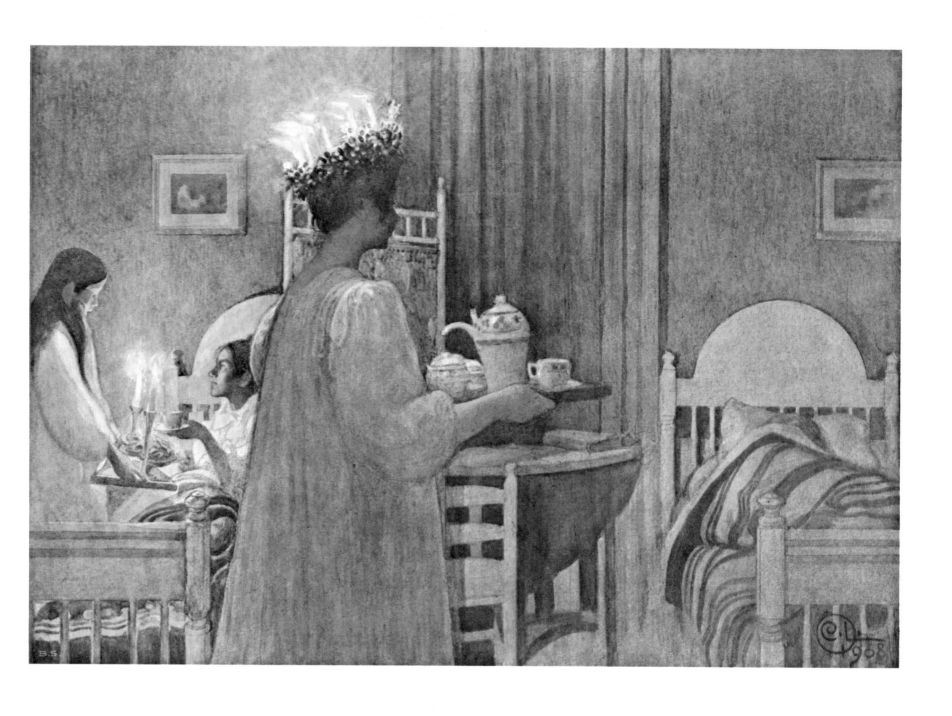

Lucia (At the House in Falun) Watercolor, 1908, *Åt Solsidan,* 1910

Christmas Morning Drawing from *Larssons,* 1902

Christmas Vignette from *Spadarvet,* 1906

The Day Before Christmas Eve Watercolored, pen and ink drawing, 1892, Carl Larsson Farm, Sundborn

Now It's Christmas Again Triptych, oil, 1907, The
Museum, Helsingborg

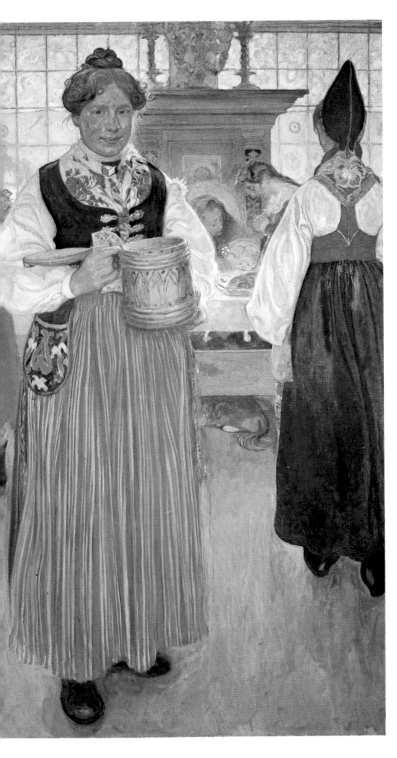

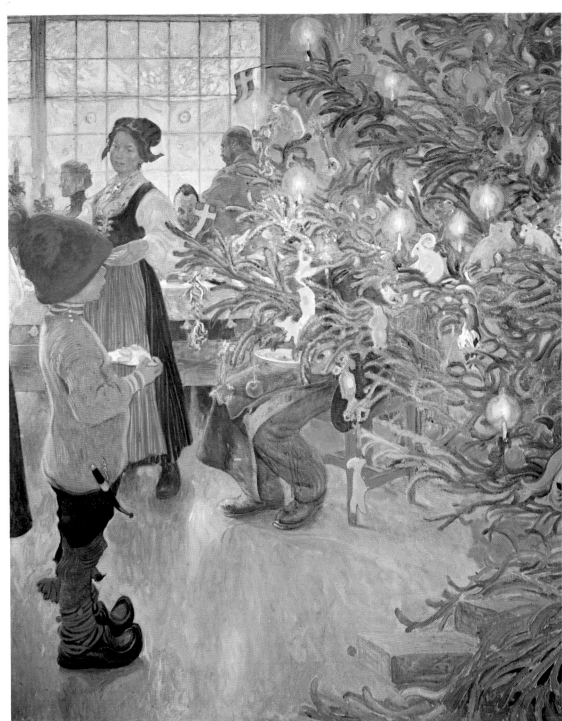

Martina and the Breakfast Tray Etching, tinted, 1904, Art Museum, Göteborg

Christmas Eve Watercolor, about 1904, from
Spadarvet, 1906, Albert Bonniers Förlag, Stockholm

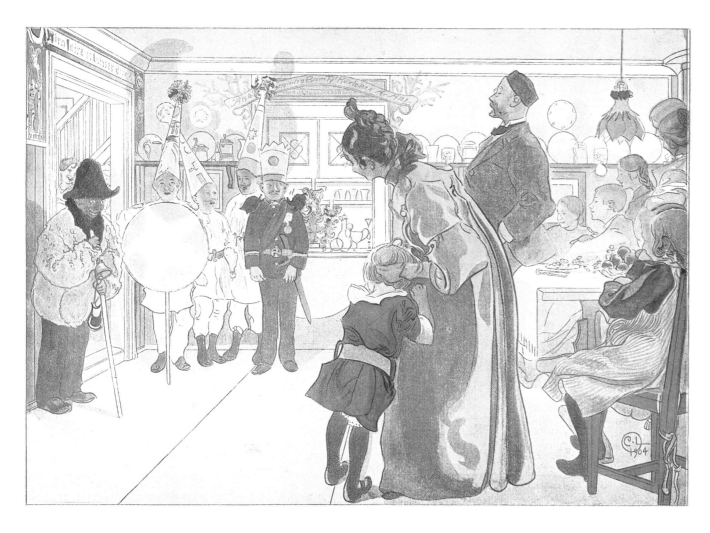

"Star Boys" call at Larssons' Watercolor, 1904, from
De Mina, 1919

A Girl from Rättvik Drawing, vignette from
Spadarvet, 1906

A Rättvik Girl Drawing, vignette from *Andras Barn,*
1913

A Rättivik Girl by Wooden Storehouse Watercolor,
undated, Ahlen's Collection in Dalarnas Museum at
Falun

Carpenter Hellberg's Children Watercolor, 1906, Art
Museum, Göteborg

Anne (In the Ancient Cottage in Falun) Watercolor,
1912, from *Andras Barn*, 1913

Rosalind Watercolor, 1911, from *Andras Barn*, 1913

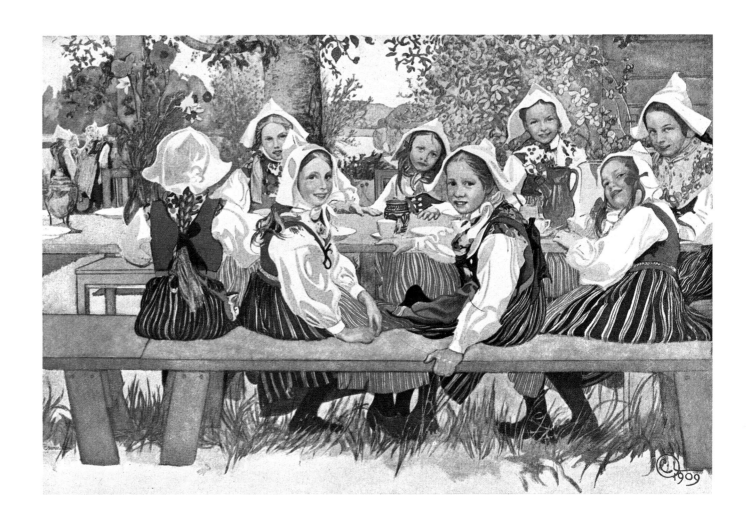

Kersti's Birthday Watercolor, 1909, from *De Mina,* *1919*

Matts Larsson Watercolor, 1912, from *Andras Barn,* *1913*

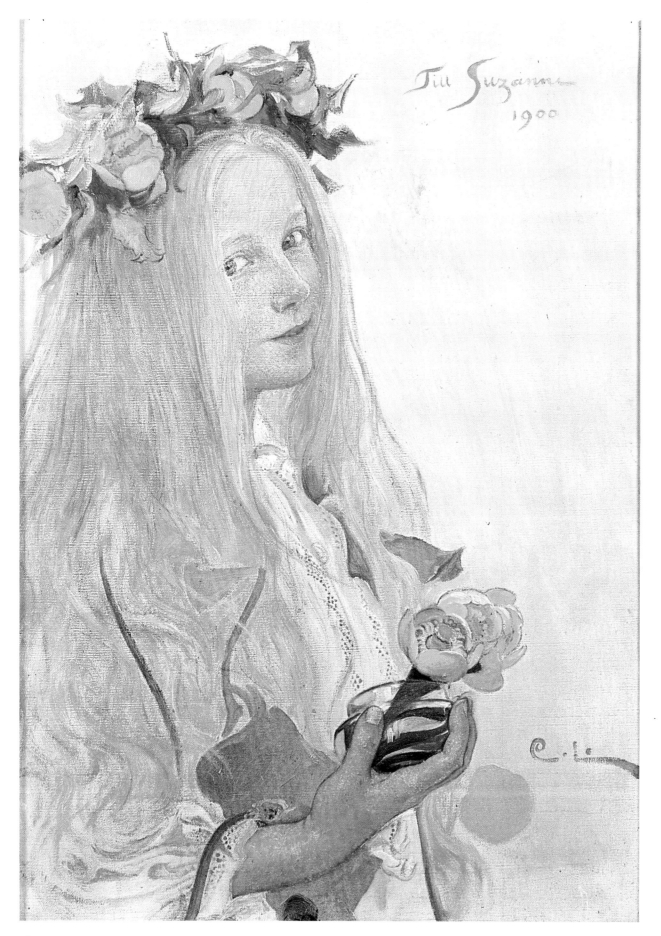

Till Suzanne
1900

Suzanne Study for *Name-Day Morning Serenade*, oil, 1902, Tage Ranström, Eskilstuna

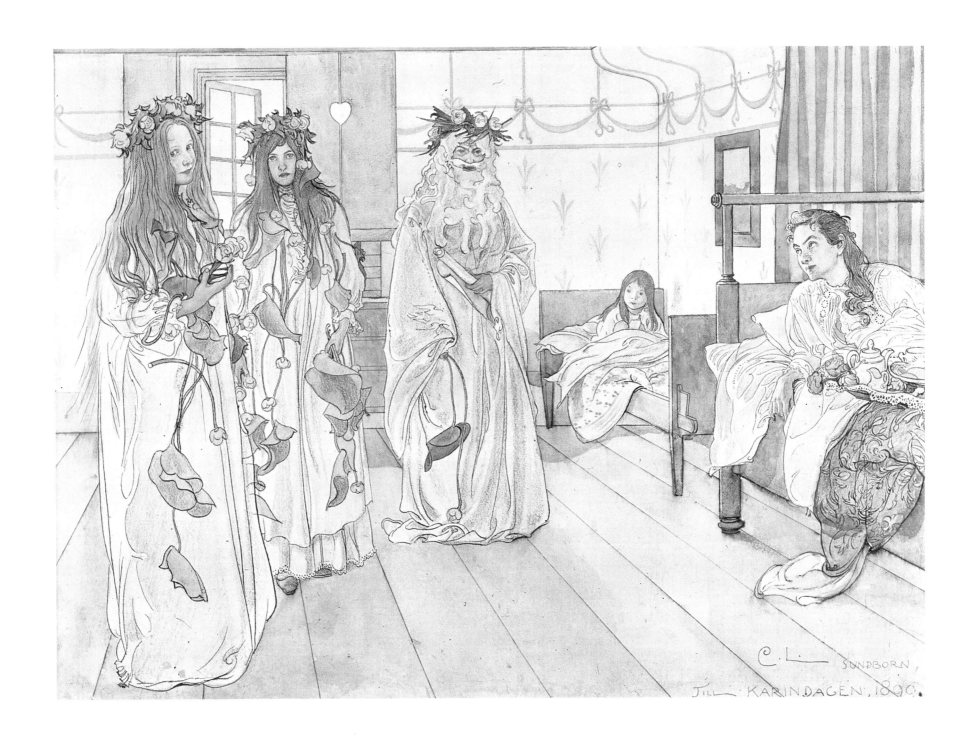

For Karin's Name-Day 1899 Watercolor, The Carl
Larsson Farm, Sundborn

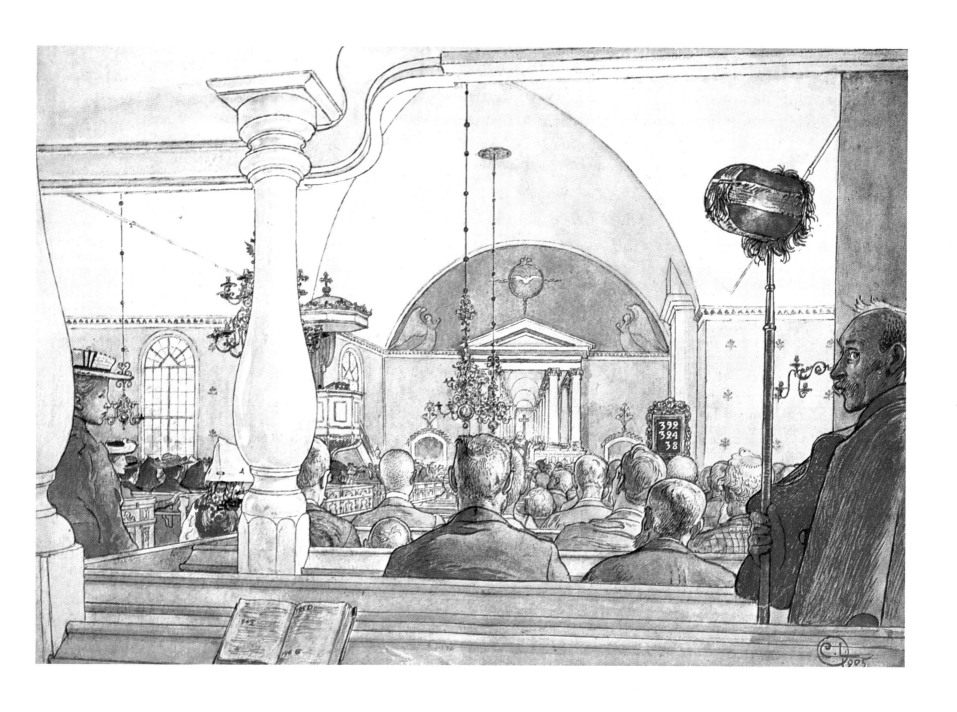

At Church Watercolor, 1905, from *Spadarvet,* 1906,
Albert Bonniers Förlag, Stockholm

The Old Church at Sundborn Watercolor, undated
(about 1894-1897), from the *Ett Hem* series, Na-
tionalmuseum, Stockholm

In the Carpenter Shop Watercolor, undated (about 1904), from *Spadarvet,* 1906, Albert Bonniers Förlag, Stockholm

The Manure Pile Watercolor, undated (about 1904), from *Spadarvet,* 1906, Albert Bonniers Förlag, Stockholm

The Bridge Watercolor, undated (about 1894-97),
from the *Ett Hem* series, Nationalmuseum, Stockholm

A page from *North Woods*, from *Jul (Christmas)*, 1890

North Woods, Lakes Amungen and Draggen, Finnbacka. Heading for the text in *Jul (Christmas)*, 1890

Harvesting Ice Watercolor, undated (about 1904),
from *Spadarvet*, 1906, Albert Bonniers Förlag,
Stockholm

The Falun Yard (Esbjörn on Skis) Watercolor, 1909,
from *Åt Solsidan*, 1910

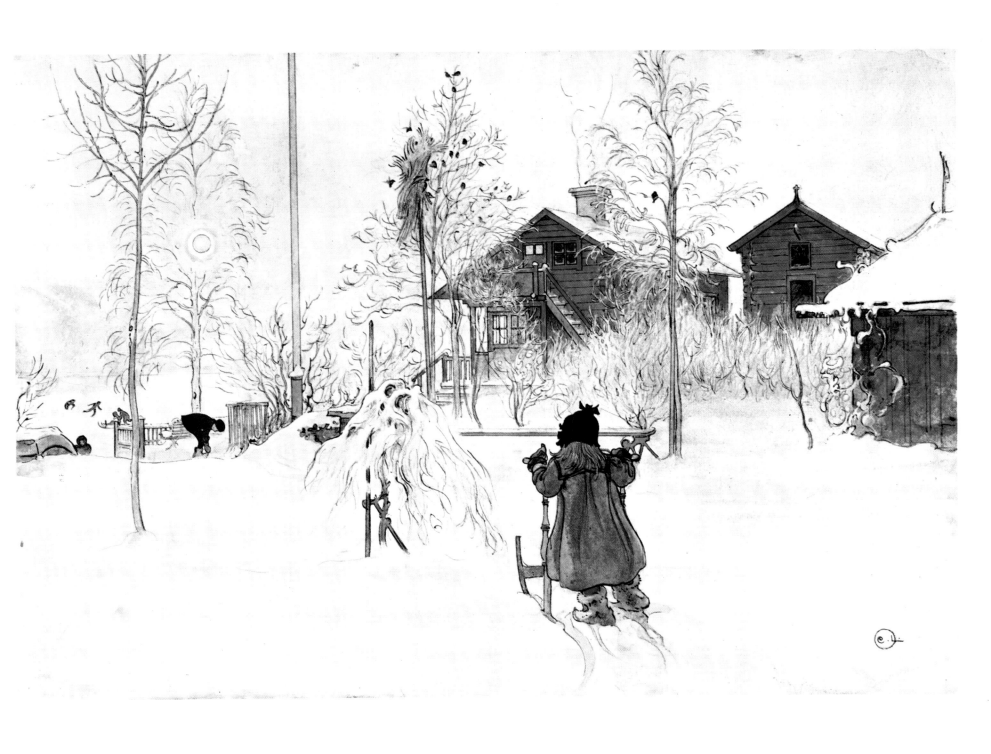

The Front Yard and the Wash House (Brita and Her Sled)
Watercolor, undated (about 1894-97), from *Ett Hem,*
1899, Nationalmuseum, Stockholm

91

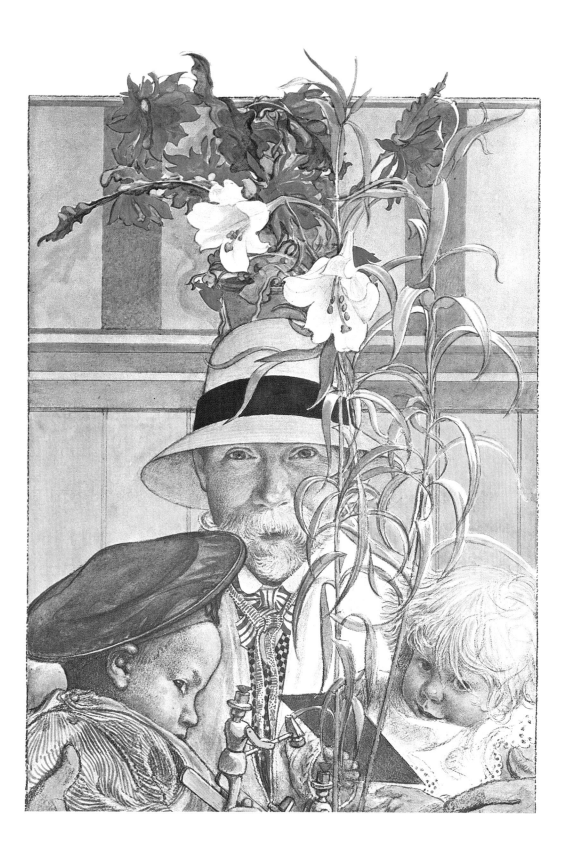

LIFE OUTDOORS

Since the end of the last century not only critics of our culture and do-gooders but also artists and architects have been pumping for outdoor life. If all this sometimes sounded a little like education for supermen or at least a new race of humans, we can nowadays shrug off such ambitions as history. Larsson's being ''discovered'' in the United States in the sixties of our own century was probably thanks to people like the hippies and flower children, and if he now finds another new generation of friends it will certainly include the groups that are concerned about the ecology of our world. All these generations have been enchanted by Larsson's pictures, in which he depicts life outdoors with his lovable story-telling ways. We can be glad these pictures of his are better than all the theories that ensnared them—beginning with him himself.

Our next group of pictures make your mouth water for all sorts of relaxed outdoor activities—winter sports, water sports, coffee on the terrace, reading under a tree, eating in the open, strolling, yes, even a nap in the fresh air.

''Flowers, beloved children of Earth! What fantasy in your form, what radiance in your colors, what fragrance from your chalices, what heavenly purity! Then come little children, because no matter how runny their noses they are the purest things, after you flowers. Flowers and children, I ought never to paint anything else but you. But I do love them best.'' (Åt Solsidan 1910)

''The yard. Any of you who have been following the Larssons through the years will recognize it. When I stick my nose out into the open early in the morning, that's the first thing I see. I like that. The air is clean and cool and the sun shines so shyly through the morning mists. Kicki jumps and barks with joy at seeing me all fresh and spry and begs me to throw a stone, and Pamphilos, our cat, takes a big leap out fo the bushes at me. I fill my morning pipe and light up and smile all to myself and I don't need anything funny to make me do it.'' (Larssons 1902)

''It rains and snows all at the same time and all of nature is like a big damp poultice. But we think that's great. To walk across soft meadows on wobbly tufts of grass and it goes squish under our feet. We follow our noses along the brook and breathe the fresh air that seems as if it's going to wash all the dust out of our lungs. And no gnats or mosquitos; we just enjoy life with nothing to bother us.... I'm trying to let you in on all our family secrets. But it's so damned hard, with my natural shyness and all...'' (Larssons 1902)

Frontispiece for Andras Barn, Watercolor, from *Andras Barn,* 1913.

92

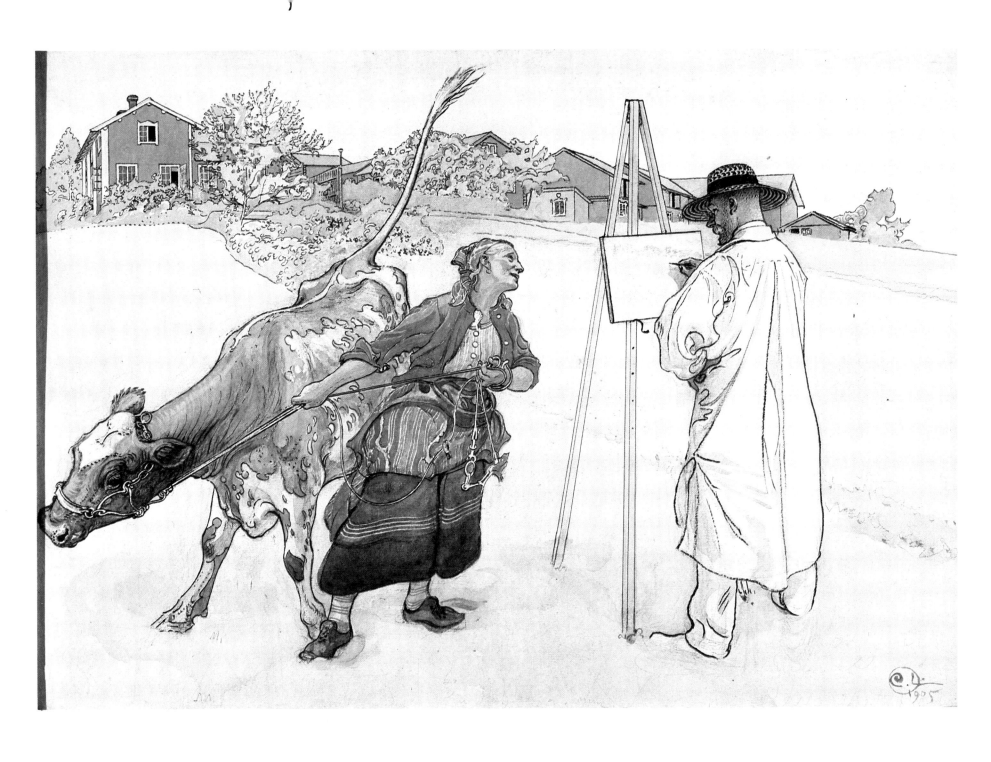

On the Farm (Johanna with Heifer) Watercolor, 1905, from *Spadarvet,* 1906, Bonniers Förlag, Stockholm

Sowing Watercolor, 1905, from *Spadarvet,* 1906, Albert Bonniers Förlag, Stockholm

Flower Bed Charcoal and chalk, 1906, Stig Ranström, Göteborg

Karin by the Manure Bed Charcoal and pencil, undated, Stig Ranstrom, Nationalmuseum, Stockholm

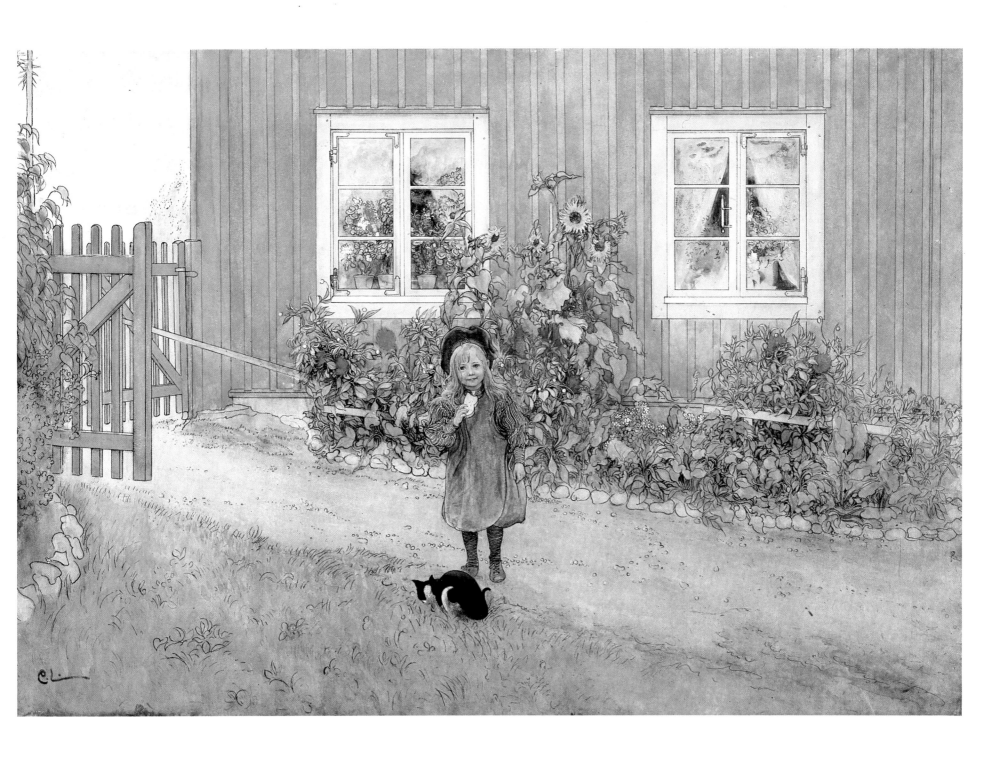

Kersti with Cat in the Flower-Bed. Watercolor, un-
dated (about 1900), Albert Bonniers Förlag, Stockholm

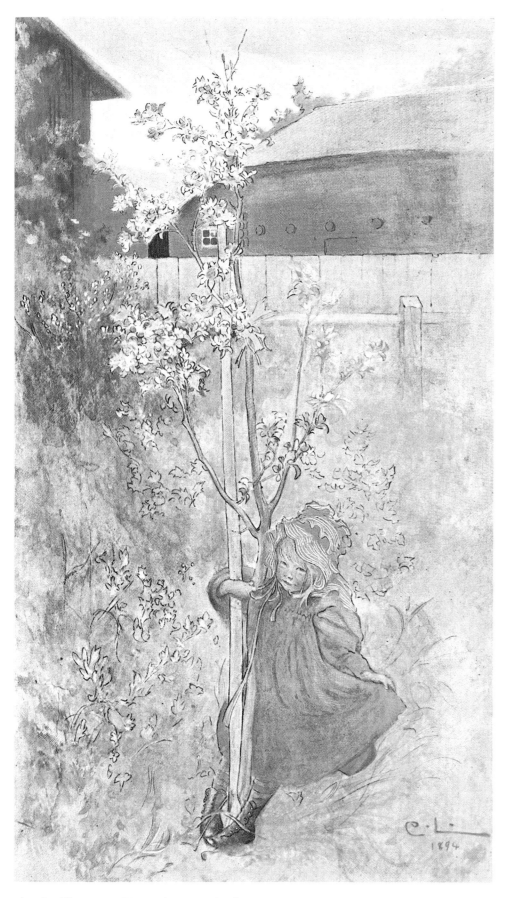

Apple Blossoms Watercolor, 1894, from *Larssons*, 1902

Esbjorn with his Very Own Apple Tree Etching, 1908, Art Museum, Göteborg

"If I were a poet I'd be all right. One thing sure is that I can't put out with my prose any more than you can drink in with your own eyes from the picture (Apple Blossoms). But my very deepest instinct tells me how the metric feet of a poem would dance in time with Lisbeth's little legs, both of us, she and I, going around the little apple tree. And if they spun around very long the whole world would be spinning around us! How could it help it?" (Larssons 1902)

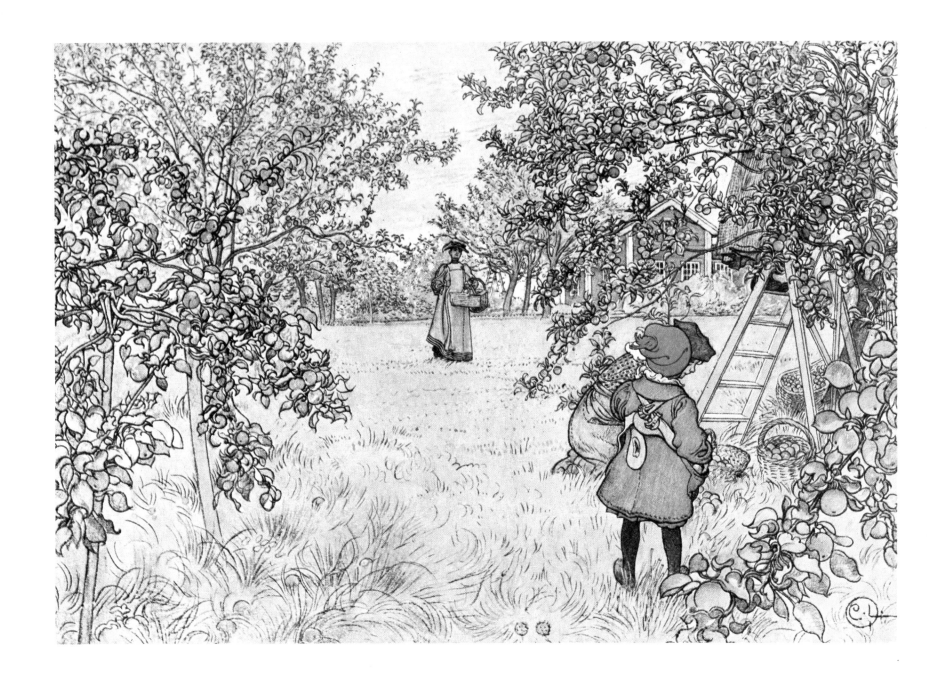

Apple Harvest Watercolor, undated (about 1905),
from *Spadarvet,* 1906, Albert Bonniers Förlag,
Stockholm

Grandfather Oil, 1909, Carl Larsson Farm, Sundborn

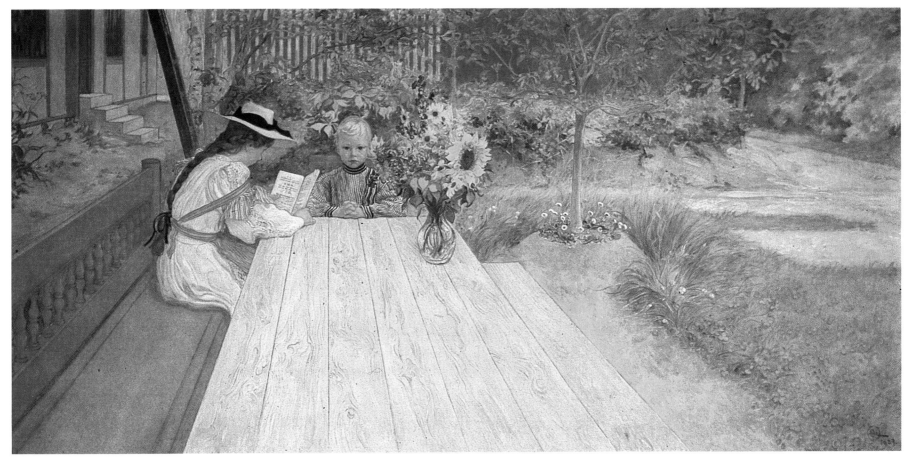

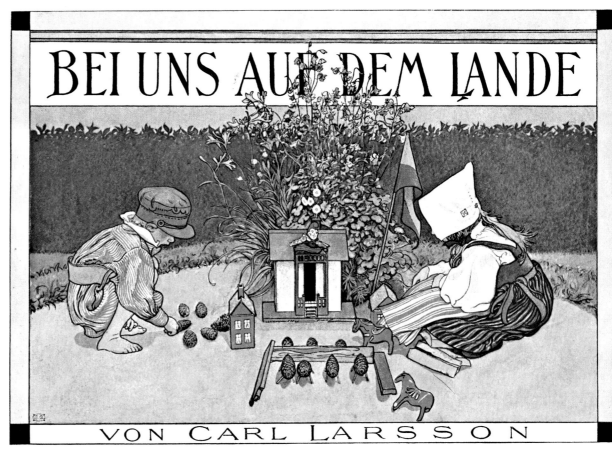

The First Lesson Oil, 1903, DeGeer Community School, Norrköping

"Bei uns auf dem Lande" Frontispiece to the German edition of *Spadarvet,* 1906

"One winter some renovations were going to be made while we were away. They were going to take advantage of our not being there and get rid of the old masonry hearth made of big chunks of stone in order to replace it with this miserable, ridiculous iron box, with ornaments all over it, gruesome, apathetic curly-cues and (—pretty idea! Where did you dig that up, you Bolinder's Ironworks?—) a version of Thorwaldsen's Night! This sheet-iron armorplate instead of the old masonry mantlepiece!—When I first discovered this piece of vandalism I was anything but pleased. In order to rescue the sacred stones of the hearth I built a table and a bench out of them out in the yard between two cherry shrubs, where we usually drink our afternoon coffee in the summer." (Ett Hem 1899)

Our Court-Yard Watercolor, undated (about 1900), from Larrson, 1902

Table and Bench in the Court-Yard Vignette from Ett Hem, 1899

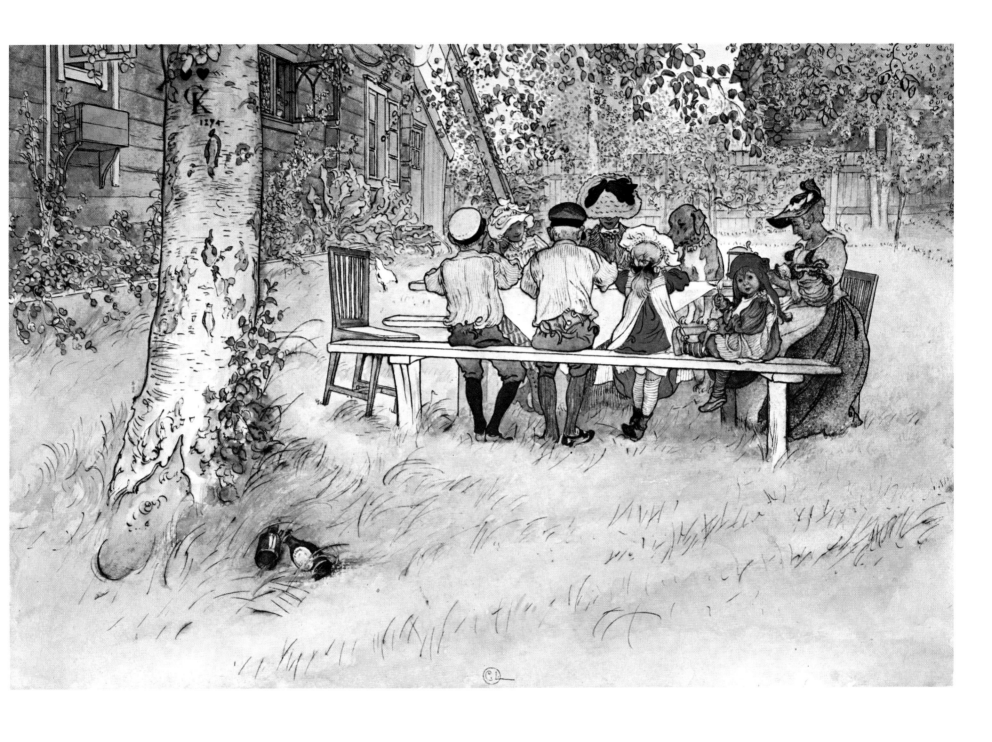

Breakfast under the Big Birch Watercolor, undated (about 1894-97), from *Ett Hem*, 1899, National-museum, Stockholm

"On sunny, clear days we eat under the big birch behind the house. You know, this birch is the prettiest thing of all! If it weren't for this tree the whole place wouldn't mean anything to me. It gives such wonderful shade and there's always just a little breeze right at that spot, so the gnats and moths don't like it there. Out there we all feel more at ease and the bare-footed children drink their rich milk with heavenly eagerness. And the way they chatter and romp..!" (Ett Hem 1899)

In the Hawthorn Hedge Watercolor, undated (about 1900), from *Larssons,* 1902

A Fairy Watercolor, undated (about 1900), from *Larssons,* 1902

Girl Among the Hawthorn Blossoms Watercolor and gouache, undated (about 1898), Art Museum, Göteborg

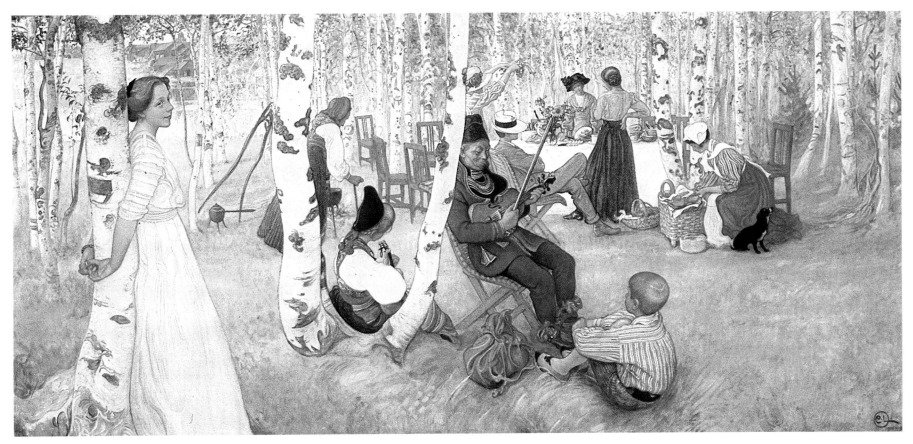

Breakfast in the Open Oil, 1910-13, Norrköping
Museum

Karin and Esbjörn (on a Bench) Etching, 1904, Art
Museum, Göteborg

A Rose and a Back Etching, 1908, Art Museum, Göteborg

Idyll Watercolor, 1901, from *Larssons*, 1902

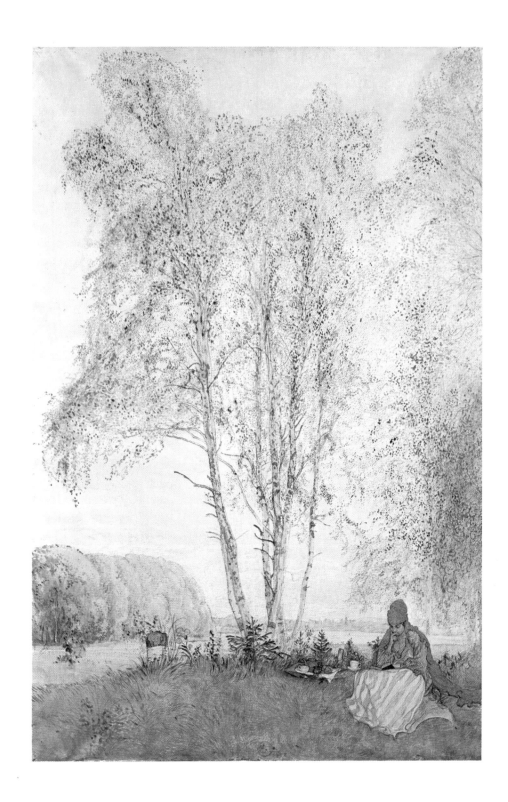

A Nap Outdoors Watercolor, undated (about 1900), from *Larssons,* 1902

Under the Birches Watercolor, 1902, Thielska Galleriet, Stockholm

"When You Sleep on a Bed of Roses" Fairy tale, drawing for Topelius' *Läsning för Barn,* 1902-03

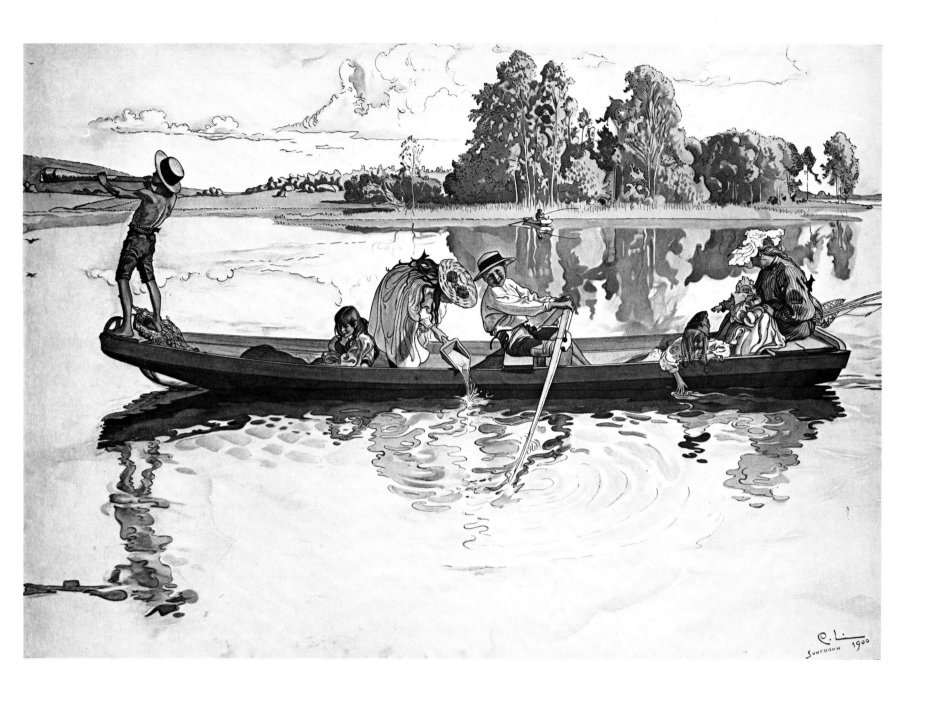

Viking Expedition Watercolor, 1900, Privately owned

Fishing Watercolor, undated (about 1905), from *Spadarvet*, 1906, Albert Bonniers Förlag, Stockholm

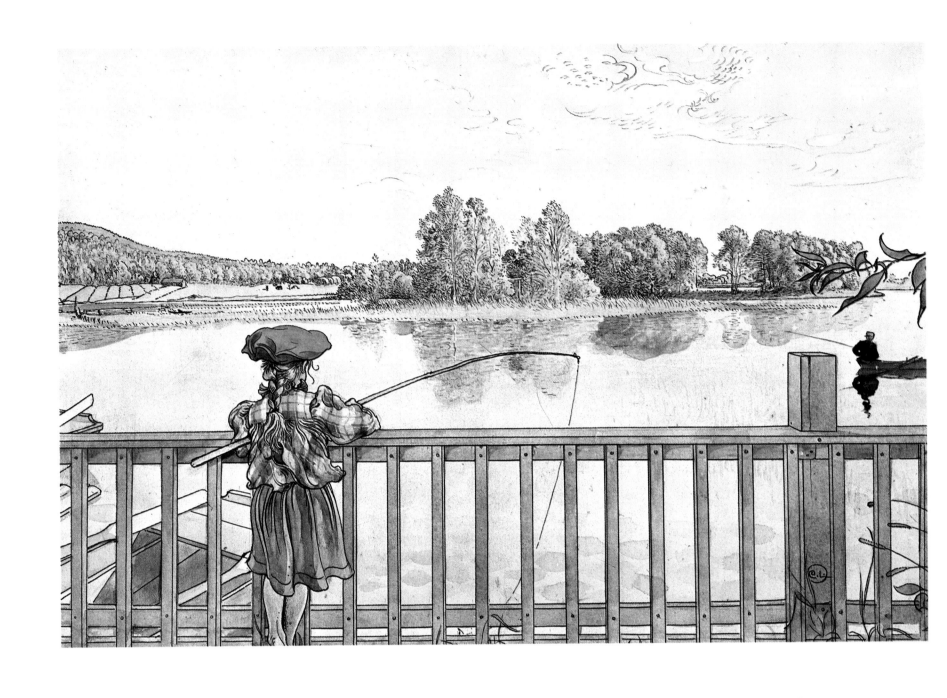

Lisbeth, Fishing Watercolor, undated (about
1894-97), From *Ett Hem*, 1899, Nationalmuseum,
Stockholm

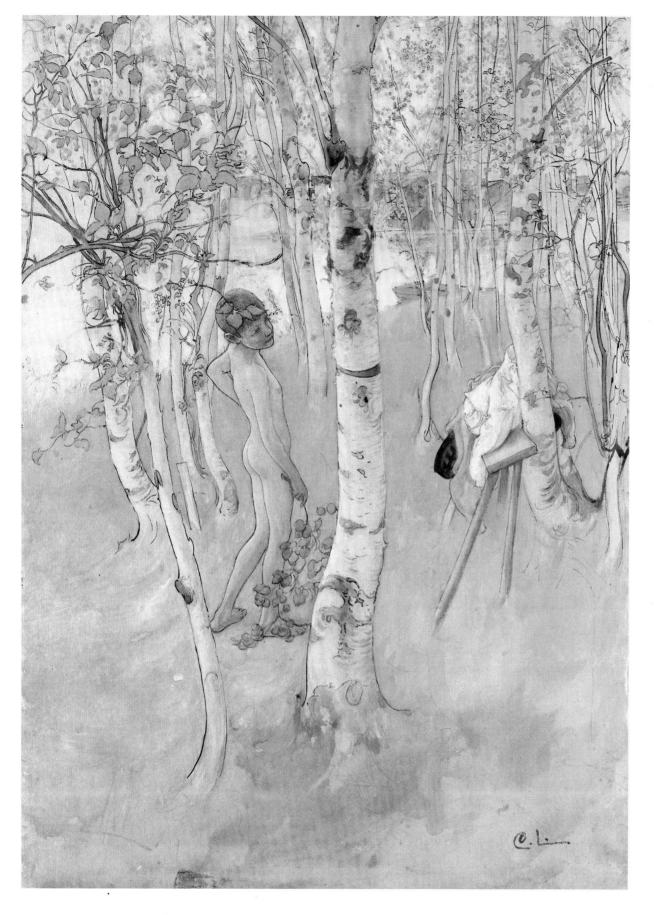

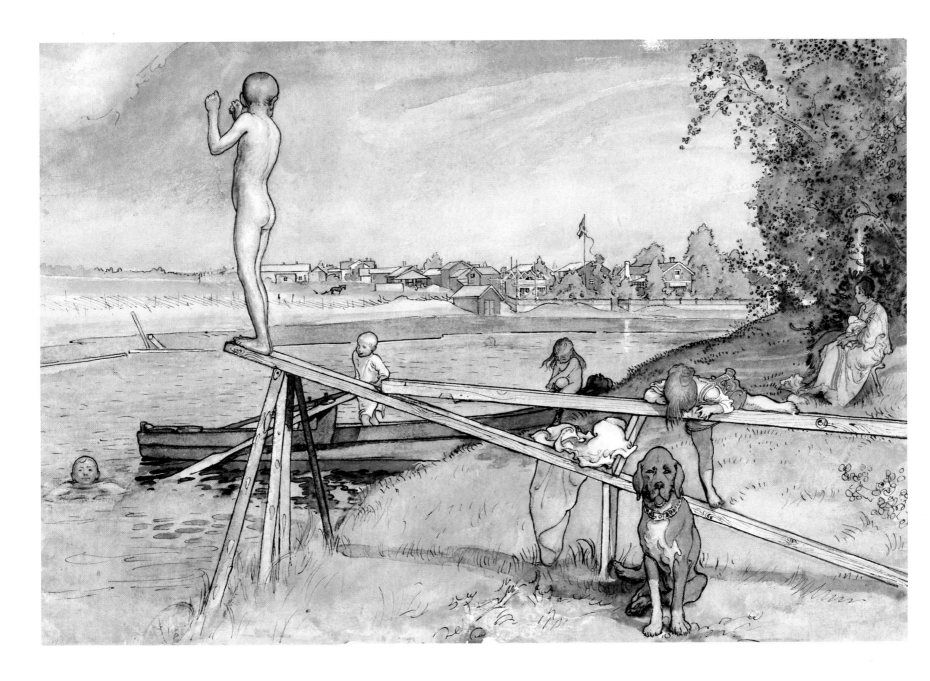

Ulf Goes Swimming on "Rumpus Island" Water-color, undated (about 1900), from *De Mina*, 1919, Nationalmuseum, Stockholm

Water Lilies Etching, 1911, from a 1910 watercolor sold to a collector in the Netherlands, Nationalmuseum, Stockholm

Vignette: *Boy on the Shore Opposite the Carl Larsson Farm* from *Andras Barn*, 1913

A Good Place to go Swimming Watercolor, undated (about 1894-97), from *Ett Hem*, Nationalmuseum, Stockholm

"It is no simple matter to write something about walls, windows and ceilings. That's why I feel it's refreshing to go for a walk with you through the village. We could have rowed a little way down the creek and watched the children bathing. There is a good spot for that there. It's called 'Rumpus Island' and is now part of my own property. Ever since the time I dragged the children straight from bed and took them there (we rowed over, and first I tossed them in the water and then myself) it has been the general swimming hole for the whole neighborhood. In summer time it is full of good-looking naked forms. They fashion some sort of spring-board and there is clapping and splashing and merriment; they climb up into the boats, balance a minute and then tumble headlong into the water and then climb out again puffing and yelling and laughing." (Ett Hem 1899)

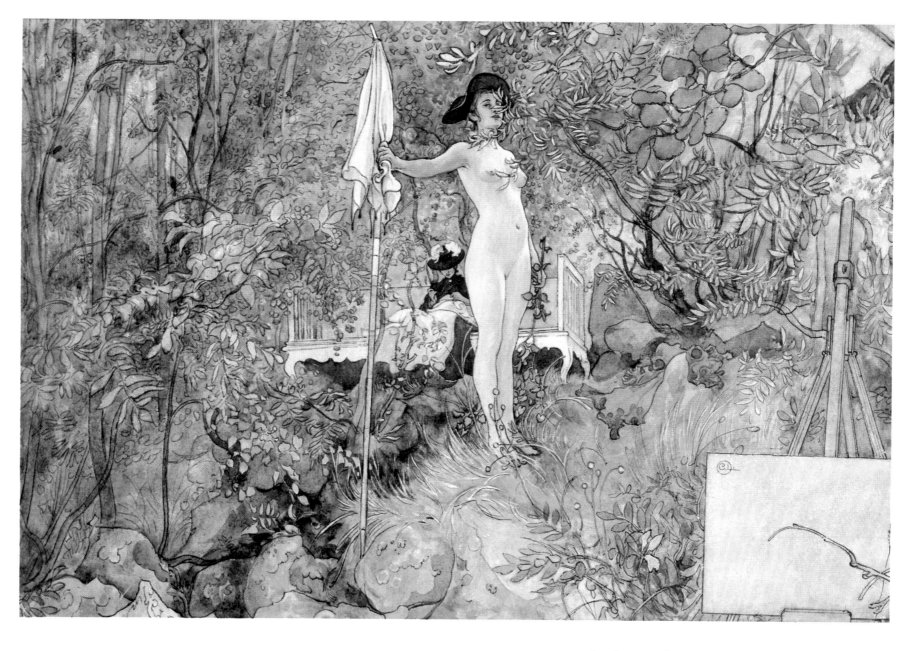

Outdoor Studio Watercolor, undated (about 1900), from the *Ett Hem* series, Nationalmuseum, Stockholm

Karin Cutting Carl's Hair Vignette from *Ett Hem*, 1899

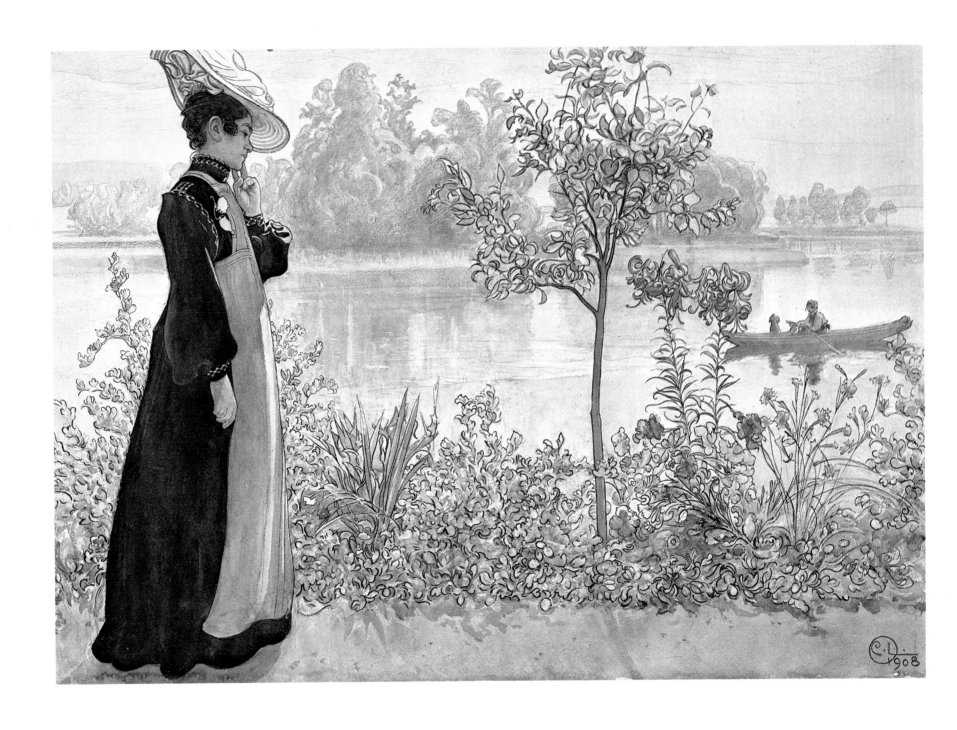

Late Summer/Karin by the Shore Watercolor, 1908,
from *Åt Solsidan,* 1910, The Museum, Malmo

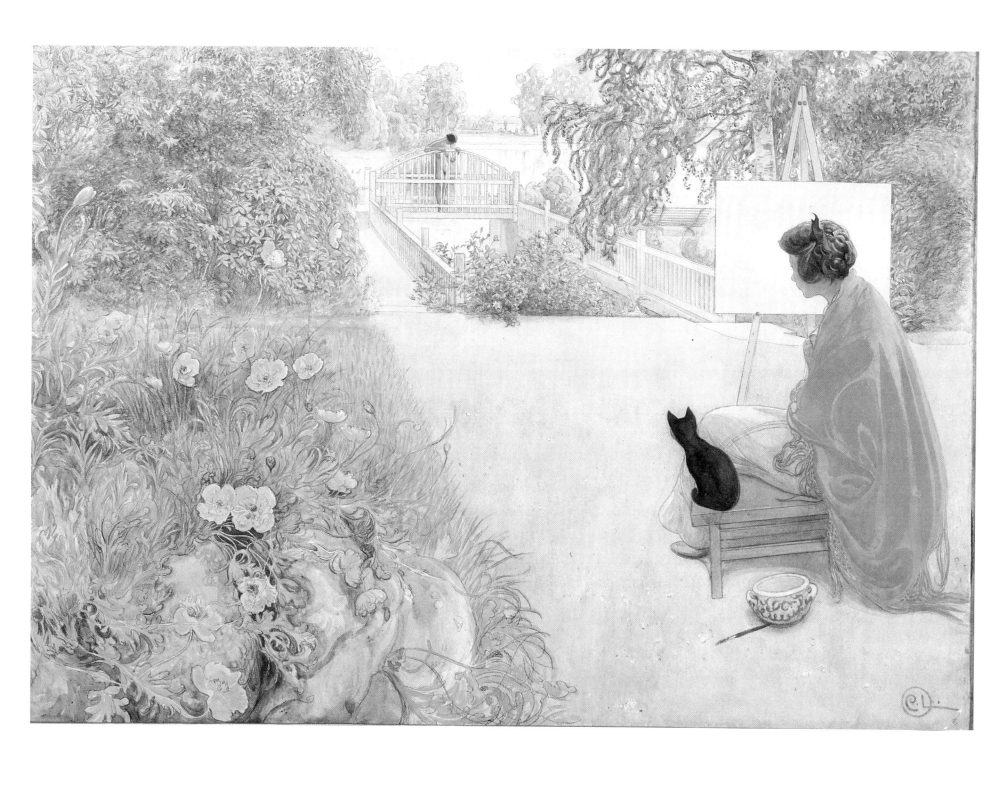

Bridge Watercolor, 1912, Privately owned (Finland)

"*On August fifteenth the crayfish season opens. Then it's as if we are full of new life. All the nets and fishing-rods are ready and when the stroke of midnight sounds I row out, no matter what the weather's like, and lower the nets in the dead of night into the black water.* *Then I sleep till five o'clock when it's time to waken the older children. And then we haul in the nets as the sun comes up like a big pancake above the tops of the bulrushes. The picture with the table all set speaks for itself, I think.*" *(Ett Hem 1899)*

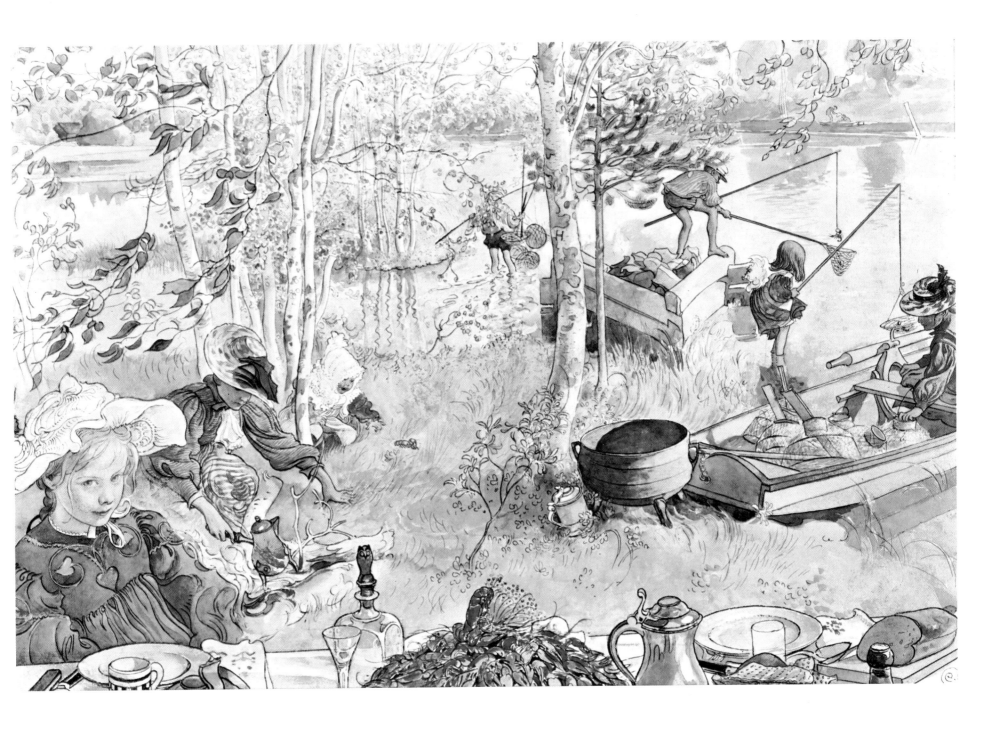

The Crayfish Season Opens Watercolor, undated (about 1894-97), from *Ett Hem*, Nationalmuseum, Stockholm

Vignette: On ''Rumpus Island'' from *Larssons*, 1902

Across the River Vignette from *Åt Solsidan*, 1910

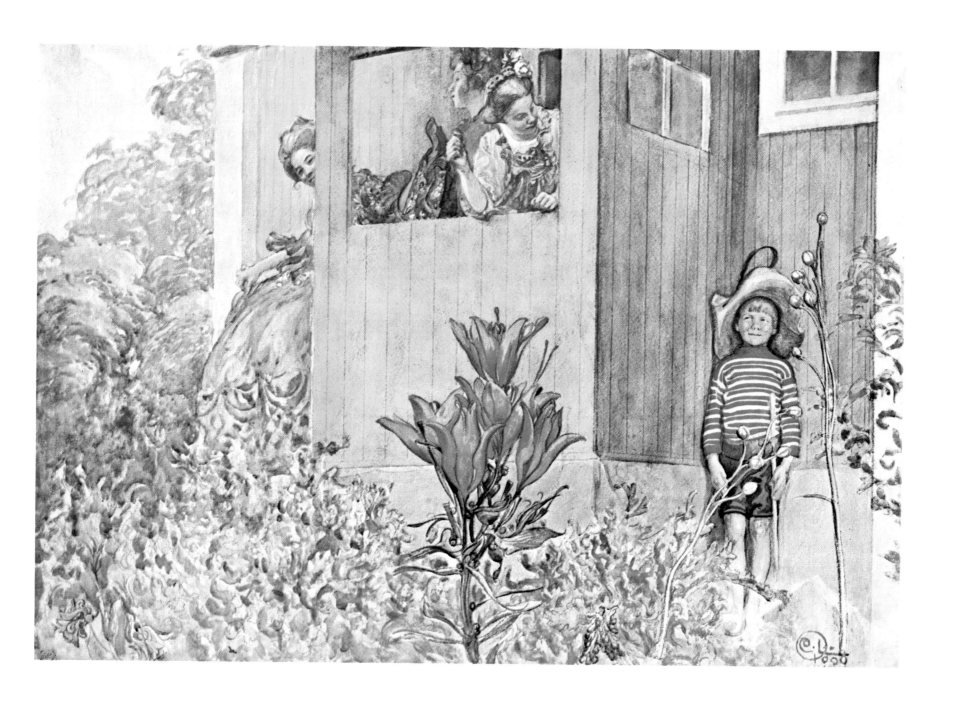

"Dressing Up" (Masquerade) Watercolor, 1900, from
Åt Solsidan, Owner unknown.

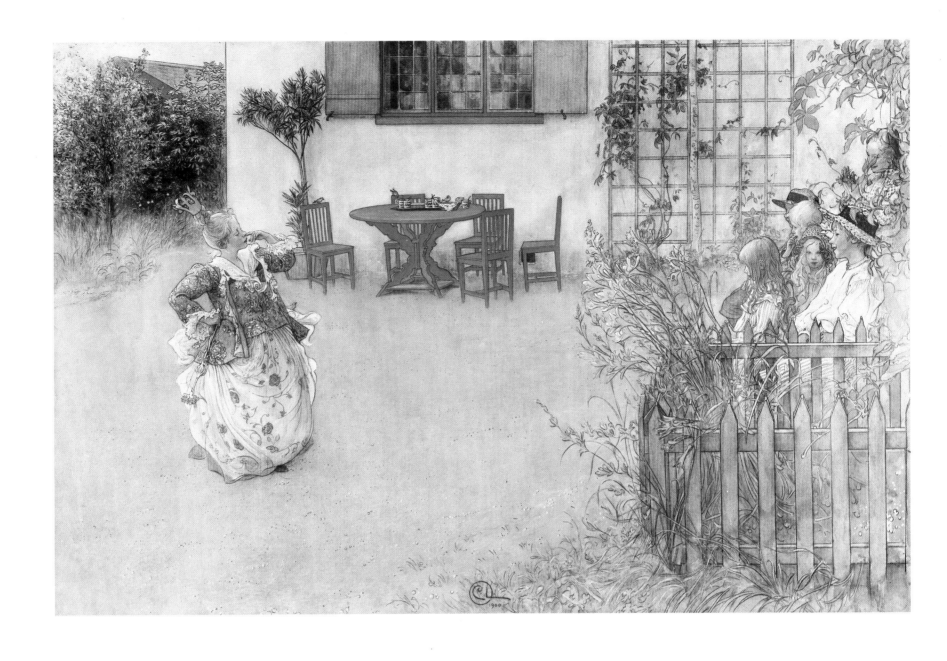

Lisbeth Playing the Wicked Princess From *Fågel Blå
(Bluebird)*, watercolor, 1900, State Art Museum,
Copenhagen

THE LARSSON FAMILY

It isn't only spiteful people who have made the remark during Larsson's lifetime that the Larssons were the most widely-known family in all Sweden. They were familiar of course because of Larsson's pictures, but especially because of his books. Larsson himself published six books, only one of which—the last one, *Andras Barn (Other People's Children)* 1913, contains no pictures of his family. Larsson liked to ask the riddle: *'Why are Kronos and Carl Larsson alike?'* The answer? *'Because they both live off their children!'*

If the reader looks in vain for certain Larsson family pictures on the following pages it is because his parents and his wife have an important role to play in other chapters of our picture section. Because really if not all, at least two thirds of all Larsson's pictures have to do with his family. In the main he considered his family life and his marriage to be happy. If we may believe his writings, not only his wife but, as far as their ages would permit, his children, too, went along with his wishes. Therefore it is no wonder that he also presents his family happiness to ''the world'' in order to make the world a better place by doing so.

It is to be sure a part of his confession of faith to downplay the dark sides of life, which brought him the reproach of falsehood. The series of pictures shown here proves however that he sometimes deviated from his principles. Otherwise he would not, for instance, have executed a drawing of a self-portrait, repeated also in the form of an etching, which shows him in an unmistakably depressed state. On this motif, oddly

The Larsson Children as the Sun Cover vignette from *Larssons,* 1902

Frontispiece to *De Mina,* 1895

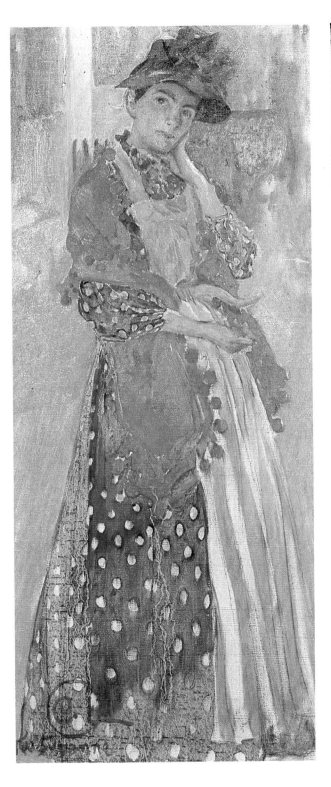

Karin Study for *De Mina,* oil, 1892, Tage Ranström, Eskilstuna

My Loved Ones Watercolor, 1893, from an oil, 1892, from *De Mina,* 1895-1919

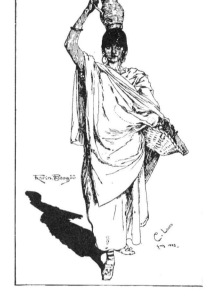

The Bride Watercolor, 1883, from *Larssons,* 1902, Madeleine Sager, Stockholm

Self-Portrait, At a Costume Party Title-piece for *Palett-skrap,* 32, 1882
Karin Bergoo, At a Costume Party Drawing for *Palett-skrap,* 32, 1882

Karin and Carl Oil, on two folding panels at Hotel Chevillon, Grèz, 1882
Self-Portrait Drawing, 1883, from the *Svea* calendar, 1884
After the Ball Drawing, from a letter to Karin, 1883

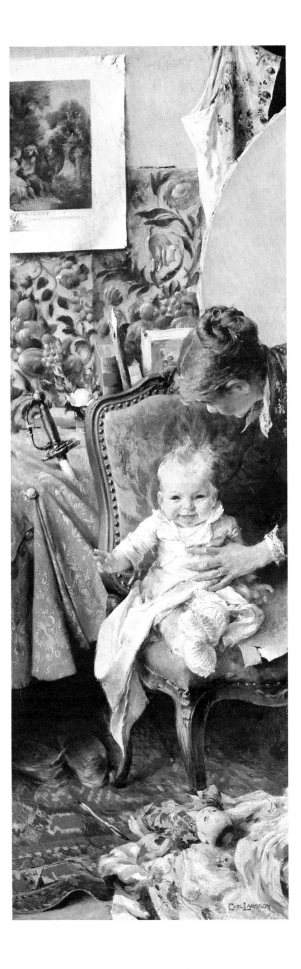

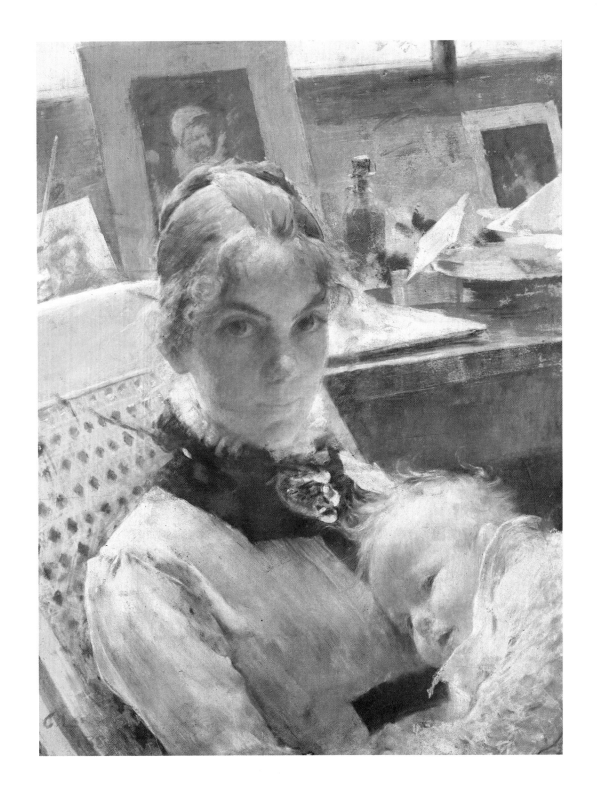

Little Suzanne Oil, 1885, from *Larssons,* 1902, Art
Museum, Göteborg

Studio Idyll Pastel, 1885, Nationalmuseum, Stockholm

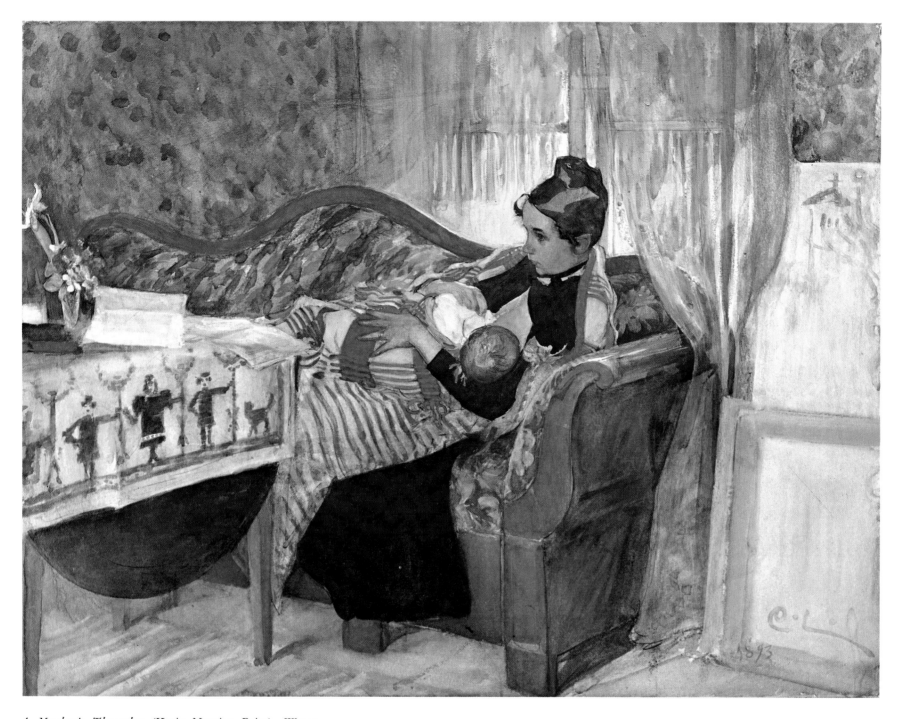

A Mother's Thoughts (Karin Nursing Brita) Water-color, 1893, from *Larssons,* 1902, Prince Eugen's Waldemarsudde, Stockholm

enough, he expended a great deal of care, even in the drawing stage; we therefore have reproduced this drawing in color. None of his pictures however says anything about the reasons for his depression. Attempts by art historians to intrepret his pictures with this in mind must be regarded as failures. The thought behind these attempts is too involved and on the other hand not thorough enough. Here and there in Larsson's writing is found a passage that seems to be lifting the veil. Alongside common everyday causes for "depression," such as the older children leaving home, there are attacks on his art on the part of the profession and the press. Mainly however a certain predisposition toward this character trait seems to have been a contributory factor; one outstanding testimony to this fact is the "fairy tale" he wrote about *The Dandelions,* which we have included in this volume. If, finally, we examine this very closely and read his writings with this in mind, this

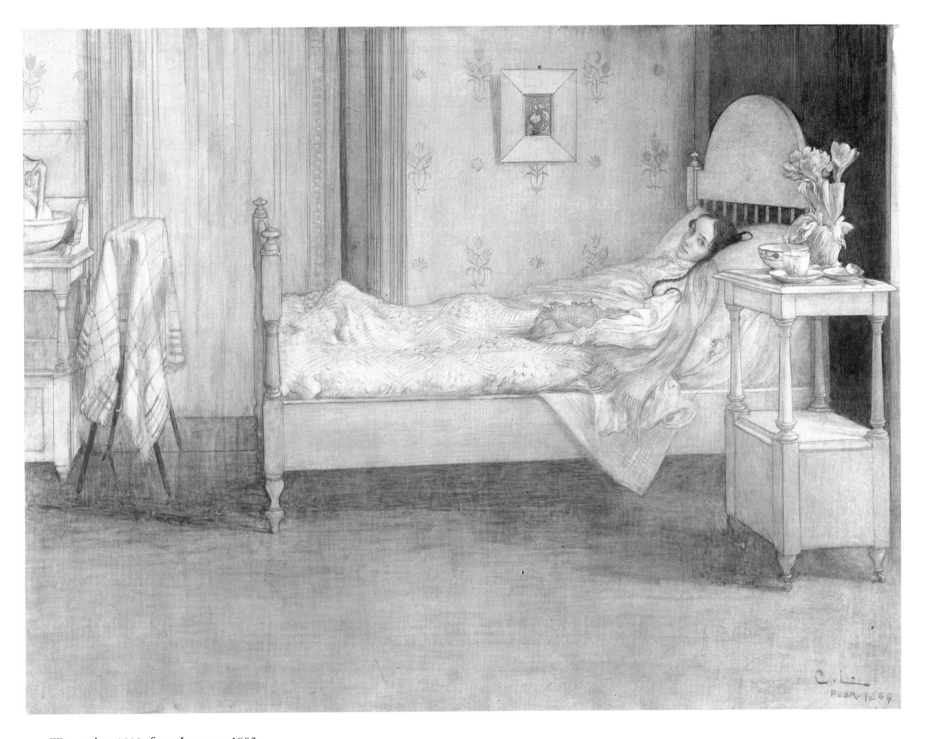

Convalescence Watercolor, 1899, from *Larssons,* 1902,
Nationalmuseum, Stockholm

character trait constitutes rather a gift. For in my opinion it is a matter of the measure of his sensitivity to the world and his own ego, which is a vital requirement of any artistic personality.

Once we come face-to-face with these considerations many of his pictures, especially those of his family and his self-portraits, take on a new flavor. If M. von Heland wants to get to the bottom of the notion of the Larsson pictures actually being Karin's works of art, we are now able very easily to brush aside this far too extreme thesis and say that here we are probably dealing with a family, a married couple, existing as a single organism, as "one flesh," Carl Larsson as its best seismograph understanding how to make manifest this vital spark even to us, generations later. We have consciously included in the following selection of pictures also "problem pictures," pictures whose core of meaning is not immediately evident. But it is not really a disadvantage that lack of space forces us to omit detailed commentary on these pictures: the reader will have all the more opportunity to try to solve the puzzle for himself.

Karin Charcoal and chalk, undated, Nationalmuseum
Stockholm

Karin's Nameday, 1896 Drawing from *Larssons*, 1902 *Karin Larsson 1883* Drawing from *De Mina*,
1895/1919

"My Soul Dwells in Paris" Drawing, from a letter to
Albert Bonnier, his publisher, 1882

Karin as a Grandmother Drawing from *De Mina*,
1895/1919

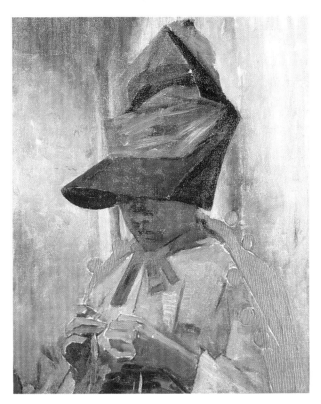

Karin, Wearing a Big Hat Sketch in oil, 1905, The Carl Larsson Farm, Sundborn

Karin at the Loom Photograph, 1913

Karin Charcoal and pastel, 1903, Lars Larsson-Hytte, Smedjebacken

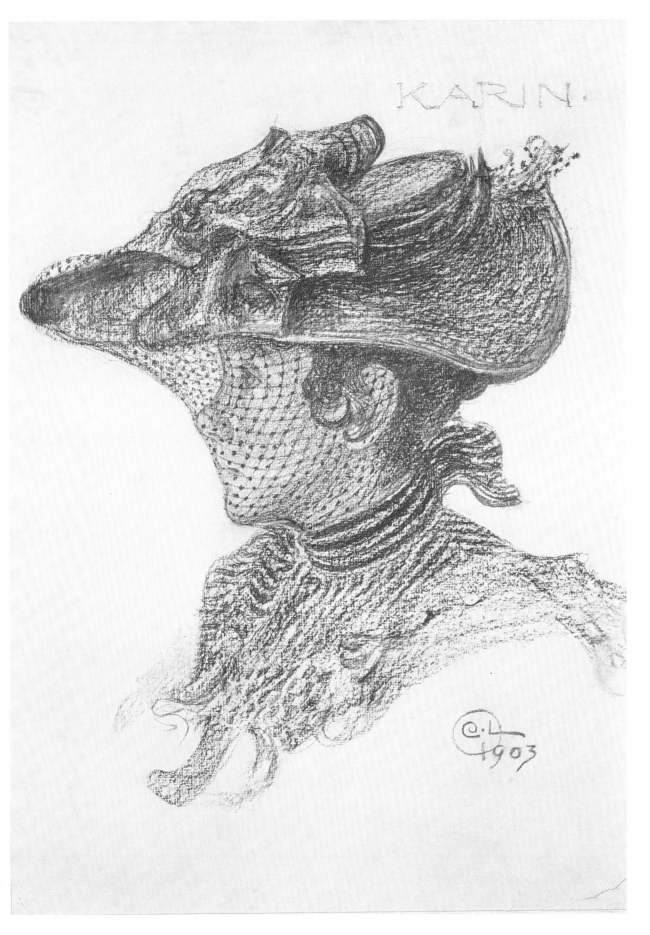

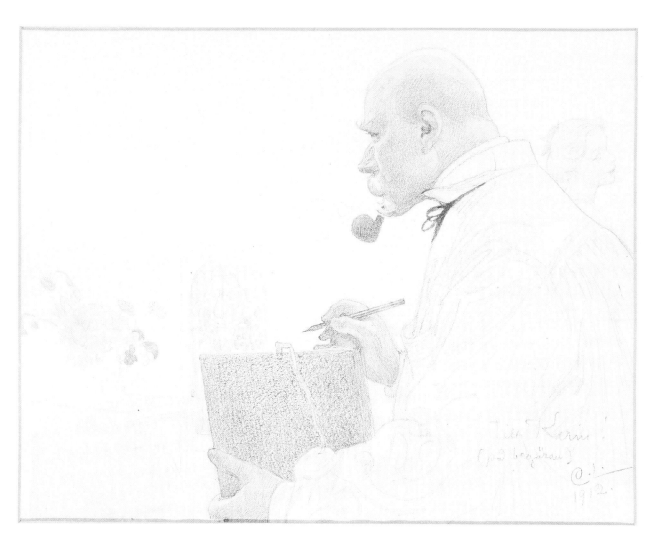

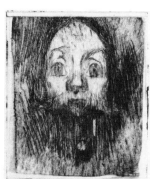

Self-Portrait Tinted drawing, 1912, The Carl Larsson
Farm, Sundborn

Carl Larsson at 60 Photograph, 1913

124

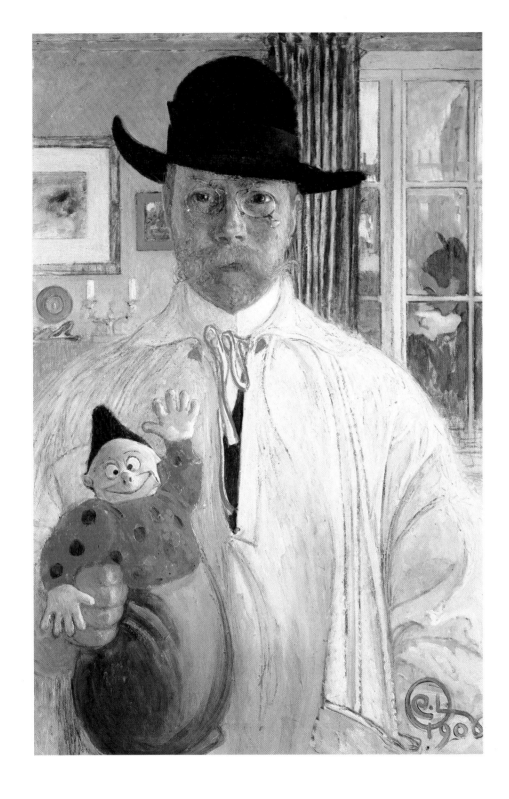

Self-Portrait Etching, 1896, Art Museum, Göteborg

Self-Portrait in Artist's Smock Etching, 1896, Art Museum, Göteborg

Caricature Etching, 1896, Art Museum, Göteborg

Writer's Ghost Etching, 1896, Art Museum, Göteborg

Karin and Carl Larsson in the Studio Photograph, 1913

Karin in the Studio Watercolor, 1912, Privately owned *Introspection* Oil, 1906, Uffizi Gallery, Florence

ESBJÖRN: JAG VILL INTE BLI NÅGON PAPPA UTAN EN KARL, FÖR INTE KAN PAPPA GRÄFVA DIKEN OCH INTE KAN HAN TÄLJA PINNAR

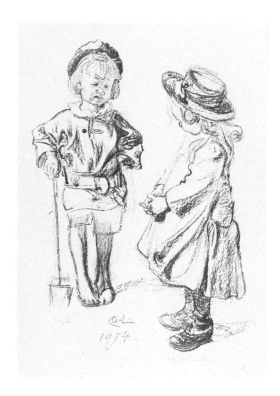

Esbjörn: "I Don't Want to be a Papa..." ("I'd rather be a man, 'cause Papa can't Dig Ditches and Whittle Sticks") Watercolor, 1904, *De Mina,* 1919

Boy and Girl (Esbjörn and Brita Hellberg) Charcoal, 1904, Nationalmuseum, Stockholm

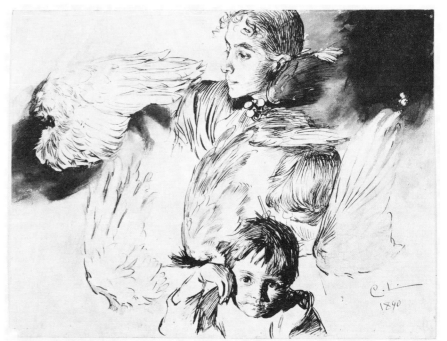

126

Dream Journey Watercolor sketch for stained glass window in the dining room at Sundborn, 1905, The Carl Larsson Farm, Sundborn

Karin and Esbjörn Watercolor, undated (about 1909) Privately owned

Carl Larsson Showing Karin's Portrait on the Sliding Door Frontispiece for the Carl Larsson issue of *Idun,* 1913

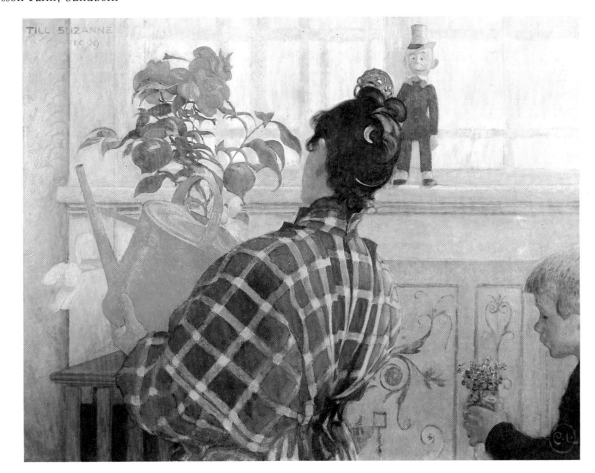

Mamma and Pappa Drawing by Suzanne, from *Ett Hem,* 1899

Group-Photograph of Albert Engström, Carl and Karin Larsson with Anders Zorn, published in the Carl Larsson issue of *Idun, 1913*

The Artist's Wife and Children, Study of Bird's Wings Pencil and wash drawing, 1890, Nationalmuseum, Stockholm

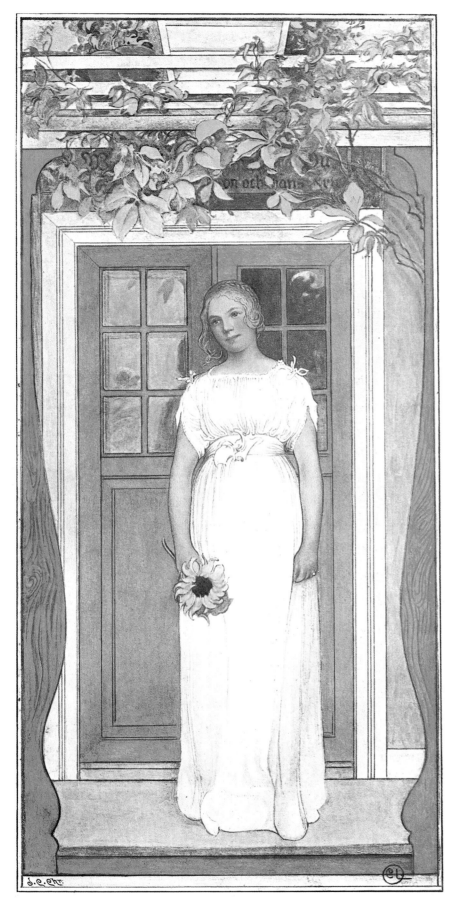

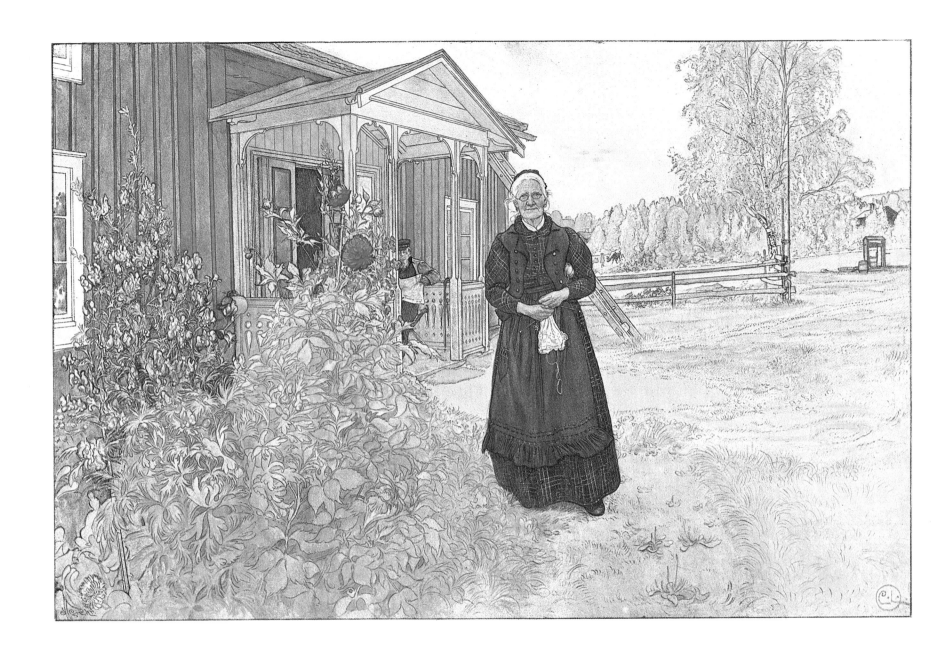

Eighteen Years Old Watercolor, undated (about 1902), from *Larssons,* 1902

Suzanne as a Red Cross Nurse Watercolor, 1910, Prof. Stig Ranström, Goteborg

Suzanne, la Grèziote (Native of Grèz) Drawing, undated, from the Carl Larsson issue of *Idun,* 1913

Suzanne Watercolor, 1894, Art Museum, Göteborg

Father and Mother Watercolor, 1901, from *Larssons,* 1902

Catch-up Home Work in Summertime Watercolor, undated, from *Larssons,* 1902, The Atheneum, Helsinki

Pontus on the Floor Oil, 1890, Nationalmuseum, Stockholm

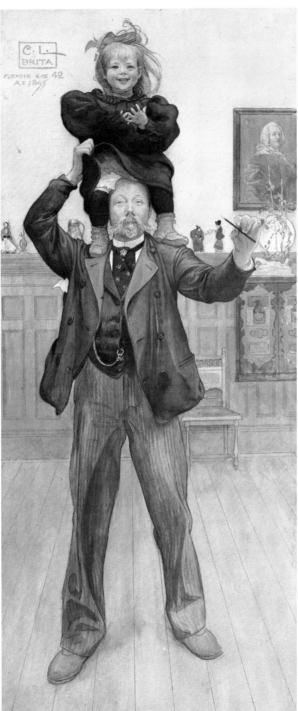

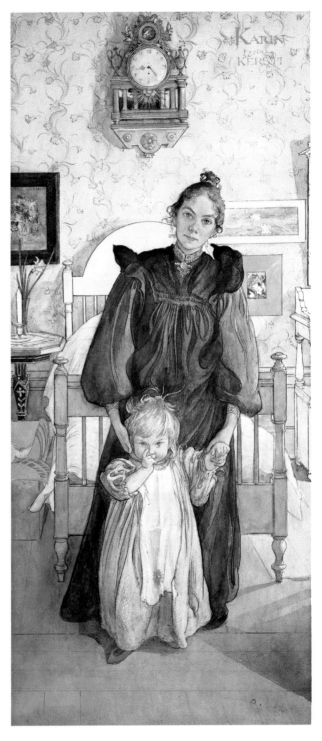

Ulf and Pontus Watercolor, 1894, Art Museum, Göteborg

Brita and I Watercolor, 1895, Art Museum, Göteborg

Karin and Kersti Watercolor, 1898, Art Museum, Göteborg

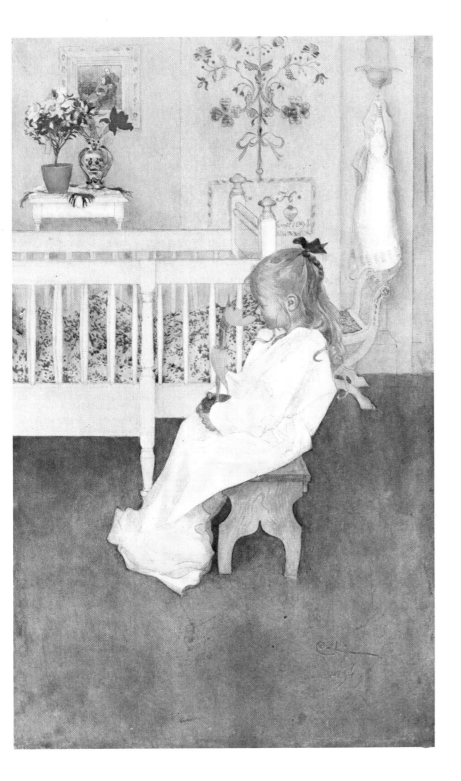

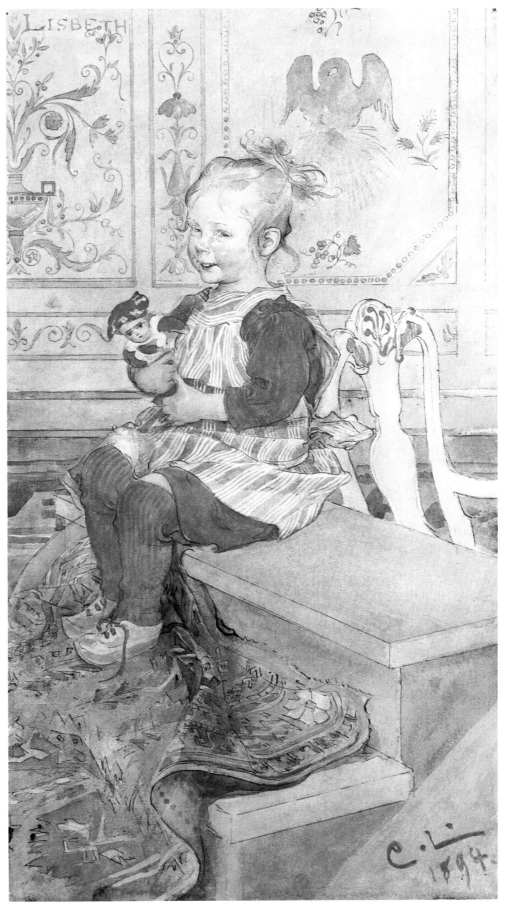

Lisbeth Eating her Porridge Hand colored etching, 1894, The black for contours and the red-brown wash-tones printed from one and the same plate (second stage). Lettering not yet added. Art Museum, Göteborg

Lisbeth in her Night Dress with a Yellow Tulip Water-color, 1894, Privately owned

Lisbeth Watercolor, 1894, Art Museum, Göteborg

The Bridesmaid Watercolor, 1908, from *Åt Solsidan,*
1910, The Atheneum, Helsinki

Brita on June 22, 1893 Drawing, from *Larssons*, 1902

"Papa, I'm Eating Waffles" Drawing from *Larssons*, 1902

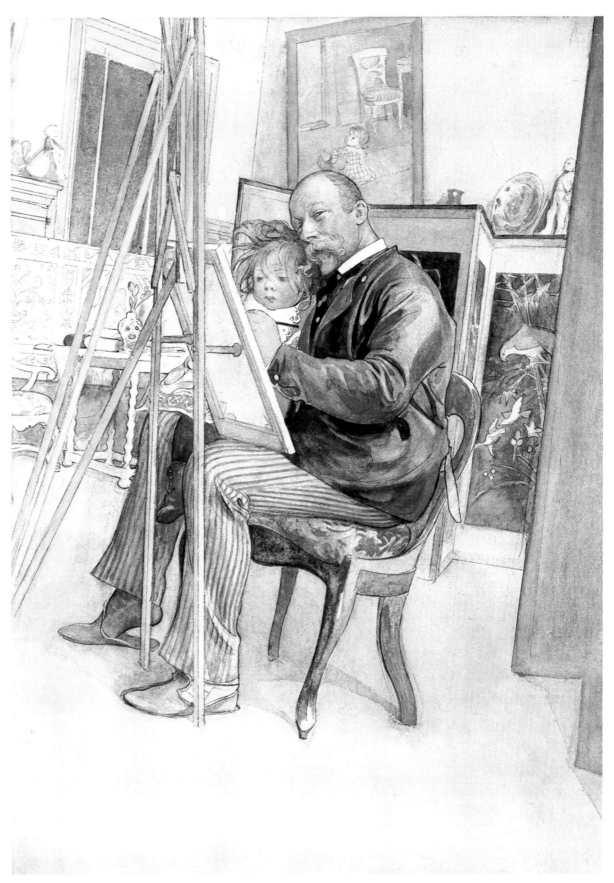

Seen in the Mirror Watercolor, 1895, Art Museum, Göteborg

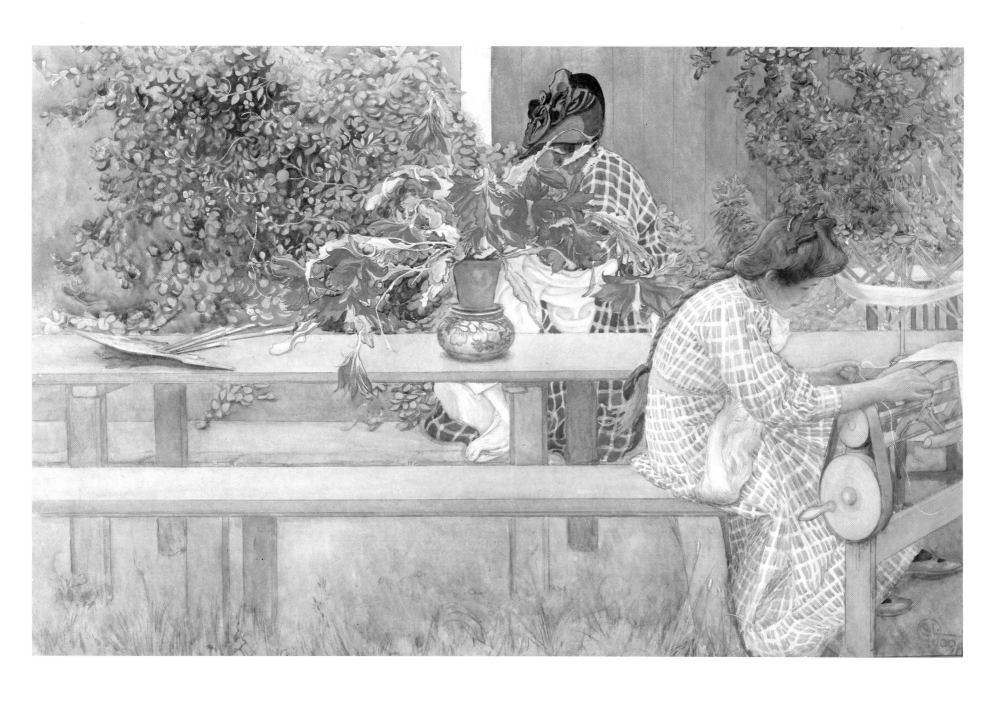

Karin and Brita with Cactus Watercolor, 1910,
Thomas Normark, Västerås

Pontus' Birthday Drawing from *Strix*, 1897

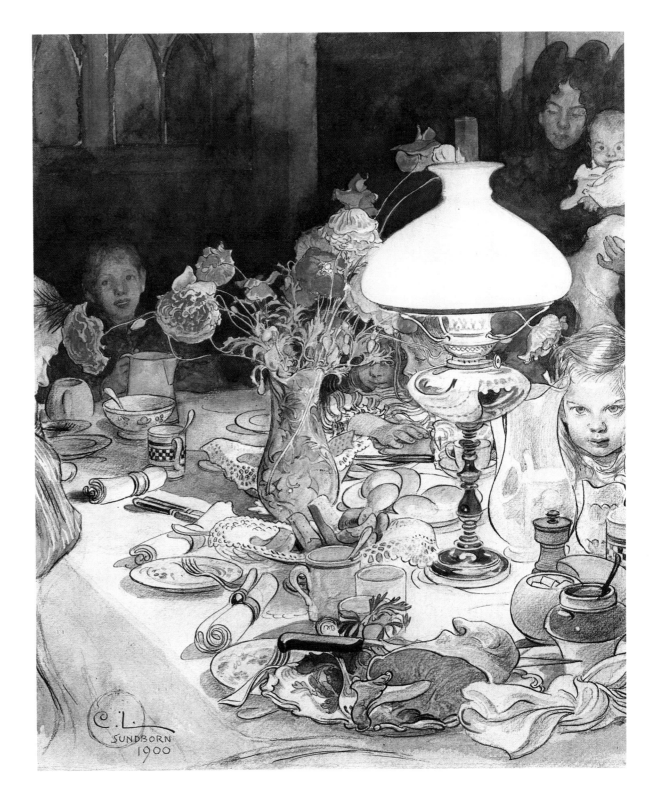

Around the Lamp at Evening Watercolor, 1900,
Thielska Galleriet, Stockholm

137

Kersti 1899 Vignette, drawing from *Ett Hem,* 1899

Kersti on the Bench Pencil, 1904, Art Museum, Göteborg

Kersti on the Bench Etching, soft-base, 1904, Art Museum, Göteborg

Karin and Kersti Pencil, 1904, Art Museum, Göteborg

Karin and Kersti Etching, 2nd stage, 1904, Art Museum, Göteborg

A Late-Riser's Miserable Breakfast Watercolor, 1900, from *Larssons,* 1902

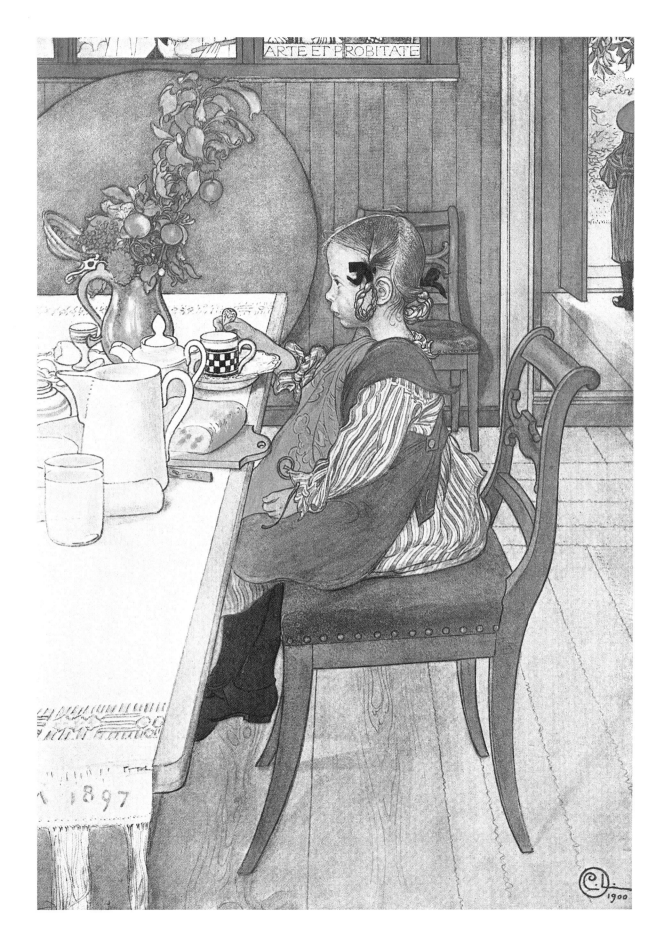

Esbjörn, Fishing Watercolor, 1903, from *De Mina*, 1919

Esbjörn November, 1900 Watercolor, 1900, from *Larssons*, 1902, Art Museum, Göteborg

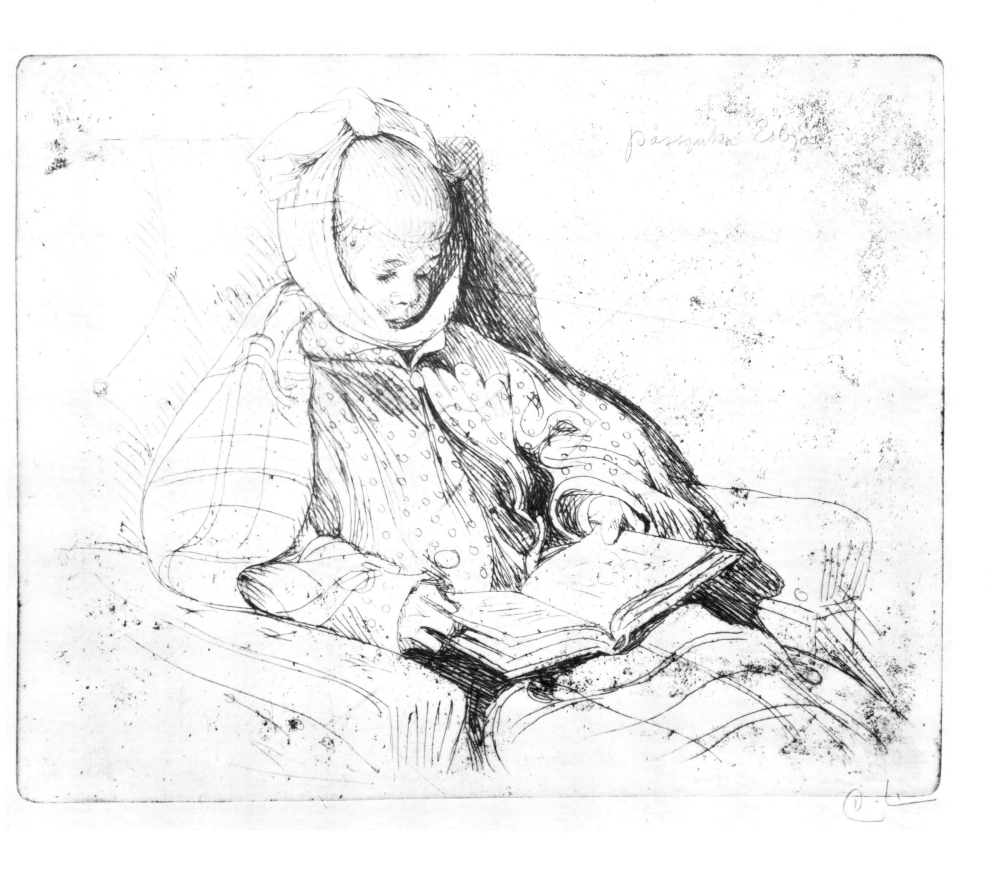

Mumps Etching, 1912, plate no. 1, Art Museum,
Göteborg

THE HOME

At this point in the book, its closing pages, we finally come to the most interesting chapter. For if now and then in the course of the nearly century-long history of the public's acceptance of Larsson the popularity of his family pictures may have waned a bit from place to place and country to country, the Larssons as interior decorators have seen to it that subsequent generations have been able to discover ''their'' Larssons. As we have said, it was probably in Germany of the 1920s, for example, where the tradition of handicrafts, practical beauty and clear color as the basis for interior decoration roused such enthusiasm among the proponents of the *Bauhaus* trend and Functionalism, that people were singing Larsson's praises as the person who had taught us to bring the outdoors indoors and include it in the living quarters.

Here too we must unfortunately forego detailed commentary. But we do so with good conscience again, all the more since we are about to let Larsson speak for himself. In splendidly powerful words inspired by his own thoughts he stumps for his own ''ideas for living,'' which once again were in large part team-work, since Karin's share in it was (and according to art historians still is) great and growing. The pictures have been so arranged that they lead us from room to room. Thus as far as possible we have grouped together pictures that can show how the Larssons put one of Carl's demands to work; *''A home is not a lifeless object but a living entity, and like everything that is alive it must obey the law of life: it must keep changing from moment to moment...''*

''It was an ugly, unattractive little structure situated on a pile of rubble. It was known as ''Little Hyttnäs'' to distinguish it from ''Big Hyttnäs'' that belonged to the nearest neighbor. The little bit of soil on which potatoes we grew had been carted in from somewhere else and only a handful of loam enabled a few lilac bushes to waft the fragrance and splendor of their native Persia all around. The little shack is located not far from where the Sundborn creek makes a bend and broadens out a little. A narrow, steep path leads directly to the water and there stands an old skiff as a sign that this is the 'harbor.' Nine slender birches had taken root unbidden in the rubble and as a matter of fact they didn't look as though they were suffering any... At this spot I was overwhelmed by the splendid feeling of isolation from the noise and bustle of the outside world such as I had

First Glimpse of Sundborn Pencil, 1884, Prof. Stig Ranström, Göteborg

Ett Hem Frontispiece to the book, watercolored drawing from *Ett Hem,* 1899

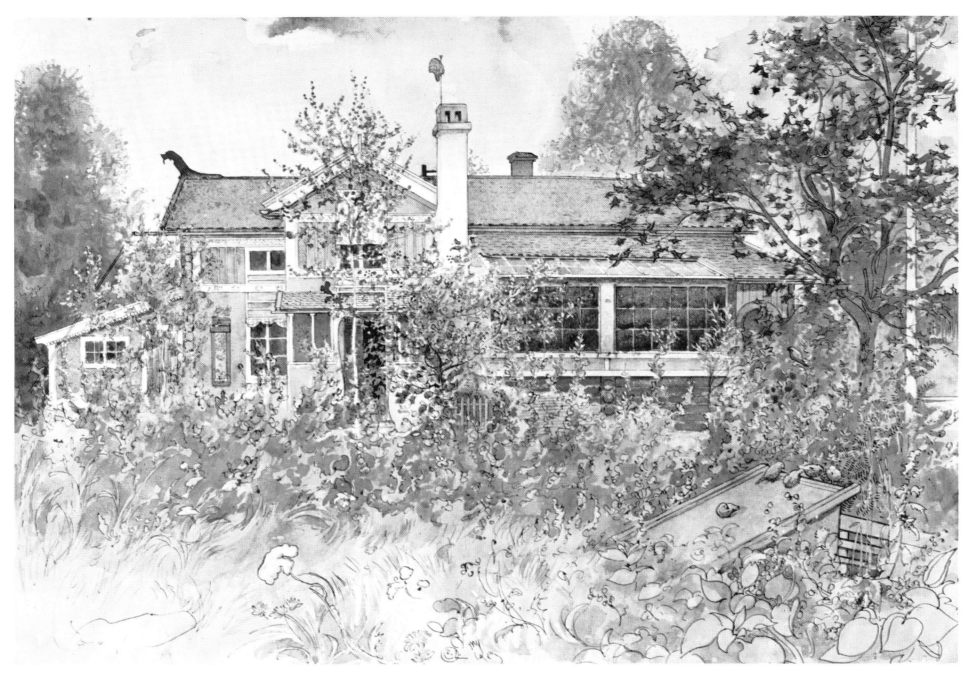

The Cottage Watercolor, undated (about 1894-97),
from *Ett Hem*, Nationalmuseum, Stockholm

The Poor Box at Sundborn Drawing from *Ett Hem*,
1899

Lilla Hyttnäs before Reconstruction Drawing from *Ett Hem*, 1899

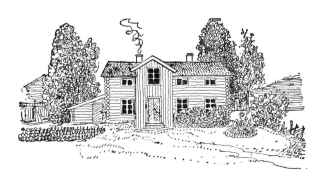

The Veranda Watercolor, undated (about 1894-97), from *Ett Hem*, Nationalmuseum, Stockholm
Suzanne on the Front Stoop Watercolor, 1910, Tage Ranström, Eskilstuna

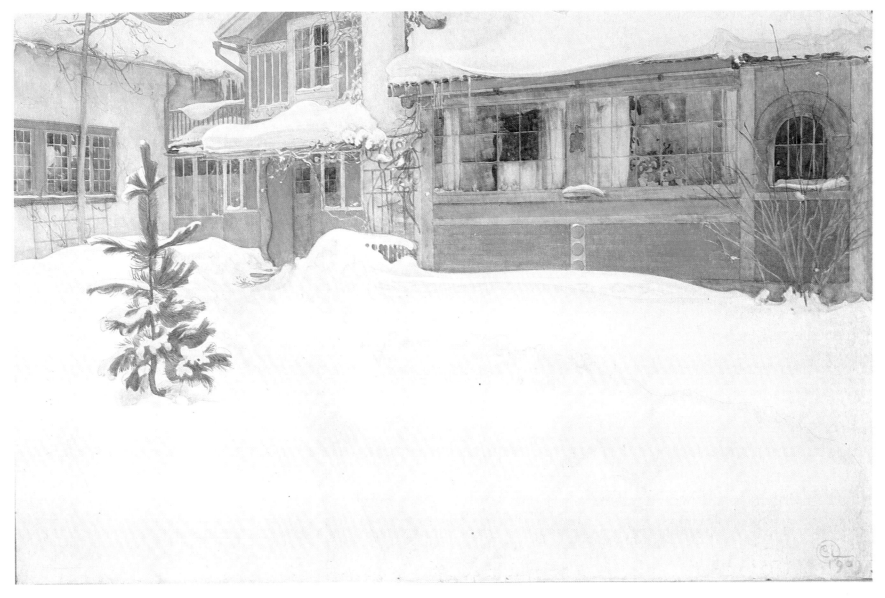

The Cottage in the Snow Watercolor, 1909, from *Åt Solsidan*, 1910, Art Museum, Åbo, Finland

The Dwelling in Sundborn in the Winter Photograph, 1913

Rear View Vignette, from *Åt Solsidan*, 1910

The Well. Vignette from *Åt Solsidan*, 1910

felt only once before. That had been on a farm in France... and here (my father-in-law was giving me) the house and everything in it... There has been a lot of carpentry and masonry work done here every summer as far as time and pocketbook would allow. My own work flowed so easily, I almost was going to say, in time with the hammering and chopping by the artisans from the village. Every plank, every nail, every hour's wages cost me an anxious sigh but I said to myself, 'All in good time.' I had to have the house just the way I wanted it or else I would never have felt right in it, and it was obvious to me that my work would have suffered otherwise. The results of this remodeling of my shack are what I want to show you—you, some of whom may own bigger country places than I do, maybe even only castles in the air. I'm doing it, not only out of vanity in showing off how I have things, but because I think I have gone about all this with so much common sense that I feel—dare I say it?—it might serve as an example

(—there, I've gone and said it!—) for a lot of people who feel the urge to furnish their homes nicely. Here it is, a house that was not worth much in dollars and cents and whose furnishings were worth even less. The 'renovation' (sounds so elegant, doesn't it?) was done at the cost of some risky attacks on the annual budget—which we met sometimes one way and sometimes another. And now the cottage is finished—I think—but, dear reader and viewer, before you start having a look around, listen first to a sermon about art in the home. Other people have done better at it than I have, but that can't be helped... There are two possibilities, either the tiresome old saying about 'doing it right the first time' or the tasteless commercialism of the luxury-lover. The factory, the barracks, the hospital and the country estate are all unbearably monotonous in that respect. The farmer tries to get it monotone like this, but thanks to the red paint his cottage turns out to be what the city-dweller, with a longing sigh, calls

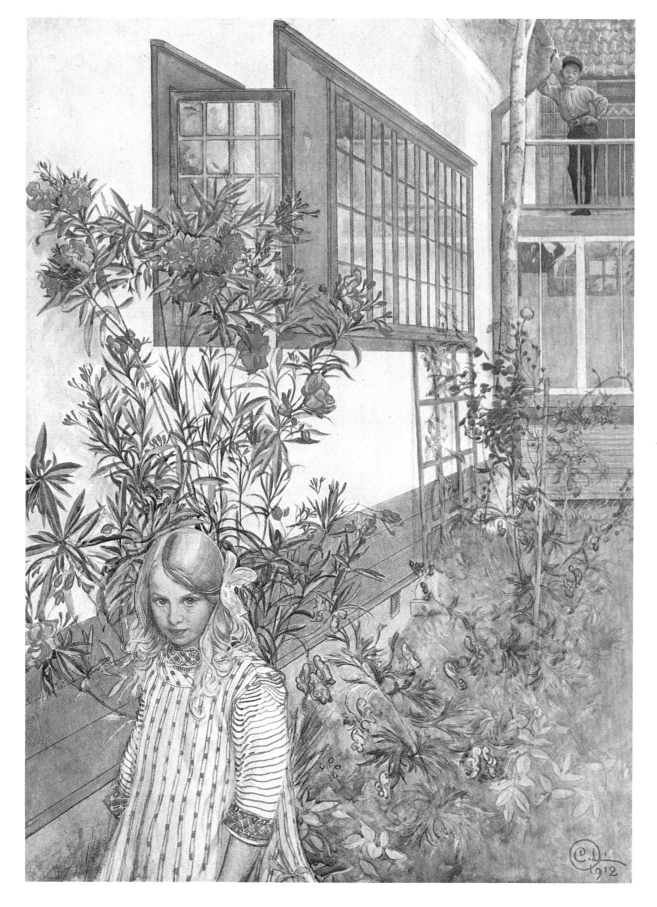

'rustic,.' The contrast to the straight lines, the draperies hung idiotically over doorways and windows, in corners, and behind pictures by city people, their what-nots and little cabinets crammed with cheap trash, their artificial flowers with bows and ribbons and microbes. What lamps, what lamp-shades! Plush and cretonne! Amid all that gaudy rubbish and tinseled knicknacks sit the master of the house and his lady, beaming out over all their splendor and are convinced that they have fulfilled the demands of modernity as enunciated at the pinnacle of Society. One man is as good as the next, thinks the Swedish farmer. He has a fine settee made of mahogany-stained common wood straight from some furniture factory, a bureau with dreadful nickle-plated hardware, a walnut chiffonier, a black-and-gold rocker, and in the middle of the room stands a wobbly, round extension-table with a table-cloth on it with a cheap printed flower pattern. And on this cloth stands a still cheaper kerosene lamp, just as hideous as the one at the home of the gentry I mentioned above. But the cheap wallpaper is not so awful as the ones that cost a lot more a roll. That's how things are today. But how did it used to be?'' (Ett Hem 1899)

''When we came here there wasn't much green to be seen. But I pushed the rubble aside here and there, bought some good topsoil to fill the gullies and set out seedlings of birch, linden, chestnut, willow, hawthorn, barberry and other 'stupid ornamentals'—alder, elderberry, buckthorn, aspen, even oak, apple, jasmine, roses, gooseberry and raspberry—a little spruce and a small pine. This little drawing shows the last-named the way it looks in winter protected by some long cord-wood. Everything thrived except that. It is eight years old now and is barely alive but it's my pet. I go have a

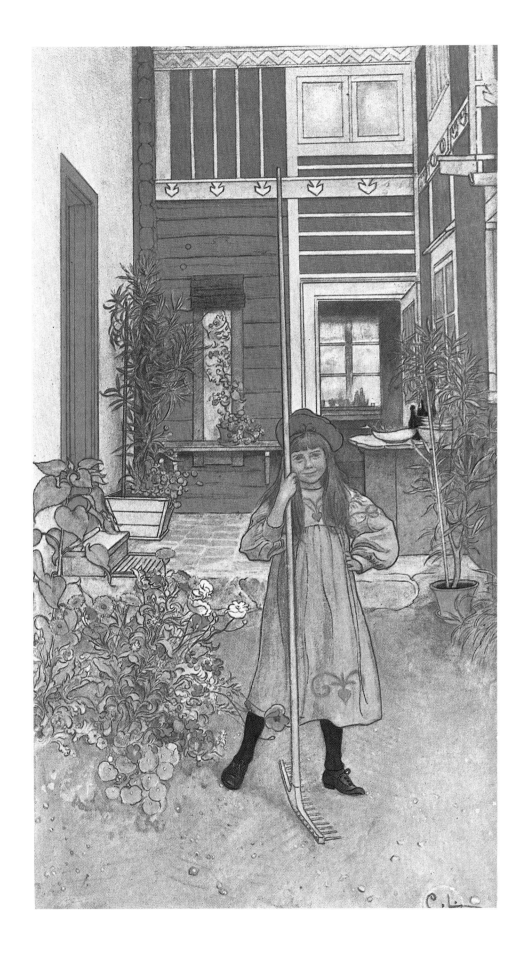

look at that first to see if it hasn't grown a little over night.'' (Ett Hem 1899)

''If I should die, which, oddly enough, is perfectly possible, I think to myself that our home will go on, all the same, but yet not exactly the same. But it wasn't exactly the same yesterday, either. A home is not some lifeless object, but is alive and like all living things it must obey the law of life and must change from moment to moment; at best it may enjoy a long life, only to cease to be in the end. But I like to think my home will live on for generations. Maybe I'll make the children's children a new book about it. You ought to buy it. Because you, dear reader, must never die, never become extinct.'' (Åt Solsidan 1910)

''This is an excellent opportunity for me to mention the fact that at the time when these drawings were being drawn the whole building consisted of nothing but four rooms and the kitchen plus the built-on studio. The room referred to a moment ago (the little winter studio) was added on later.'' (Ett Hem 1899)

''It is Brita (in the picture entitled Raking) whose job it is to rake the courtyard on Saturday afternoons—naturally in return for jingling coins. I enjoy seeing the open space behind her because it isn't any longer the way it appears in the picture. A larder has been built in and stocked—For its dedication I wrote, 'We put goodies into the larder and hope that soon it will be full. That was rather a big addition, with four chambers and the necessary entries and a new entrance passageway which was long and dark and narrow, so no spooks would dare enter there.' I think it looks as inviting in the picture as it actually was, so that I get quite sentimental.'' (Larssons 1902)

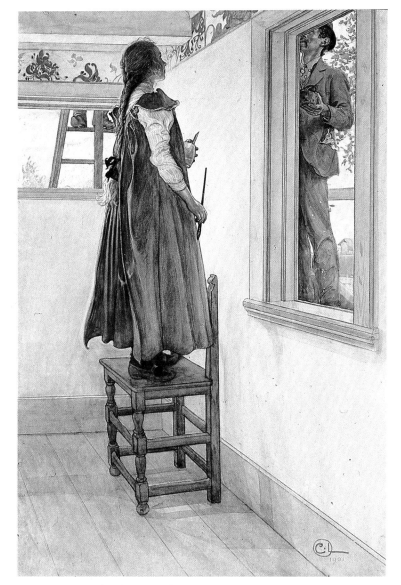

C.L. With Flower Pot Drawing, from a watercolor of 1909, Frontispiece to *Åt Solsidan*, 1910

Suzann' and another 'ann Watercolor, 1901, Privately owned

With Gunlög, the First Grandchild, in the Parlor at Sundborn Photograph, 1913

148

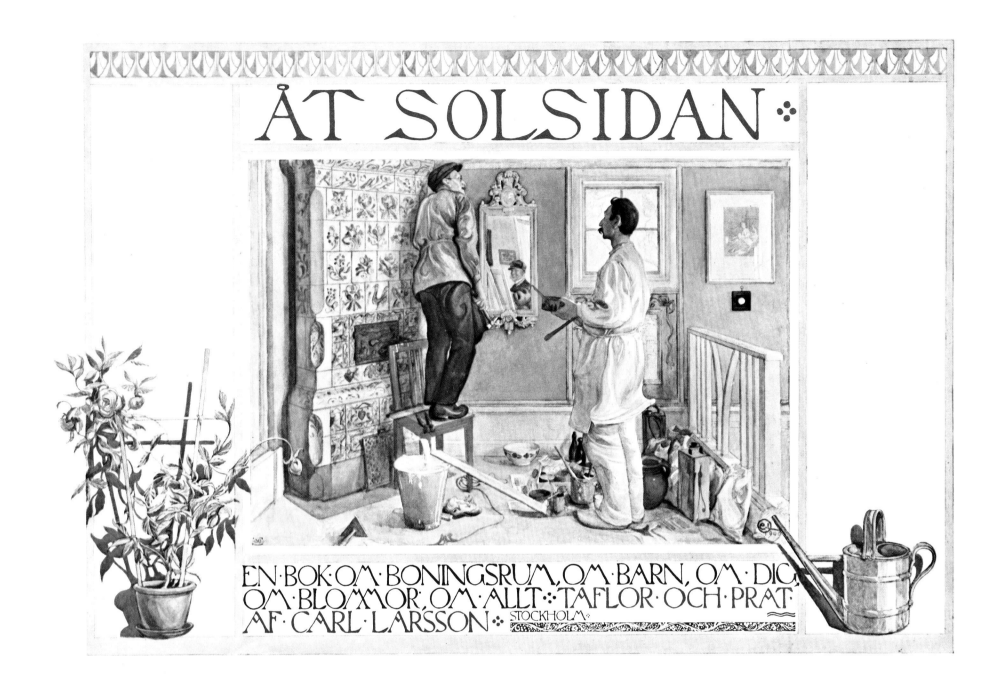

Frontispiece for *Åt Solsidan* Watercolor, 1909, from
Åt Solsidan, 1910

The Flower Window Watercolor, undated (about 1894-97), from *Ett Hem*, Nationalmuseum, Stockholm

Vacation Reading Assignment Drawing, from *Ett Hem*, 1899

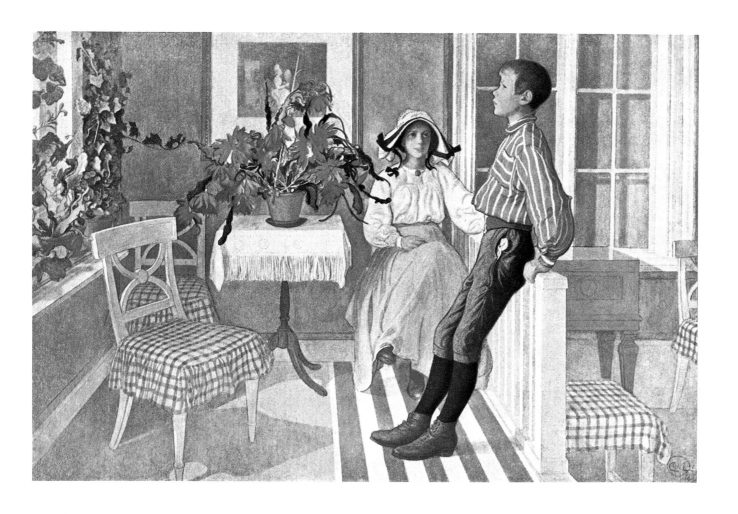

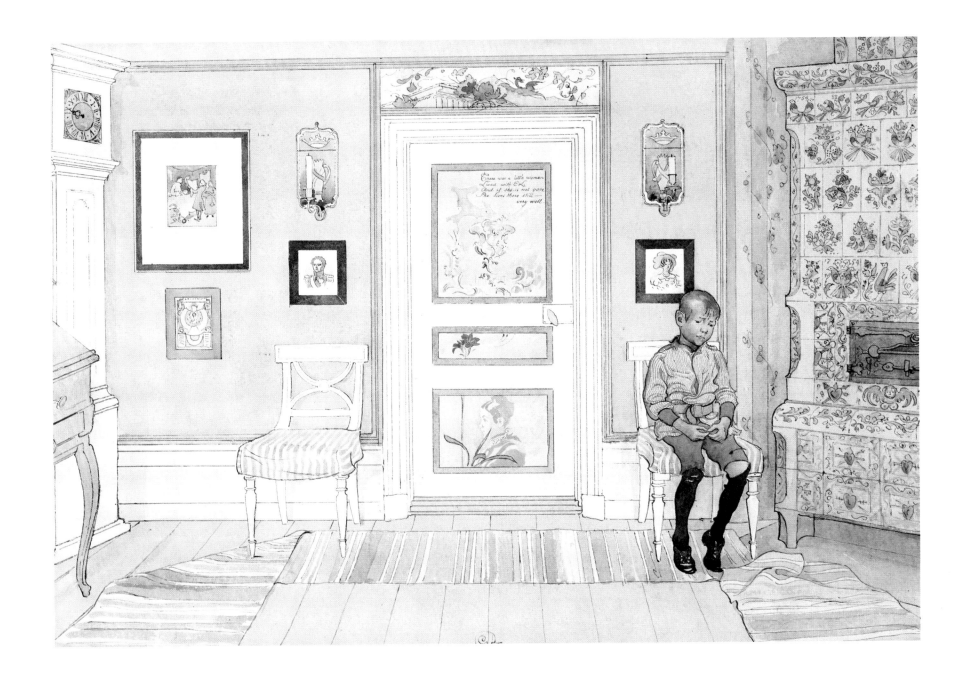

Brother and Sister Watercolor, 1909, from *De Mina*, 1919

Mrs. Vendela Pfannenstill Etching, 1908, Art Museum, Göteborg

Brita, Reading Etching, 1910, Art Museum, Göteborg

Put in the Punishment Corner Watercolor, undated (about 1894-97), from *Ett Hem*, 1899, Nationalmuseum, Stockholm

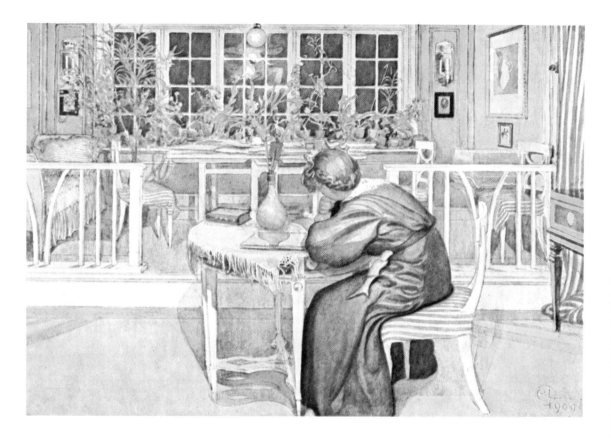

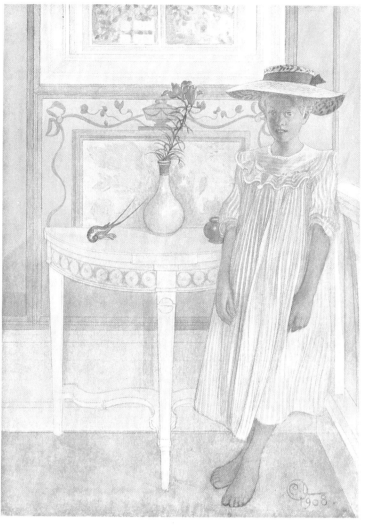

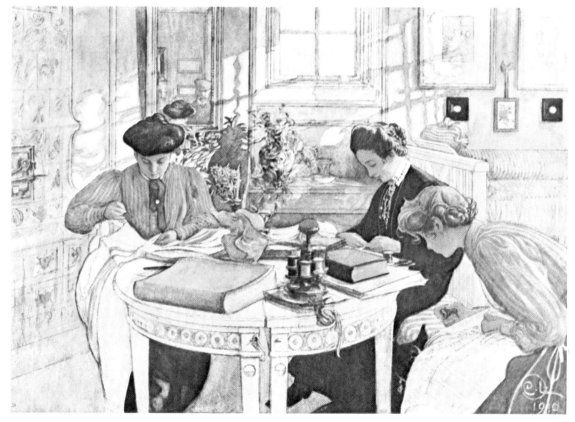

Ingrid E. Watercolor, 1908, from *Andras Barn,* 1913

For the Trousseau Watercolor, 1910, from *Åt Solsidan,* 1910

On the Eve of the Trip to England Watercolor, 1909, from *Åt Solsidan,* 1910

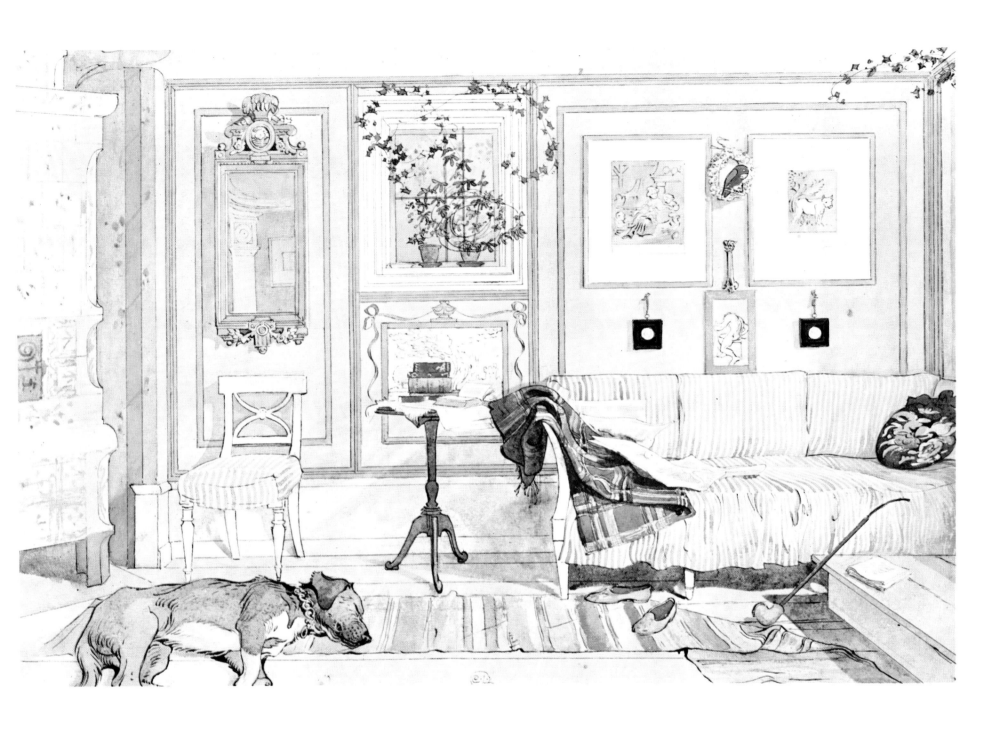

Lazy Nook Watercolor, undated (about 1894-97),
from *Ett Hem*, Nationalmuseum, Stockholm

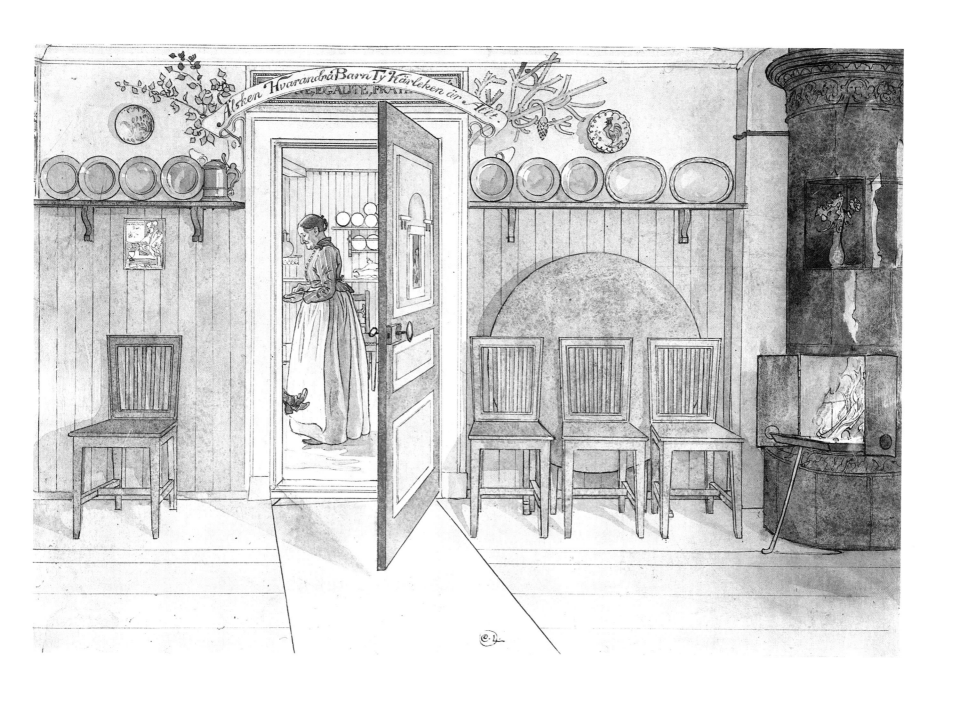

Old Anna Watercolor, undated (about 1894-97), from
Ett Hem, Nationalmuseum, Stockholm

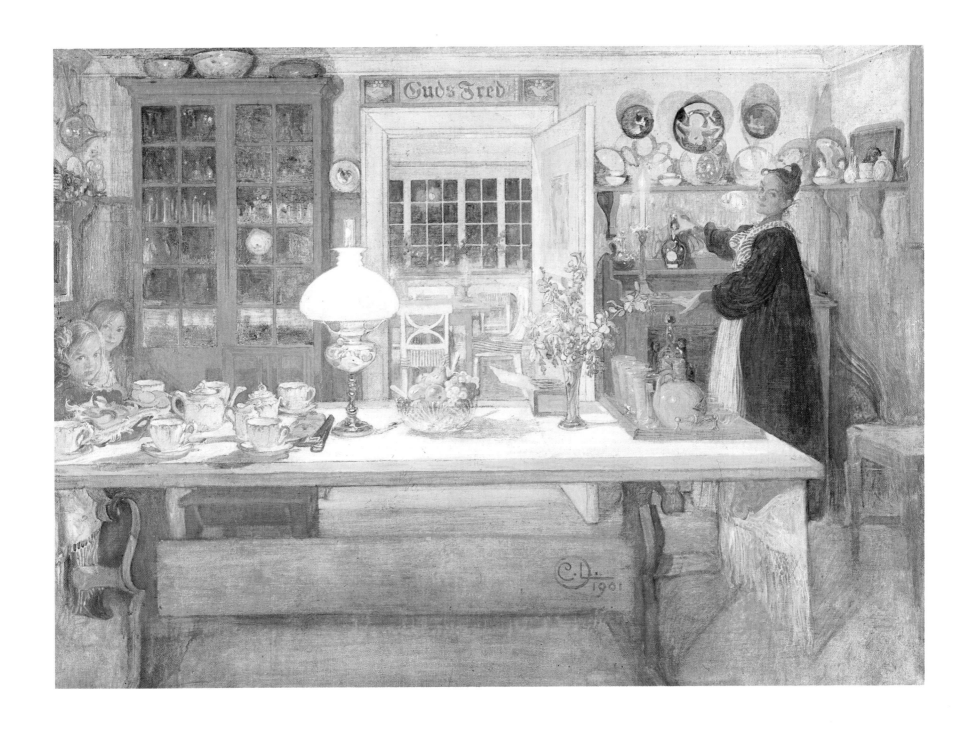

"Just a Sip?" Oil, 1901, from *Larssons,* 1902, Na-
tionalmuseum, Stockholm

157

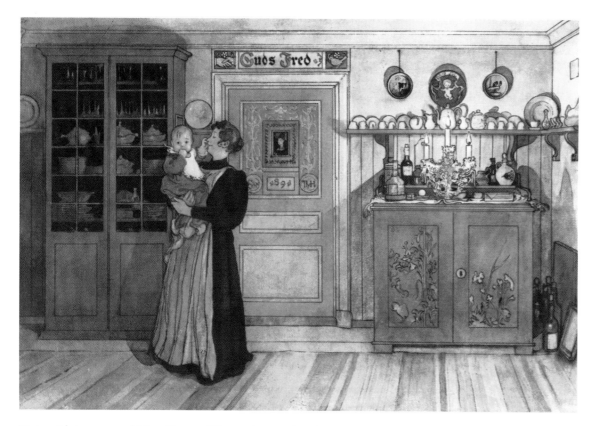

Twixt Christmas and New Years Watercolor, undated (about 1894-97), from *Ett Hem,* Nationalmuseum, Stockholm

Granddaughter Gunlög without her Mama Watercolor, 1913, from *Andras Barn,* 1913

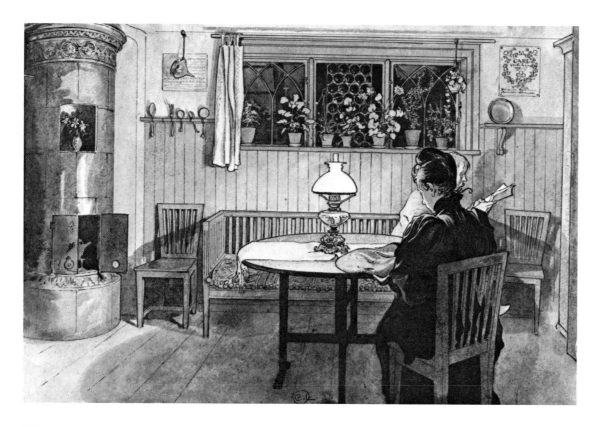

When the Children Have Gone to Bed Watercolor, undated (about 1894-97), from *Ett Hem,* Nationalmuseum, Stockholm

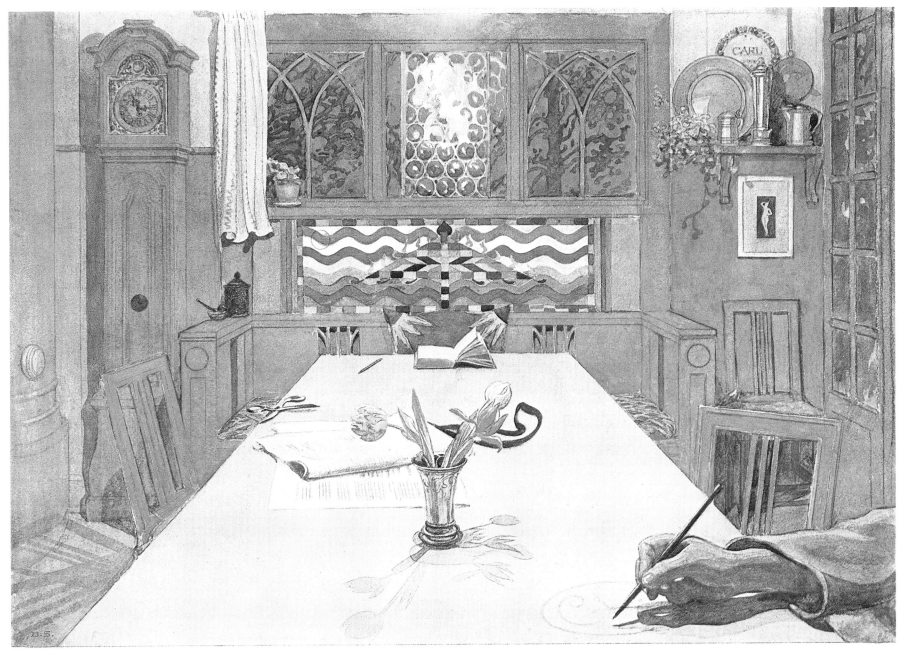

Day is Done, Good Night! Tail-piece from *Åt Solsidan*, watercolor, undated (before 1910)

In the Dining Room Photograph, 1913

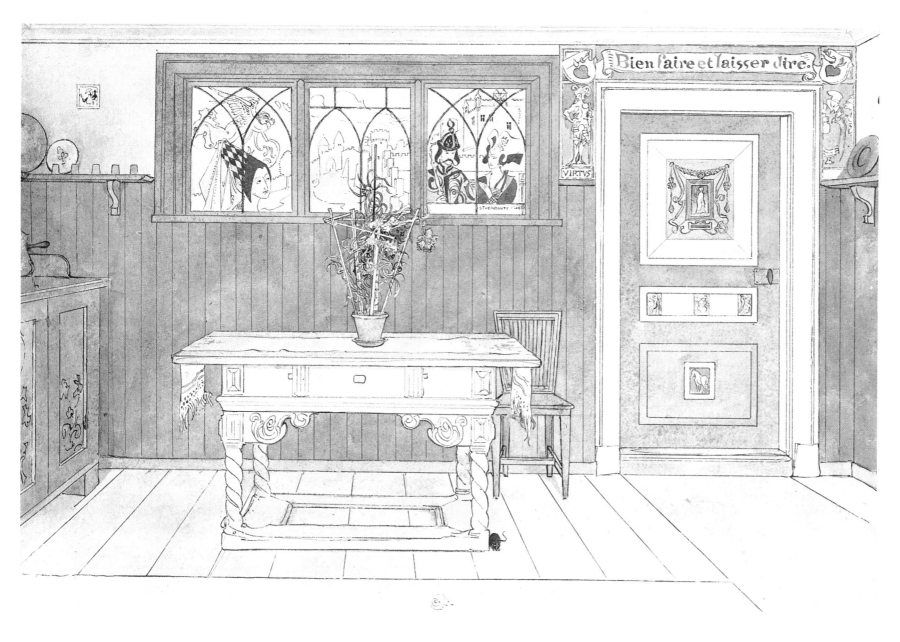

On window glass: Bien faire et laisser dire.

VIRTVS

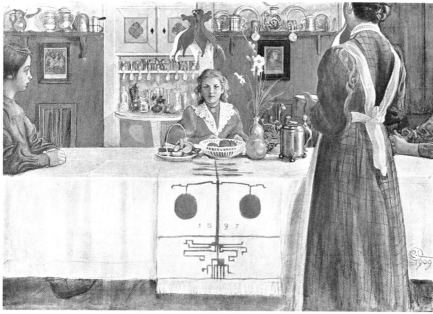

The Dining Room Watercolor, undated (about 1894-97), from *Ett Hem,* Nationalmuseum, Stockholm

A Friend from the City Watercolor, 1909, from *At Solsidan,* 1910

Karin, Reading Watercolor, 1904, Privately owned

The Other Half of the Studio Watercolor, undated (about 1894-97), from *Ett Hem*, Nationalmuseum, Stockholm

The Cat on Grandma's Couch Vignette from *De Mina*, 1895/1919, from the chapter on Grandma.

Kersti in the Studio Vignette from *Larssons*, 1902

Sunday, the Day of Rest Watercolor, undated, from *Larssons*, 1902, Nationalmuseum, Stockholm

Around the Coffee Table in the Workshop, Sundborn Photograph, 1913

In the Studio, at the Spinning Wheel Vignette from *Larssons*, 1902

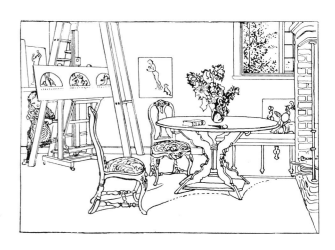

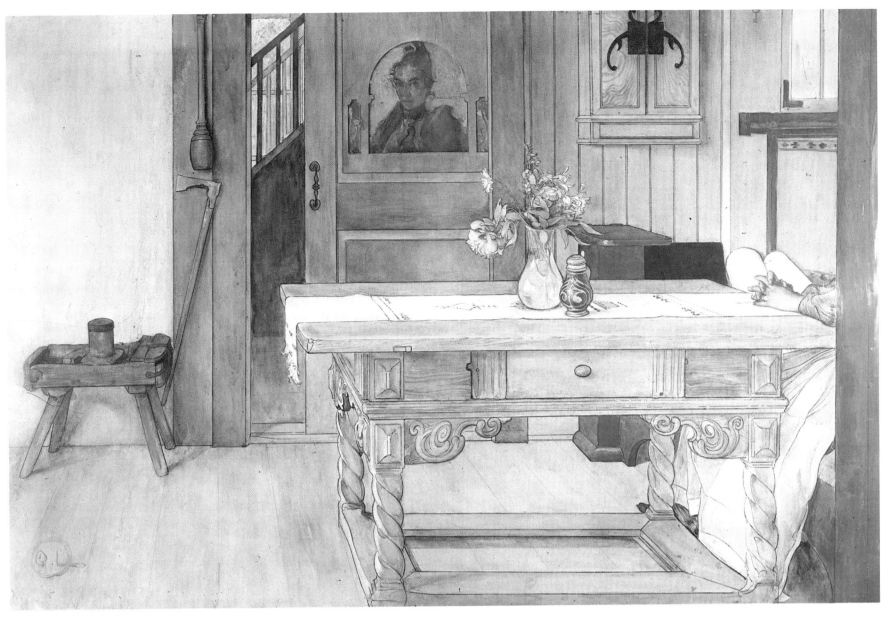

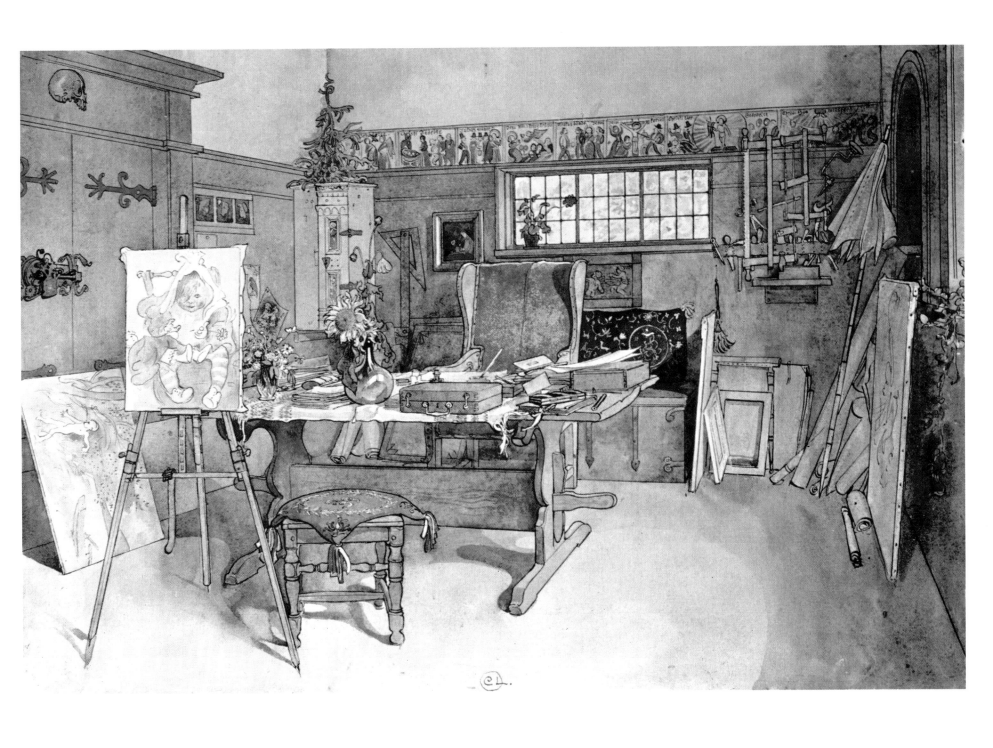

One Half of the Studio Watercolor, undated (about 1894-97), from *Ett Hem*, Nationalmuseum, Stockholm

"But let's look around a bit in the studio. You can see an old carved table which will probably last a few more centuries yet. In that colossal old armchair over there, which surely has a couple of hundred years behind it, I have been sitting, drawing all the pictures for Sehlstedt's Ballads and Viktor Rydberg's Singoalla... A frieze runs along the wall on the wainscot, depicting the life of the Savior. It is a peasant painting from the province of Halland, done a century ago. All the characters except Christ himself are in the contemporary dress of that district. It possesses the same original naiveté and grace as Giotto's frescos but is of much more far-reaching interest to me." (Ett Hem 1899)

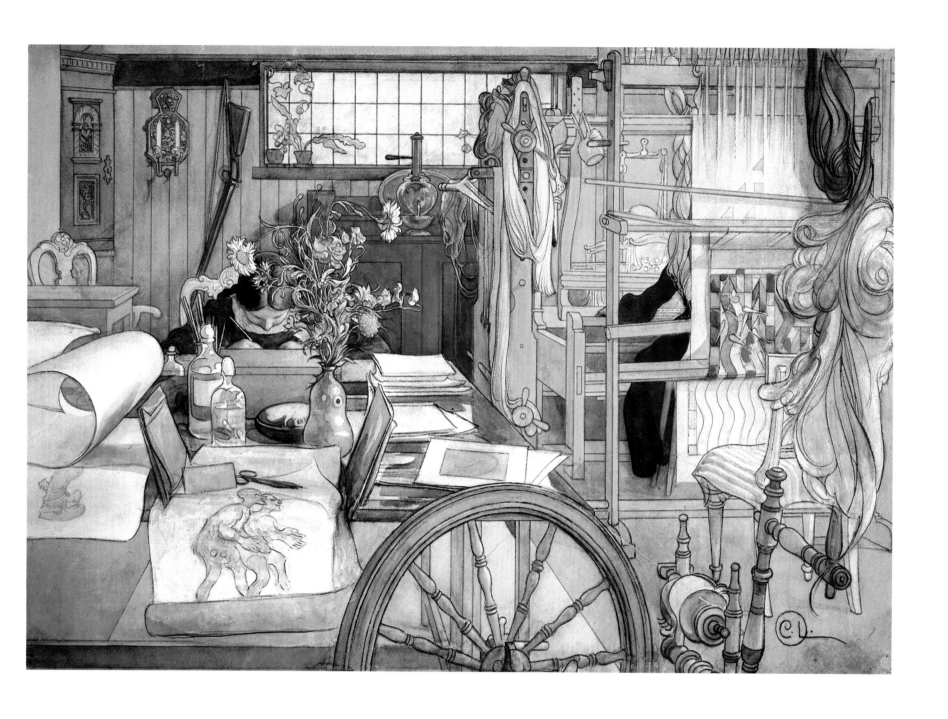

The Workshop Watercolor, undated, published in *Åt Solsidan*, 1910; subsequently reworked, The Carl Larsson Farm, Sundborn

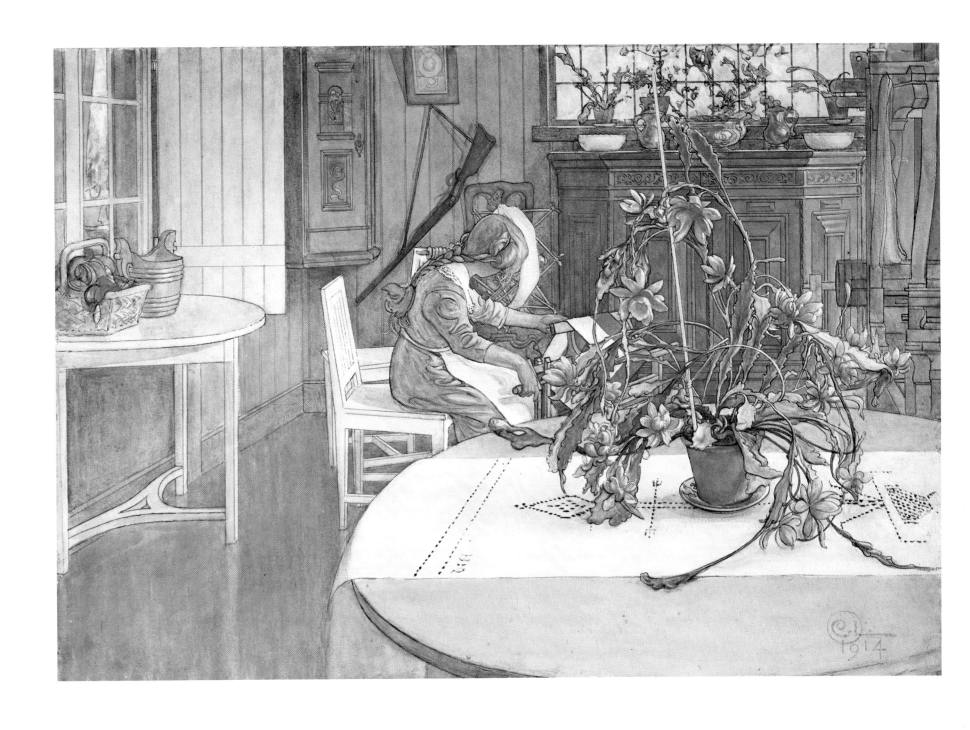

Interior, with Cactus Watercolor, 1914, Museum,
Helsingborg

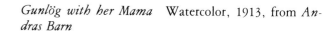

''For some time I have been busy building myself a real big box of a studio, with north light and plenty of room to move around in. Since it has been changed from its originally intended purpose the new one is now referred to as just 'the studio.' The one we are now in has gradually taken on a quite different character and is the childrens' work-room. The boys hammer and chisel here and Suzanne does weaving.'' (Ett Hem 1899)

''My old workshop you have seen, but now it has become my wife's sewing room, for weaving and spinning as well as sewing go on there. When we have guests for dinner that's where the smörgåsbord is laid out.'' (Åt Solsidan 1910)

Azalea Watercolor, 1906, Thielska Galleriet, Stockholm

The Workshop Vignette from *Ett Hem,* 1899

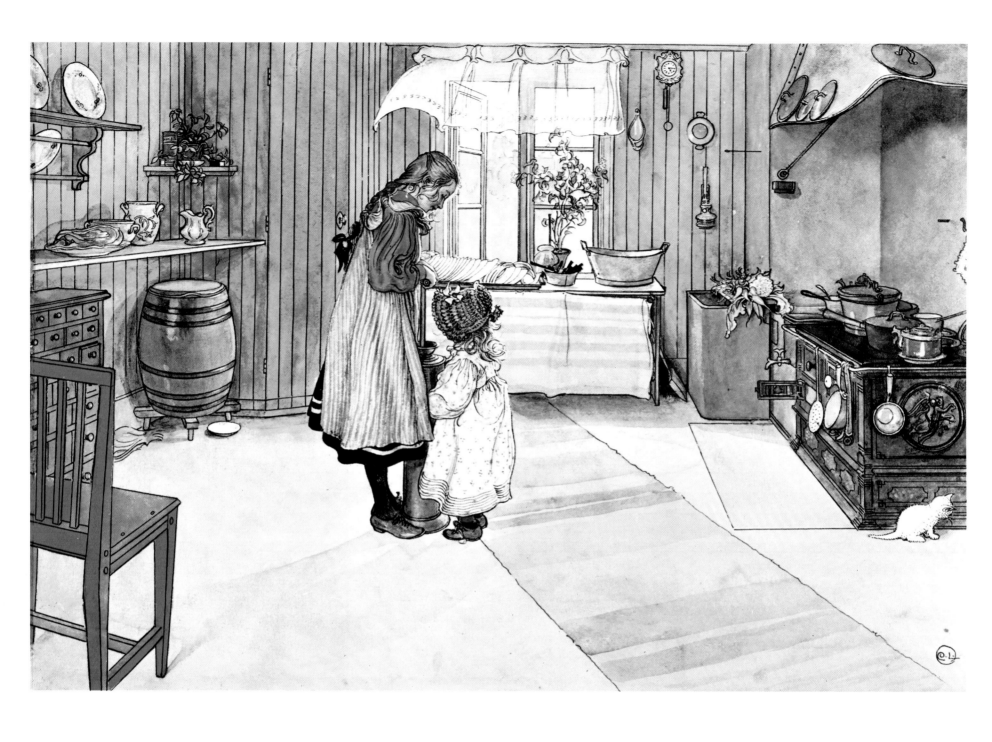

The Kitchen Watercolor, undated (about 1894-97), from *Ett Hem*, Nationalmuseum, Stockholm

"Anna and the cook are two potentates that it is difficult to feel comfortable under the same roof with. Under the kitchen ceiling, that is. The old one wants to live there in winter where it's warm, and when her bed is pulled out and Emma moves in it's always difficult for her again. But they are both agreed that the kitchen is the only room in the house that still 'makes sense.' You see, this kitchen is extremely plain but it's clean and arranged pretty attractively for its purpose." (*Ett Hem* 1899)

In the Studio after the Ball Watercolor, 1908, from *Åt
Solsidan,* 1908, Museum, Malmö

Peek-a-Boo! Colored lithograph, 1901, The Carl Larsson Farm, Sundborn

Stage Props Vignette from *Andras Barn*, 1913

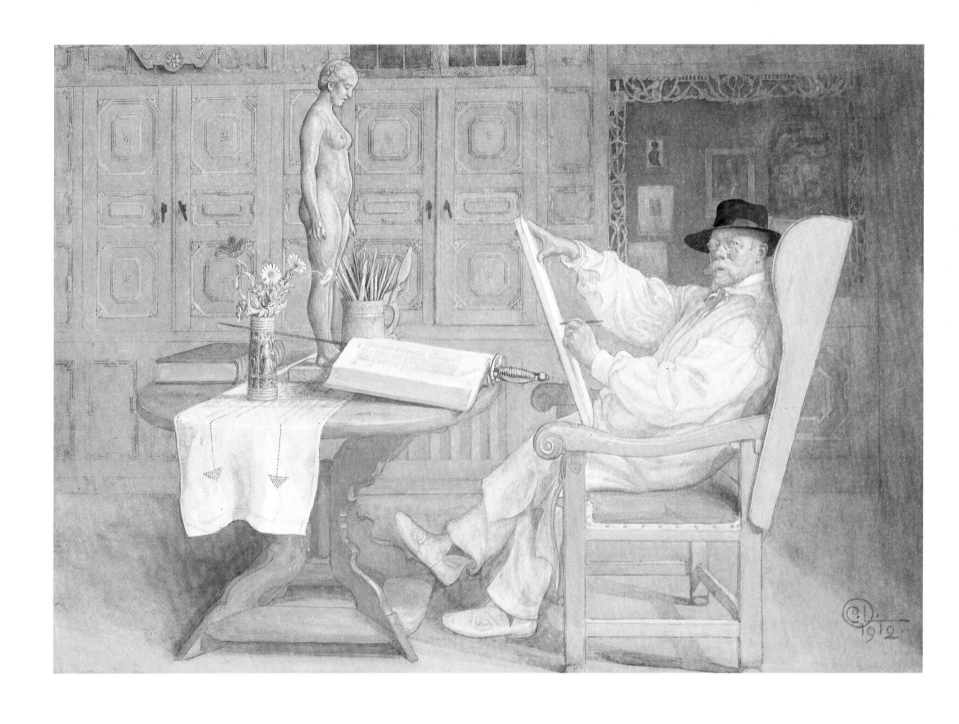

Self-Portrait in the Studio Watercolor, 1912,
Museum, Malmö

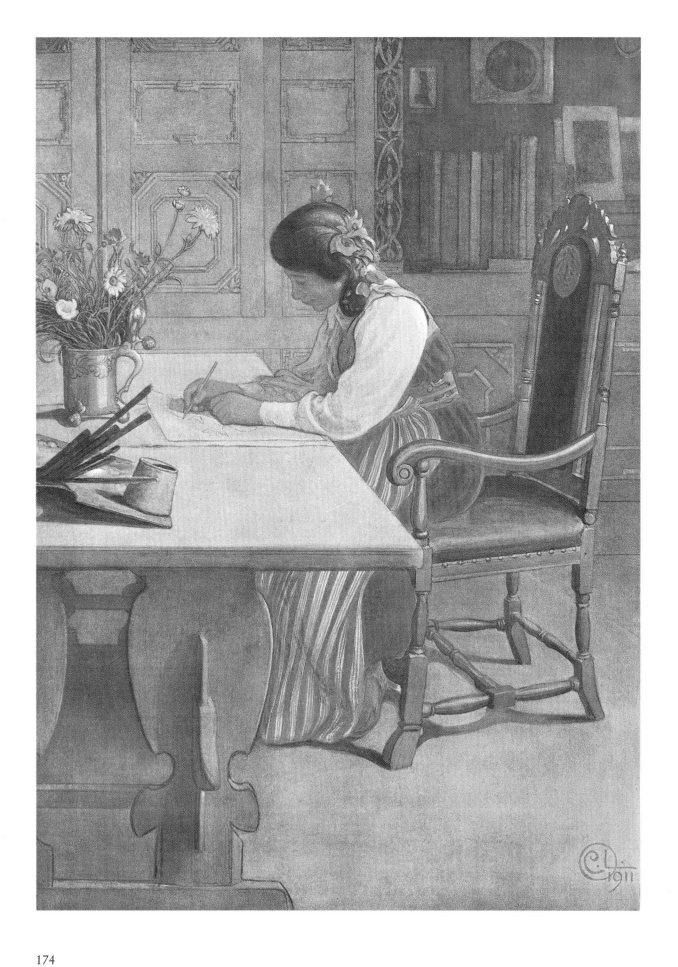

Hilda Watercolor, 1911, from *Andras Barn,* 1913

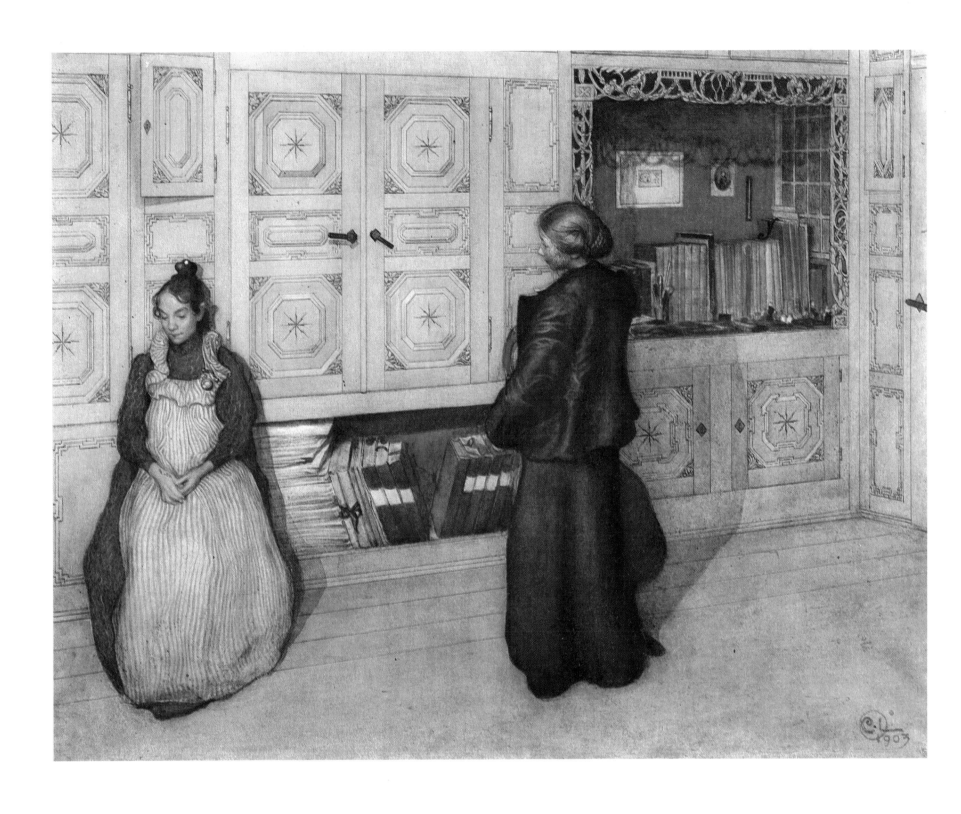

Mother and Daughter Watercolor, 1903, Thielska
Galleriet, Stockholm

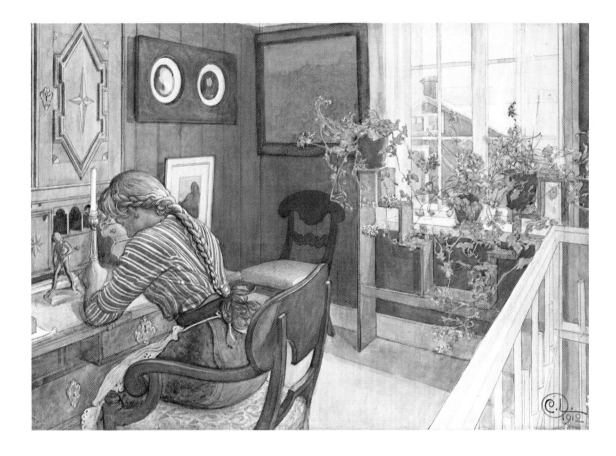

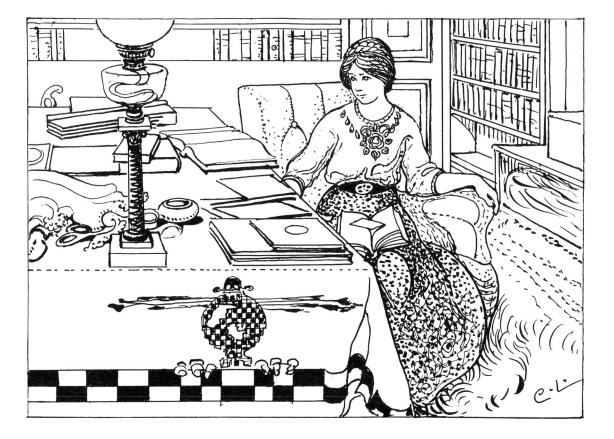

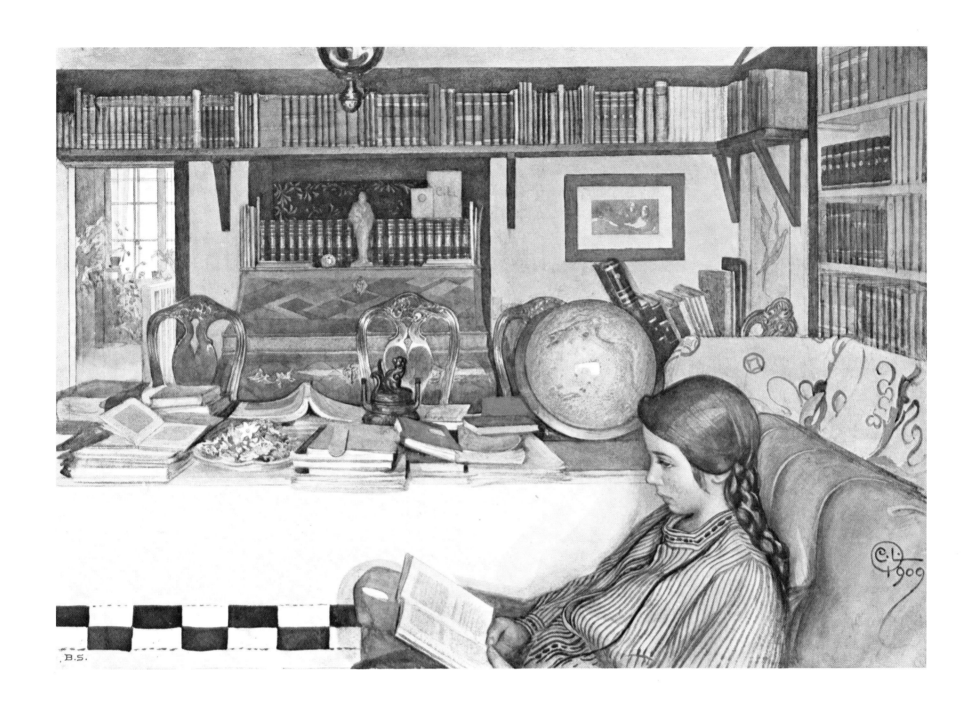

The Reading Room (with Kersti Reading) Watercolor,
1909, from *Åt Solsidan,* 1910

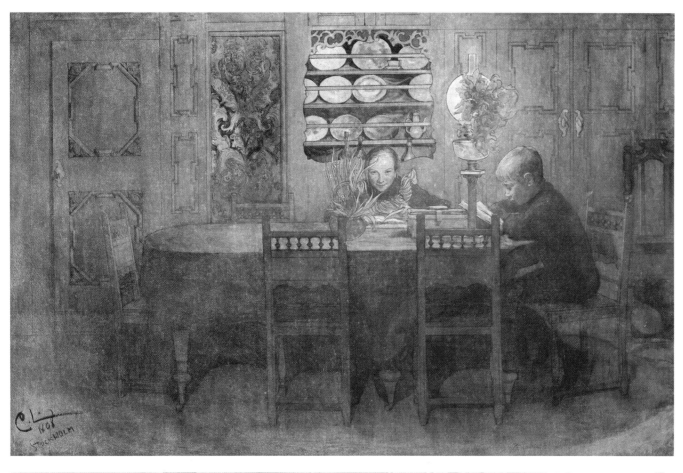

Homework Watercolor, 1898, from *Larssons*, 1902, Art Museum, Göteborg

The Antiquity room. That's what we call it, because that's where all the old things I have dug up are stored and classified and yet everything has some practical use. It is actually the guest-room of the house, because this is where travelers and visiting friends and others can crawl inside those old Frisian wall-panels, where a bed is supposed to be located and actually is, and where you can see Esbjörn changing his shirt at the moment, balanced on the bolsters. There are all sorts of things here: old Flemish paintings, wardrobes, chests, and tables from the fifteenth and sixteenth centuries, a tea-table with painting by Elias Martin, a chandelier from the time of Gustav III and Emilia Högqvist's mirror from Framnas, an old clock and old books, a remarkable little spice-cabinet and a rococo night-stool... the blue object over there, and old coins."
(Åt Solsidan 1910)

"Antiquity Room" Watercolor, 1909, from *Åt Solsidan*, 1910

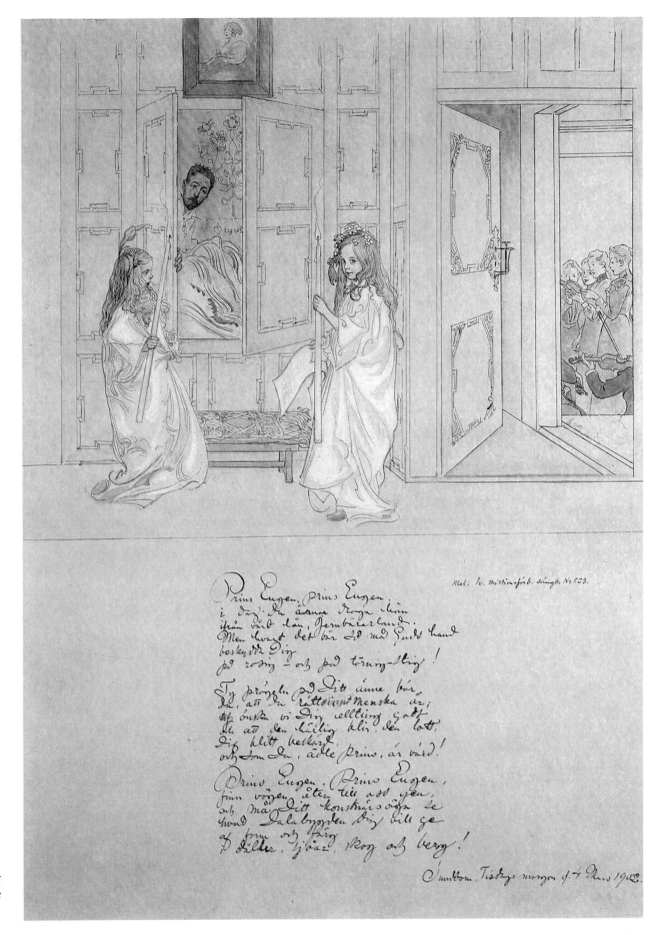

Morning Serenade for Prince Eugen at Carl Larsson's Home on March 4, 1902 Watercolor, 1902, Prince Eugen's Waldemarsudde, Stockholm

Papa's Bedroom Watercolor, undated (about 1894-97), from *Ett Hem,* Nationalmuseum, Stockholm

"This is my bedroom. It is said to be very healthful to have the bed standing in the middle of the room, but I didn't know that when it was put there... But I sleep well in my simple bed on top of straw and as soundly as a king on his catafalque. I wipe down my bedroom walls now and again with chalk and lime-water and it gets them as radiantly clean as a room in heaven." (Ett Hem 1899)

My Bedroom Watercolor, 1909, from *Åt Solsidan,*
1910

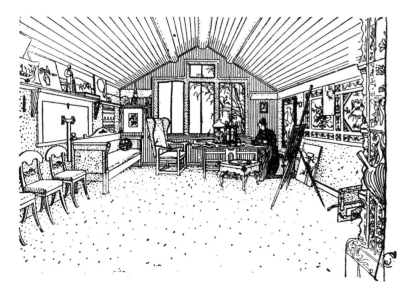

Brita's Nap Watercolor, undated (about 1894-97), from *Ett Hem*, Nationalmuseum, Stockholm

"Now, since I have remodeled a much too unlivable wardrobe room into a kind of studio, we usually sit there. It is located in line with the two bedrooms and from there Karin can hear the babies if they wake up and need a comforting word or a kiss or a back-rub when it's too hot for them to be able to get back to sleep." (Ett Hem 1899)

Winter Studio Vignette from *Ett Hem*, 1899

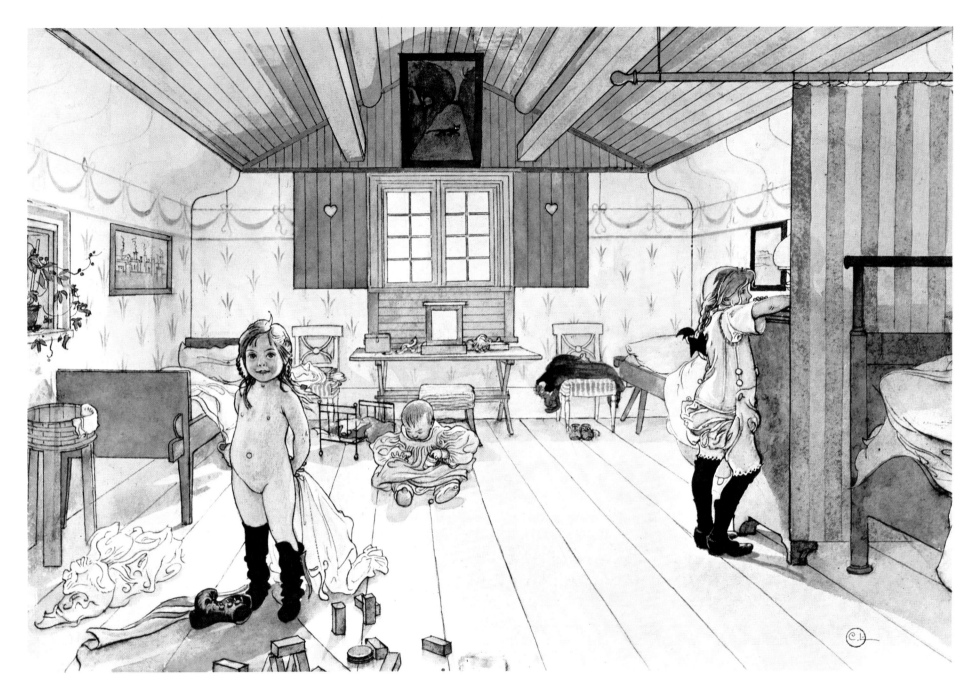

Mama's and the Little Girls' Room Watercolor, un-dated (about 1894-97), from *Ett Hem*, Na-tionalmuseum, Stockholm

The Little Girls' Bedroom Drawing, from *Larssons*, 1902

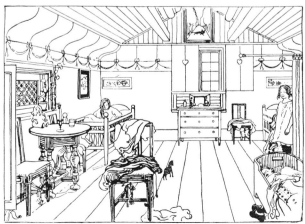

"*Aunt Emmy once made a remark about this room (mama's and the younger girls' room) after I had chop-ped down the nice flat ceiling (to get more air) and add-ed a side window, installed smaller window-panes in the gable-wall and gone over the almost-new wallpaper with white paint, and said she, at least, wouldn't like to sleep in a jail like that. No, Aunty, don't say that again!*" (*Ett Hem* 1899)

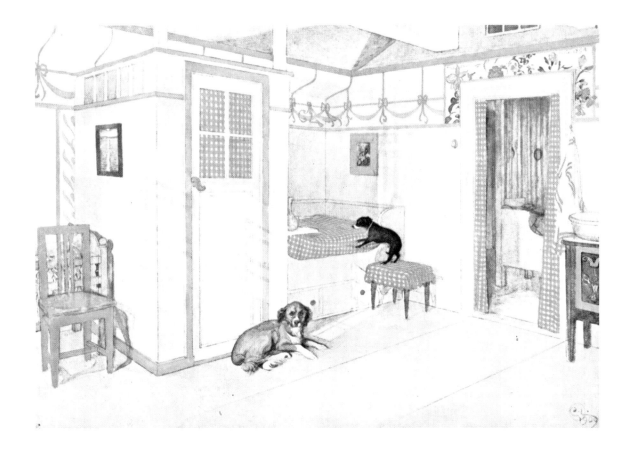

Joupjoup and Kiki Watercolor, 1909, from *Åt Solsidan*, 1910

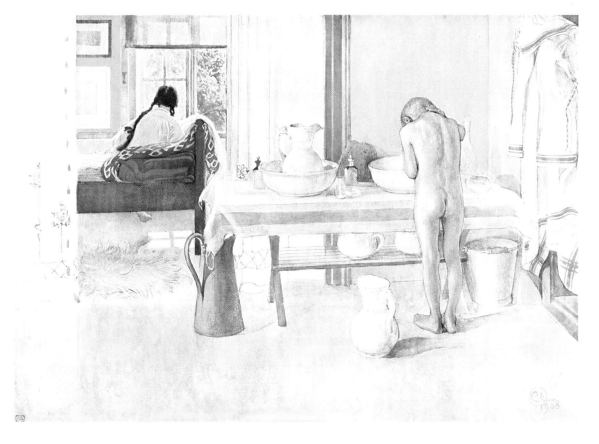

"You seem to be wondering where the older children sleep. Look at the gable-end of the cottage and you'll see a small added-on wing. It used to be a wood-shed, but since we had two of them I converted one into two bedrooms. It only took a couple of days. Simple wood sheeting and plank-beds fastened to the walls. Suzanne lives in the smaller one and the two boys in the bigger one. What about winter-time? Well, let's not talk about that. You don't have to be so fussy about children. Besides, there are other possibilities. In the new wash-house there are two nice little rooms with stoves. In the upstairs one—you can see it clearly through the frost-clad trees in the winter picture where Brita is going by on her kick-sled—is where the maids live in summer and at Christmas-time." (Ett Hem 1899)

Summer Morning Watercolor, 1908, from *Åt Solsidan*, 1910

184

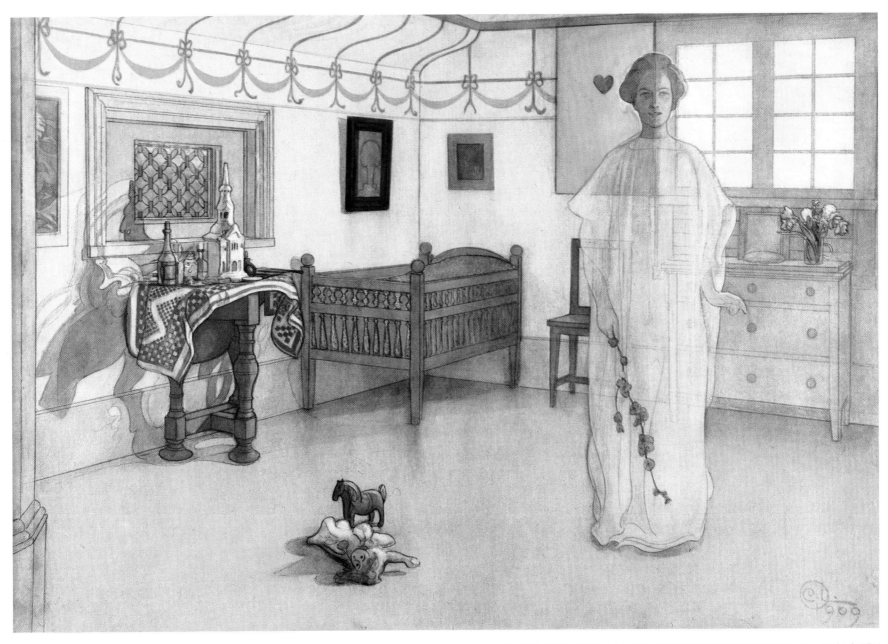

The Home's Good Fairy Watercolor, 1909, from *Åt Solsidan,* 1910, The Carl Larsson Farm, Sundborn

Cock-a-Doodle-Doo, Seven O'clock! Watercolor, undated, from *Larssons,* 1902

In the Miner's Room Photograph, 1913

A Snooze in the Miner's Room Photograph, 1913

Toy corner in the Göteborg Flat Watercolor, 1887,
from *Larssons,* 1902

Mother Kersti (Visiting Larsson's 'Nordic Museum' at Spadarvet) Watercolor, undated, from *Åt Solsidan*, 1910

"When our school-days lodging in Falun was snatched out from under us one awful day because the house had changed owners and the new one wanted to live there himself, there were no other suitable quarters available for rent. But luckily I was able to buy a little old house... We dolled it up a bit and I built a little wing on to it that serves as both a 'parlor' and a place to work. This is still so new to us that we haven't quite gotten used to it yet, so it still lacks a history..." (*Åt Solsidan* 1910)

Name Day at the Storage Shed Watercolor, undated (about 1894-97), from *Ett Hem*, Nationalmuseum, Stockholm

The Pond Vignette from *Åt Solsidan*, 1910
My Street (in Falun) Drawing from *Åt Solsidan*, 1910
"Enrichment" (in Falun) Drawing from *Åt Solsidan*, 1910
The Coal Slagheap Vignette from *Åt Solsidan*, 1910

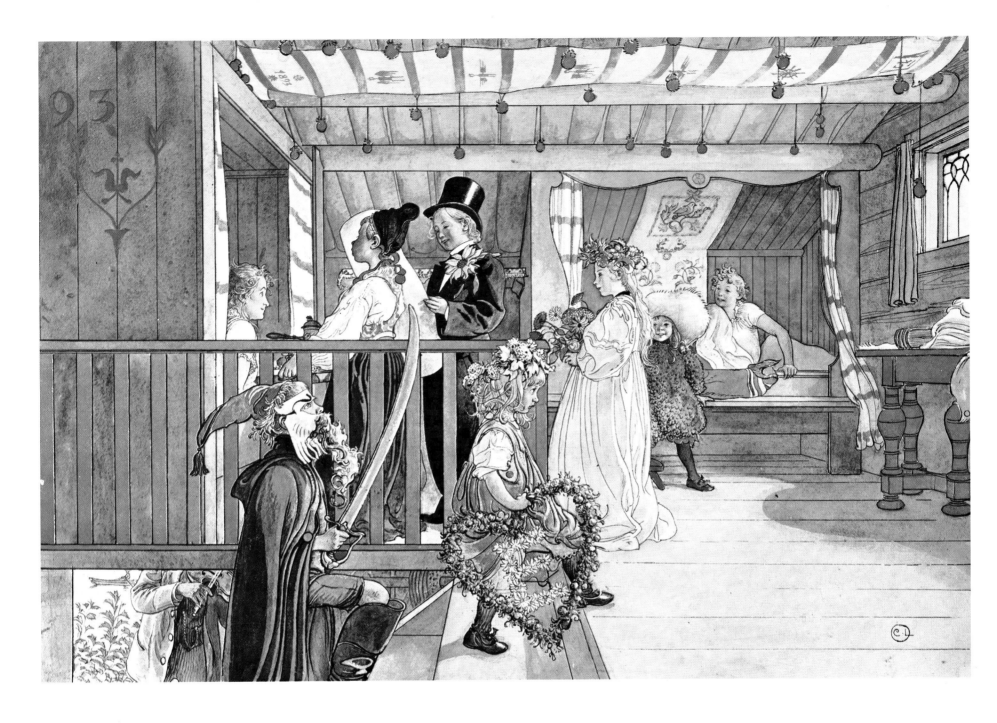

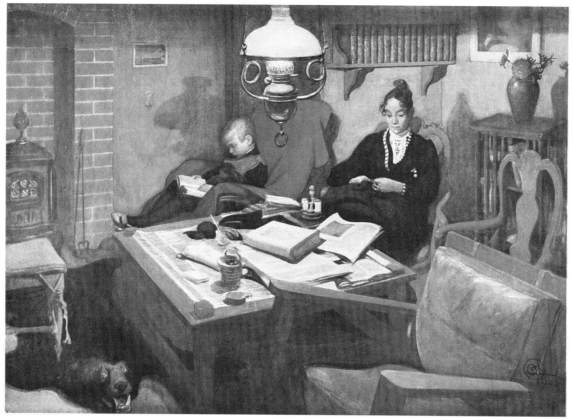

Around the Lamp at Evening (in the House in Falun) Watercolor, 1909, from *Åt Solsidan*, 1910

The Gate (in Falun) Vignette from *Åt Solsidan*, 1910

The House in Falun Vignette from *Åt Solsidan*, 1910

"Close by us lived two little old ladies; they were sisters and each one owned a tiny little house of her own. Then one of the old ladies died and right after that the other one. They left nothing but these old shacks... I was advised to buy them for the sake of the land they stood on and tear them down because they were quite rickety and were fire-traps... The purchase was consummated... On closer inspection Arnbom (the carpenter from Sundborn) declared them to be a thousand-year-old fäbod or säter hut... So now, my friends, it is a lit- tle idyll, a room with its own kitchen. The kitchen shown here serves as my etching studio and on these rough old deal floor-boards it doesn't make any dif- ference if I spill a bottle of hydrochloric acid now and then." (Åt Solsidan 1910, to accompany the picture ti- tled Where I do My Etching.*

*Cowherd's quarters in the hills for use when the cattle used to be taken to summer grazing pastures.

The House in Falun Two photographs, 1913

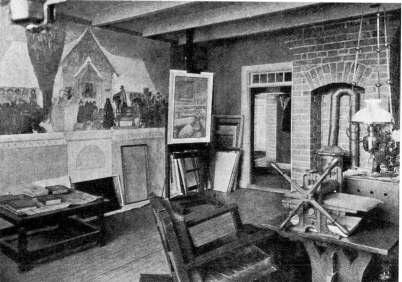

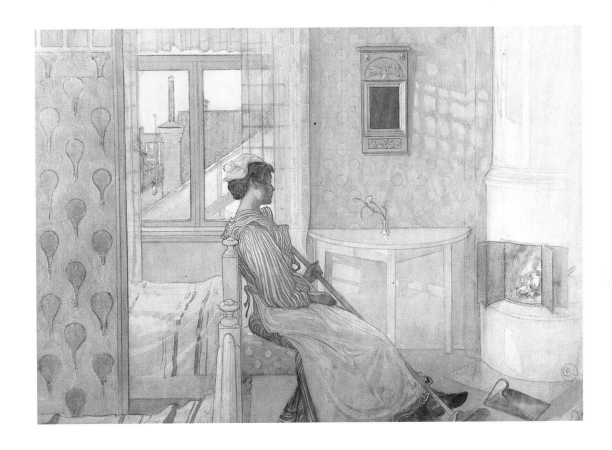

Esbjörn Reading on the Veranda Watercolor, 1908,
Privately owned

*Martina in Front of the Fire (in the House at
Falun)* Watercolor, 1909, from *Åt Solsidan*, 1910

The Mountain-Pasture Cottage. Drawing, from *Åt
Solsidan*, 1910

Where I do my Etching Watercolor, 1910, from *Åt
Solsidan*, 1910

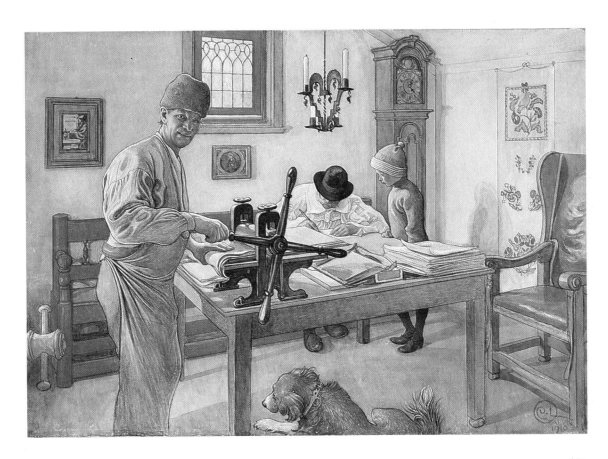

CHRONOLOGY
By Bo Lindwall

1853 Carl Larsson born May 28 at Prästgatan 78, Stockholm Sweden

1857 Only brother, John, born, while the family lived near Grevgatan in the Ladugård section of Stockholm's East End

Subsequent years. Various lodgings in the Ladugård slum area. The Ladugård ''Poor School'', later a public school, supplied Carl Larsson's first schooling. Instruction by the ''Lancaster'' system, meaning that the best pupils were appointed monitors over small groups of the others. Carl Larsson was a monitor and was paid 1 riksdaler and 24 skillings at the end of the term. (About 30 cents, U.S.)

1866 Cholera epidemic in Stockholm. Carl Larsson enrolled as a student at the preparatory section of the Academy of Fine Arts.

1869 Carl Larsson awarded one of 12 medals and promoted to the ''antique school'' of the Academy. Editor of the humorous student publication *Pajas, (Clown)*

1871 Contributes to family expenses with income as retoucher in a photographer's studio and as sketcher for the humor publication *Kasper (Punch)*

1872 Carl Larsson promoted to Academy's model school

1873 Carl Larsson promoted to Academy's painting school. Spends summer at Sickla, outside Stockholm, with Vilhelmina Holmgren, a student at the Academy

1874 Carl Larsson awarded 150 kronor and commendation from the Academy for his painting *Moses Abandoned by his Mother;* promoted to paying position at *Kasper* with annual salary of 2500 kr., more than that of the head of the Academy

1875 Carl Larsson awarded 150 kr. and commendation from the Academy for his painting *Gustaf Vasa Accuses Peder Sunnanväder Before the Court at Vasterås;* studies graphic techniques at Lowenstam school in Stockholm; receives a number of commissions for illustrating; hired as reporter-sketcher by the weekly *Ny Illustrerad Tidning;* conscripted

1876 Royal medal for his painting *Sten Sture the Elder Freeing Danish Queen Kristina from Imprisonment in Vadstena;* illustrates Hans Christian Andersen's *Fairy Tales;* death of Vilhelmina Holmgren

1877 Illustrates Asbjörnsen and Moe's *Norwegian Folk Tales;* travels to Paris April 17, studio on Rue Capron; spends summer in Barbizon; in the fall, poverty and thoughts of suicide

1878 Starvation winter in Paris; summer in Barbizon, where he paints portrait of Carl Skånberg, fellow student from the Academy, which is shown at the Paris Salon; receives 1000 kr. Academy stipend; returns to Stockholm in November; is commissioned to illustrate Z. Topelius' series of novels *Tales of an Army Doctor*

1879 Reporter-sketcher for *Ny Illustrerad Tidning;* commissioned to decorate ceiling and lunettes at Bolinder mansion, Stockholm

1880 Goes to Paris in November; lives at 53 rue Lepic

1881 Refused at Paris Salon; back to Sweden May 27; spends summer with Strindberg and family on Kymmendö (island) in Stockholm archipelago; starts work illustrating Strindberg's cultural history work *Svenska Öden och Äventyr;* back to Paris in the fall, Ave. des Tilleuls

1882 Paints *Chez le Peintre du Roi* for the Paris Salon, which refuses it; neurotic; settles in Grèz-sur-Loing, where he paints his first candid, outdoor watercolors; engaged to Karin Bergöö, 23-year-old artist, in September

1883 In Grèz; receives medal, third class at Paris Salon for Grèz watercolors; marries Karin Bergöö June 12 in Stockholm; works on watercolors and illustrations for *Skaldeförsök (Attempts at Being a Poet)* by Anna Maria Lenngren, 1754-1817; to Paris in October; 14 rue Fromentin; Nationalmuseum in Stockholm buys two watercolors; Strindberg's article on Carl Larsson in *Svea* calendar; George Nordensvan's article on Carl Larsson in *Nornan* Calendar

1884 Watercolor *Dammen (The Pond)* purchased by French government at Paris Salon; declines election as ''agré'' (associate member) at Swedish Academy of Fine Arts

1885 Trip to London in the spring; exhibits *Little Suzanne* at Paris Salon; to Stockholm in May to prepare the autumn exhibition of the artist's revolt; settles his family in Stockholm

1886 Paints *The Outdoor Painter* which is shown at Paris Salon; trip from Stockholm to Messina via Venice, Florence and Rome: illustrated account of trip in *Svea* calendar; back to Stockholm in May; engaged as teacher at Valand art school in Göteborg, starting in the fall; Artists' meeting in Göteborg; the rebels (''Opponents'') form the Artist's Union, of whose Stockholm section Carl Larsson becomes board member

1887 Takes part in International Exposition at Georges Pettit's in Paris, *''the greatest honor I ever conceived of'';* oldest son Ulf born in April

1888 To Paris April 16 to paint Fürstenberg's triptych, lives on Boulevard Arago; takes part in competition for murals at Nationalmuseum, Stockholm; in the spring the family acquires the cottage in Sundborn village in Dalecarlia, gift of Karin's father; Pontus born October 26

1889 January 12: results announced in competition for murals at Nationalmuseum: Carl Larsson wins ''a prize in the second room''; back to Sweden in June; finished triptych shown at World's Fair in Paris: medal, first class; back to Paris in the fall; home in December; family now living at Sundborn

1890 Family moves to Stockholm; Carl Larsson paints murals at girl's high school in Göteborg; starts on illustrations for Sehlstedt's ballads; new competition announced for painting murals at Nationalmuseum

1891 Carl Larsson wins first prize in new competition at Nationalmuseum; murals at girls' school in Göteborg finished; Carl Larsson leaves Artists' Union; draws illustrations for Friedrich Schiller's *Kabale und Liebe;* daughter Lisbeth born

1892 Living in Stockholm; trip to Venice via Germany, thence to Paris, with Mr. Fürstenberg, wealthy patron of the arts

1893 Spends summer at Sundborn, winter in Stockholm; finishes Sehlstedt illustrations; daughter Brita born

1894 Illustrates the Swedish poet Viktor Rydberg's gypsy novel *Singoalla;* in the spring to Germany, Rome and Paris to study fresco techniques, since government had approved his plan for murals in lower stairwell at Nationalmuseum; starts the *''A Home in Dalecarlia'' (Ett Hem)* series of watercolors; one-man exhibition in Stockholm in November

1895 Work started in May on working drawings for the museum murals

1896 Nationalmuseum murals finished in the fall; accepted by museum committee without approval; studies graphics at the Academy of Fine Arts' school of etching

1897 Buys *Spadarvet* and orchard at Sundborn; does murals in the foyer of the newly completed Opera house in Stockholm (ceiling and a number of lunettes completed in December); shows twenty of the *Ett Hem* watercolors at the Art and Industry Exhibition in Stockholm

1898 Opera auditorium ceiling finished; Carl Larsson offered professorship at Academy of Fine Arts but declines; starts on the *Korum* mural at the North Side Classical High School in Stockholm

1899 *Ett Hem i Dalarna* published with color reproductions of watercolors and text by Carl Larsson

1900 Medal, first class, at World's Fair in Paris; youngest son Esbjörn born

1901 Moves to Sundborn for good; *Korum* mural finished; first book about Carl Larsson published, by Georg Nordensvan

1903 Carl Larsson's fiftieth birthday; mural *Ute Blåser Sommarvind... (Out of Doors the Summer Winds are Blowing)* at Classical high school in Göteborg

1904 New sketch for *Gustaf Vasa's Entry into Stockholm;* work started on the *Spadarvet* album

1905 Eldest son Ulf dies, aged 18; commissioned to paint ceiling at the new Dramatic Theater in Stockholm

1906 *Spadarvet* album comes out; self-portrait *Självrannsakan (Introspection)*, later bought by Uffizi gallery in Florence; one-man show in Stockholm; Nationalmuseum approves new sketch for *Gustaf Vasa's Entry*

1907 Ceiling mural *Birth of Drama* at Dramatic

Theater finished; Carl Larsson buys house in Falun as lodgings during older children's school year

1908 Strindberg attacks Carl Larsson and his wife in *A Blue Book;* Carl Larsson paints fourteen watercolors for the *Åt Solsidan album*

1909 Paints fourteen more paintings for *Åt Solsidan;* all 28 watercolors are shown at an exhibition in Munich; Carl Larsson travels to Germany

1910 *Åt Solsidan* album published; Carl Larsson buys Lövhult, the ancestral farm in Södermanland

1911 First sketch for *Midvinterblot (Sacrifice at the Winter Solstice)* exhibited at the Nationalmuseum in February; Carl Larsson participates in an exhibition in Rome and wins first prize; Uffizi gallery purchases self-portrait *Självrannsakan (Introspection);* Carl Larsson at-tacks the latest modern art in a Swedish art periodical and is answered by Prince Eugen

1912 Trip to Germany; exhibitions in Helsinki and Åbo, Finland; participates in exhibition in Germany and is awarded the Great Gold Medal

1913 Sixtieth birthday; travel to Germany and France (first visit to Paris in 19 years, feels like a stranger); new sketch for *Midvinterblot* exhibited at Nationalmuseum in November; *Andras Barn* album comes out in July

1914 Draws poster and cover for publication of the *Bondetåg (Farmers' Protest March);* Nationalmuseum committee agrees that Carl Larsson is to complete murals for the museum but with a motif other than *Midvinterblot*

1915 The large painting, *Midvinterblot,* is hung on approval at Nationalmuseum

1916 Dedication of Stockholm's large new art gallery, Liljvalchs, with exhibition by Carl Larsson, Bruno Liljfors and Anders Zorn, with the large painting of *Midvinterblot* among the exhibits; Nationalmuseum refuses to purchase the painting and also declines Anders Zorn's offer to pay for executing *Midvinterblot* in fresco; exhibition in Copenhagen in the autumn

1917 Carl Larsson finishes autobiography *Jag (me),* which is not published until 1931

1919 Carl Larsson dies in Falun, January 22

The Curtain Falls Drawing, vignette from *De Mina,* 1895/1919